P9-DVL-070

fa Famous Artists
School

How to Draw
the Human Figure

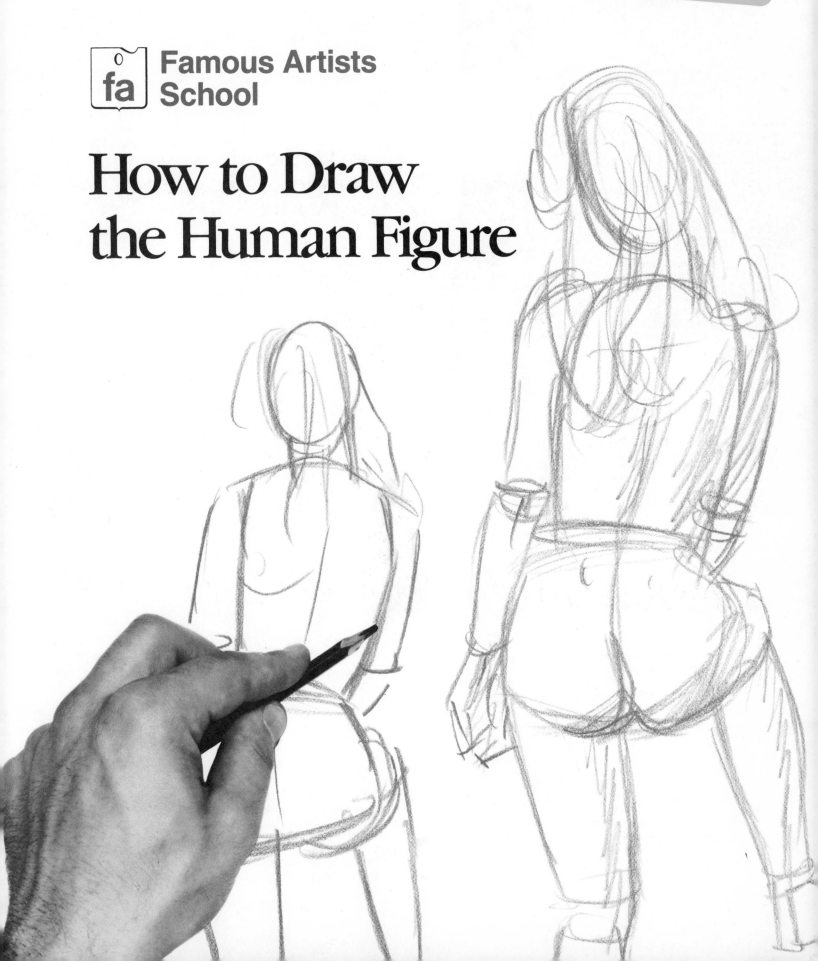

Albert Dorne
In founding the Famous Artists School Albert Dorne turned a dream into a reality. Having been one of the top illustrators in the country for years, Dorne had generously helped and advised many aspiring artists. Founding the School and rounding up the finest art faculty in America enabled him to help many thousands more.

Robert Fawcett
Because of his outstanding mastery of draftsmanship and his highly personal use of color, Robert Fawcett was called "the illustrator's illustrator" early in his successful career. His dazzling technical ability and meticulous skill grew out of total dedication and a determination to settle for nothing short of excellence.

Austin Briggs
More than 75 art awards and five medals from the Society of Illustrators have made Austin Briggs one of the most honored artists of this century. Highly skilled in black and white mediums, Briggs developed into a complete master of design and color—both in illustration and fine art.

Ben Stahl
From the time he won an art school scholarship while in his teens, Ben Stahl has impressed both the public and his fellow artists with the versatility and power of his drawings and paintings. With his generosity of spirit, he has always been glad to use part of his time teaching and inspiring others.

Arnold Blanch
The pictures of Arnold Blanch hang in numerous public collections, including The Library of Congress and The Metropolitan Museum of Art. In addition to having received countless awards and honors, this versatile artist has long been recognized as one of America's great art teachers.

Learn FIGURE DRAWING with the easy-to-follow methods of these FAMOUS ARTISTS!

The Famous Artists School series of books pools the rich talents and knowledge of a group of the most celebrated and successful artists in America. The group includes such artists as Norman Rockwell, Albert Dorne, Ben Stahl, Harold Von Schmidt, and Dong Kingman. The Famous Artists whose work and methods are demonstrated in this volume are shown at left.

The purpose of these books is to teach art to people like you—people who like to draw and paint, and who want to develop their talent and experience with exciting and rewarding results.

Contributing Editor
Howard Munce
Paier College of Art

PUBLISHER'S NOTE
This new series of art instruction books was conceived as an introduction to the rich and detailed materials available in Famous Artists School Courses. These books, with their unique features, could not have been produced without the invaluable contribution of the General Editor, Howell Dodd. The Contributing Editors join me in expressing our deep appreciation for his imagination, his unflagging energy, and his dedication to this project.

Robert E. Livesey, *Publisher*

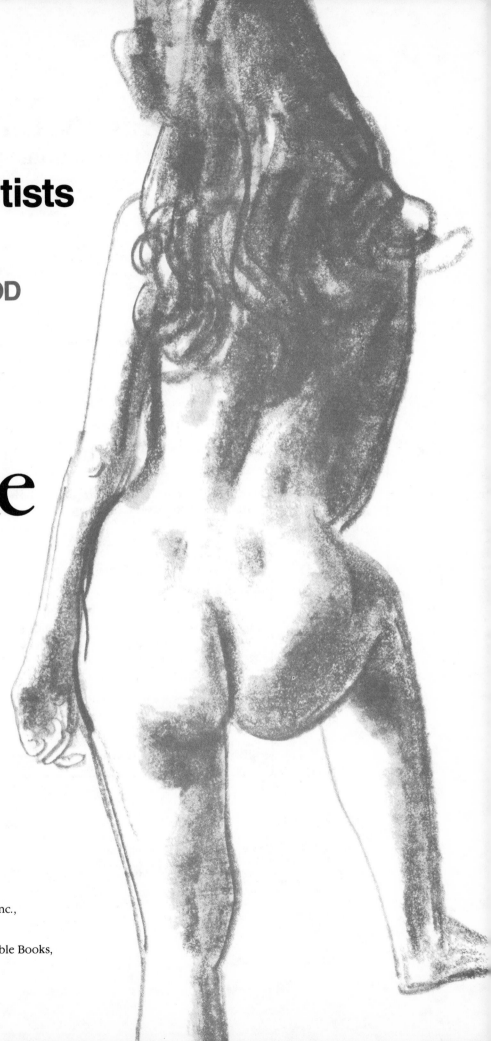

 Famous Artists School

STEP-BY-STEP METHOD

How to Draw the Human Figure

Published by Cortina Learning International, Inc.,
Westport, CT 06880.

 Distributed to the Book Trade by Barnes & Noble Books,
a Division of Harper & Row.

How to Draw the Human Figure
Table of Contents

Introduction	**Your Practice Projects...how they teach you** *page 5* **Drawing the human form** *page 6–7*
Section 1	Working tools...paper and drawing boards **8–11**. Models...and where to find them **12–13**. The gesture...a natural way to draw **14–16**. Figure drawing...step by step **17**. Try these gesture exercises **18–19**. Practice Project **20–21**.
Section 2	The basic forms **22–23**. Construction of the figure **24–25**. Developing the form figure from gesture drawing **26–27**. Practical uses of the basic form figure **28–31**. Practice Project **32–33**.
Section 3	Contour drawing **34–37**. Practice Project **38–39**.
Section 4	The figure as a solid form **40–41**. Form and bulk **42–43**. Practice Project **44–45**.
Section 5	Artistic anatomy...relative proportions **46–47**. The skeleton and muscles **48–49**. The head; the torso **50–51**. The arm **52–53**. The hand and wrist **54–55**. The leg and foot **56–57**. Practice Project **58–59**.
Section 6	Humanizing the basic form figure **60–61**. Practice Project **62–63**.
Section 7	Lighting the figure and head **64–67**. The figure in motion **68–69**. The figure in balance **70–71**. The figure...walking and running **72–73**. Drawing the standing female figure **74–75**. Drawing the standing male figure **76–77**. Practice Project **78–79**. Think with tracing paper; transfer with tracing paper **80**.
Section 8	Tracing papers...more Practice projects, Instructor overlays, extra tracing paper sheets **81–96**.
	FREE ART LESSON *(inside back cover of book)*

Copyright © 1983 by Cortina Learning International, Inc.

All Rights Reserved. This material is fully protected under the terms of the Universal Copyright Convention. It is specifically prohibited to reproduce this publication in any form whatsoever, including sound recording, photocopying, or by use of any other electronic reproducing, transmitting or retrieval system. Violaters will be prosecuted to the full extent provided by law.

Printed in the United States of America
9 8 7 6 5 4 3 2 1

ISBN 0-8327-0901-8 ISBN 0-06-464069-8

Designed by Howard Munce

Composition by Typesetting at Wilton, Inc.

Your Practice Projects...*how they teach you*

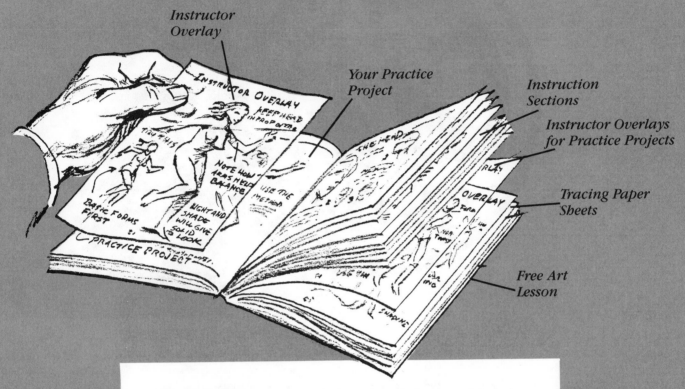

The Practice Projects accompanying each new subject give you the opportunity to put into immediate practice what you have just learned.

You can draw directly on the Project pages, using ordinary writing pencils, or take a sheet of tracing paper from the back of the book and place it over the basic outline printed in the Project and make experimental sketches. Also, you can trace the printed outline and transfer it onto any other appropriate paper. (The transfer method is explained on page 80.)

Instructor Demonstrations for the Projects are located in the last section of the book. They are printed on tracing paper overlays. You can remove them and place them either over your work or over white paper so you can study the corrections and suggestions.

Do not paint on Practice Project pages. This would damage the pages and spoil your book. If you wish to paint with watercolors you can obtain appropriate papers or pads at an art supply store. For oil paints you can get canvas, canvasboards or textured paper.

Drawing
the Human Form

"The highest object for art," said Michelangelo, master spirit of the Renaissance, "is man." The human figure is one of the most fascinating and rewarding subjects any artist can draw. Glance through any collection of art masterpieces and you will see that through the ages artists have devoted much of their time and talent to portraying the human form.

It's only natural to want to sketch people. What can interest or appeal to us more than the men, women and children who make up the world around us? Whether you draw them realistically or abstractly, in repose or in motion, performing any of the thousands of actions they are capable of, your subjects are always available, and all you need to capture them is a pad and a pencil. For you, the artist, figure drawing holds endless excitement and infinite possibilities for fun and self-expression.

You will often hear it said that figures are difficult to draw. That is true only for inexperienced artists. They are perplexed by details of features, anatomy, and clothing—but only because they have not learned to draw first things first.

The human figure is, first of all, a three-dimensional object; a solid structure of bulk and weight. To draw it convincingly, you must learn how to create the illusion of solid form on your sheet of paper. That is one of the first things we will teach you here.

Drawing on the combined know-how of the distinguished artists who make up the Faculty of Famous Artists School, we give you a thorough understanding of the basic solid form of the human body and how to construct it on paper.

Once you've learned to control the basic form you can approach more subtle and creative interpretations of the human figure with confidence. Step by step we explain the individual parts of the body, such as the head, hands, and feet, and how to draw them in different positions. An elementary knowledge of artistic anatomy is indispensable to the artist, and here we give you the information you need to make every part of your figures anatomically convincing. One of the most important lessons you will learn is that what you leave out is just as important as what you put in, sometimes more so. With the aid of dozens of diagrams, photographs, and how-to drawings, we make the movements of the body and its parts easy to understand, so you can draw them with the sureness that comes only from solid knowledge. Among the

other valuable secrets we teach you is how to give the figure naturalness and vitality by making gesture drawings. Throughout, these pages are illustrated with apt examples from the work of members of the Famous Artists Faculty and other celebrated artists.

Drawing the figure is a joy that can add richness to your spare moments and your holidays. It will sharpen your observation so that you will become aware of many new facets of the human form and its movement. Not only will it enhance your appreciation of good art, but with continued practice and study it can help you develop into the skilled figure artist you want to be.

Working Tools

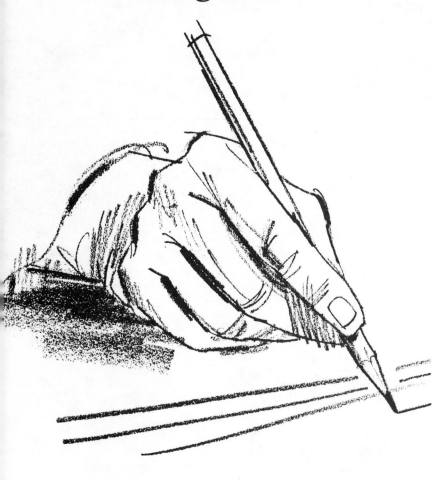

Because this book is devoted to learning to draw the figure, we shall mostly limit our working materials to classic drawing tools: the pencil, charcoal and pastel. All are black at their most intense and allow for a variety of gray shades to model with—hence, each is ideal for the purposes we shall deal in.

The pencil

You and pencils are old friends. You have been writing with them since childhood. Drawing pencils come in a variety of leads, ranging from very soft (6B) to very hard (9H) but you can get excellent results with regular writing pencils which come in grades of soft, medium and hard. The softer the pencil the thicker the lead—and therefore the broader the line you can draw with it. The harder the pencil the grayer the line it makes. Because hard pencils are likely to dig into your paper when you apply pressure, you should use a softer one when you want darker, richer lines.

The best way to get to know the diversity of tones and effects that can be achieved with these different leads is to use them and see for yourself.

A regular pencil sharpener will give you a sharp, even point suitable for much of your drawing. If you prefer, you can sharpen your pencil with a single-edge razor blade and finish by shaping the point on a sandpaper pad, or fine-grained sandpaper from your workshop or hardware store. To get a chisel point, useful for making broad strokes, first sharpen a soft pencil with a razor blade, and then rub it on the sandpaper without rolling it.

Hold your pencil any way you find comfortable. The writing grip is a good position for carefully controlled lines and details.

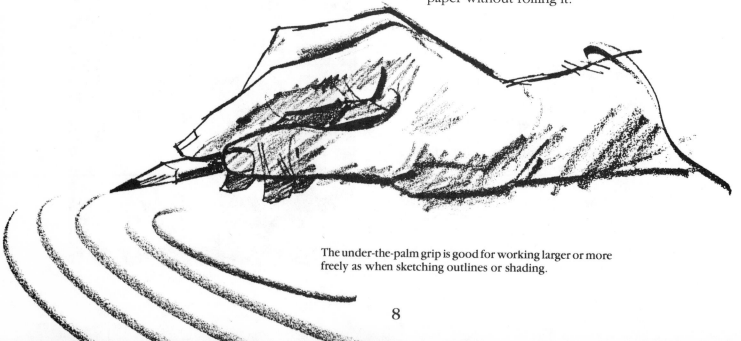

The under-the-palm grip is good for working larger or more freely as when sketching outlines or shading.

Charcoal

This wonderfully responsive medium comes in three forms.
First, there is the natural charred stick commonly called
"vine charcoal." Then there are two synthetic forms.
One is made into a pencil and the other comes as a
chalk about 3 inches long. All three forms come in
varied degrees of softness (blackness). Natural
charcoal is the most subtle and it erases most
easily, using a kneaded eraser. The pencil
kind is the least brittle and cleanest
to handle.

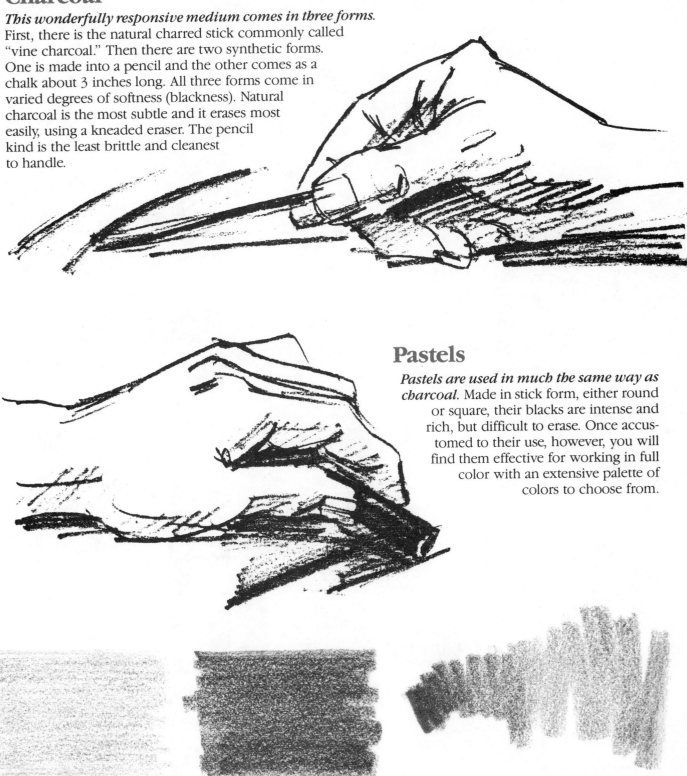

Pastels

*Pastels are used in much the same way as
charcoal.* Made in stick form, either round
or square, their blacks are intense and
rich, but difficult to erase. Once accus-
tomed to their use, however, you will
find them effective for working in full
color with an extensive palette of
colors to choose from.

Flat, even effects are made here with smooth, even, horizontal
strokes with a medium pencil or a soft pencil.

Vigorous up-and-down strokes are made here with the side of
a soft pencil. Increased pressure gives a darker tone.

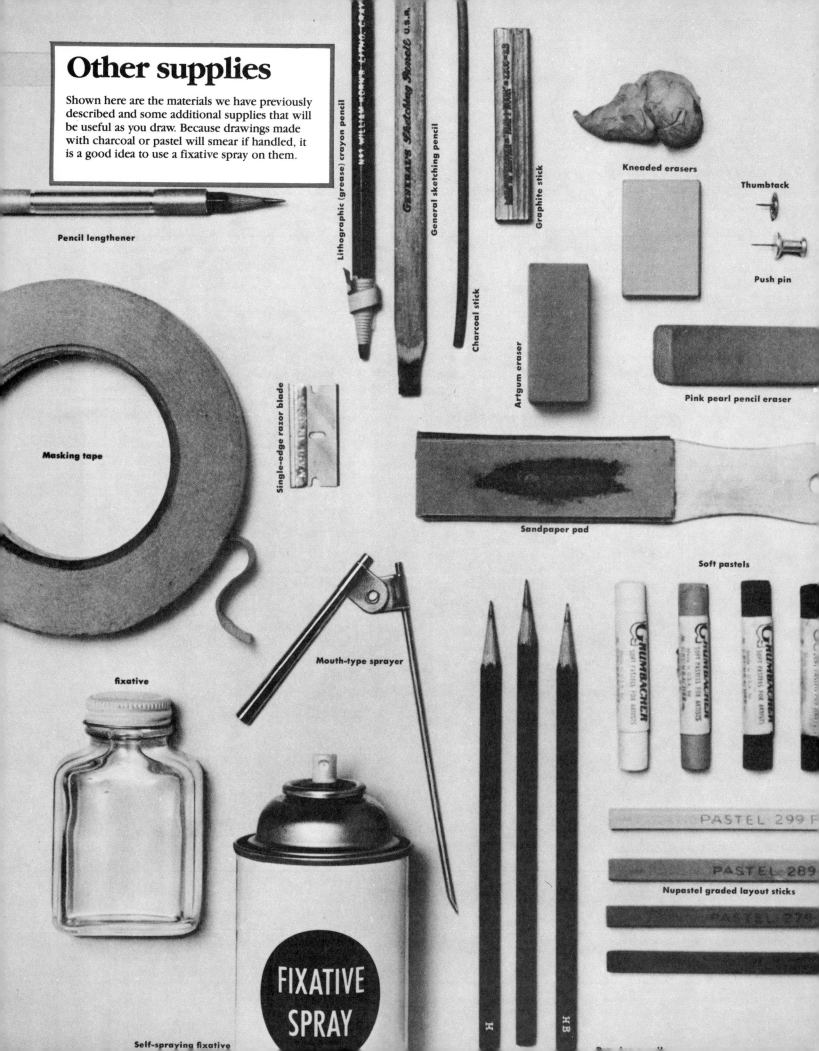

Other supplies

Shown here are the materials we have previously described and some additional supplies that will be useful as you draw. Because drawings made with charcoal or pastel will smear if handled, it is a good idea to use a fixative spray on them.

Pencil lengthener

Lithographic (grease) crayon pencil

General sketching pencil

Graphite stick

Kneaded erasers

Thumbtack

Push pin

Charcoal stick

Artgum eraser

Pink pearl pencil eraser

Single-edge razor blade

Masking tape

Sandpaper pad

Soft pastels

Mouth-type sprayer

fixative

PASTEL 299 F

PASTEL 289

Nupastel graded layout sticks

H

HB

FIXATIVE SPRAY

Self-spraying fixative

Erasing

A medium soft eraser such as a pink pearl or the eraser at the end of a writing pencil is good for most erasures. Another useful type is a kneaded eraser which can be shaped to a point by squeezing it between your finger tips. If you wish to remove a really dark area in a pencil drawing, you can lightly press a piece of Scotch tape onto the area and lift most of the pencil marks. Then, use a regular eraser to remove the rest. This way, you won't smear the dark strokes.

Papers and Drawing Boards

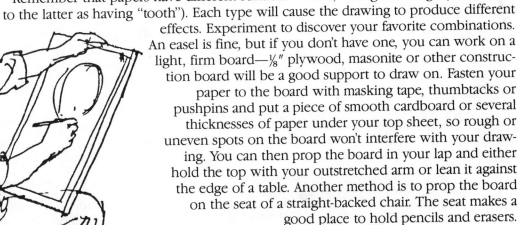

Artists are inveterate experimenters. They never cease trying new materials and combinations of materials. Most often, this concerns the stuff on which drawing is done —paper. Near the end of this book you'll find a supply of drawing paper for your Practice Projects. For additional practice sketching, typewriter paper is good. Also, a pad of common newsprint is inexpensive and good for sketching. It can be purchased at a store that sells art supplies. Another good type of practice paper is a roll of commercial white wrapping paper, but be sure it is not the kind with a wax surface.

Remember that papers have different surfaces —slick, average or rough (artists refer to the latter as having "tooth"). Each type will cause the drawing to produce different effects. Experiment to discover your favorite combinations.

An easel is fine, but if you don't have one, you can work on a light, firm board—⅛" plywood, masonite or other construction board will be a good support to draw on. Fasten your paper to the board with masking tape, thumbtacks or pushpins and put a piece of smooth cardboard or several thicknesses of paper under your top sheet, so rough or uneven spots on the board won't interfere with your drawing. You can then prop the board in your lap and either hold the top with your outstretched arm or lean it against the edge of a table. Another method is to prop the board on the seat of a straight-backed chair. The seat makes a good place to hold pencils and erasers.

11

Models... *and where to find them*

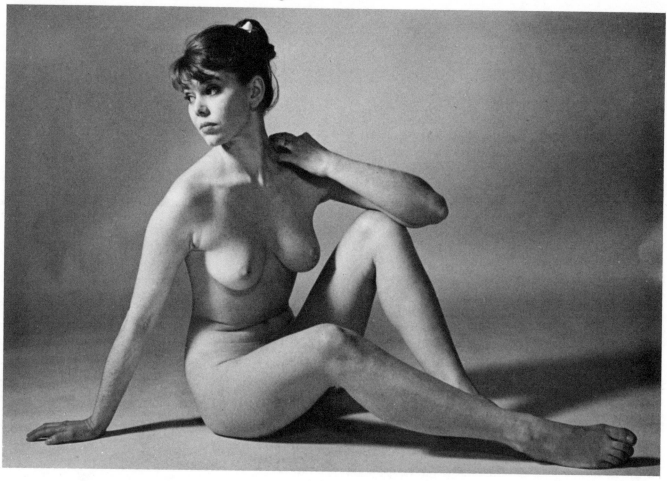

Obviously, the most efficient way to study and draw the undraped figure is to have a person pose, nude and motionless before you.

The optimum way to do that is to retain a professional model, either privately or in concert with a group of other interested artists, to form a sketch class—thereby reducing the model's fee.

Organized sketch classes usually exist in most communities of any size; check your local art supply store to see if they have listings for one. Also, see your Yellow Pages under "Models" to inquire if they pose for existing groups.

It's important at the beginning of your study of the male or female figure that you be able to see the body, and its construction, unencumbered by clothes. A model in a plain bathing suit or tight trunks is the next best thing to the nude—also that will often open the possibility of having friends or family pose for you without embarrassment.

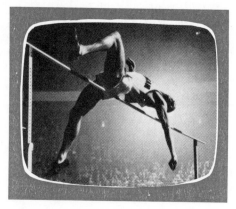

Life class in your own home

Never before has the artist had so unique an opportunity to observe the human family in all its fascinating variety. No matter where you live, right in your own home you can see and study types and characters from all over the world—on the screen of your television set. With a sketch pad and pencil, seated before your screen, you can make quick sketches and notes of the actions and characteristics of the hundreds of personalities who parade before you, in every conceivable role and activity.

Photographs can also be useful

Working from live models (even yourself in the mirror) is desirable, but there is also recourse to good photographs: those you take yourself, dictating the pose you want, or those you find in magazines. Nudist, physical culture and sports publications are excellent sources. Photos of swimming and track events are good. Basketball shots show figures running, leaping and flailing, and boxing photos allow you to study crouching poses with muscles under tension.

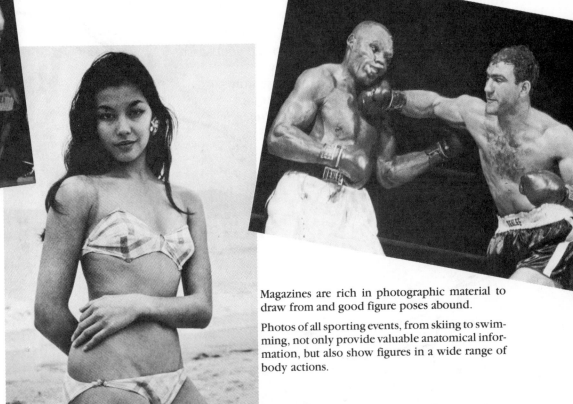

Magazines are rich in photographic material to draw from and good figure poses abound.

Photos of all sporting events, from skiing to swimming, not only provide valuable anatomical information, but also show figures in a wide range of body actions.

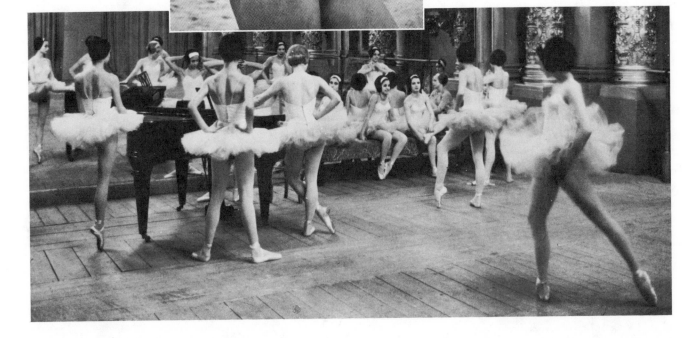

Gesture Drawing...*a natural way to draw*

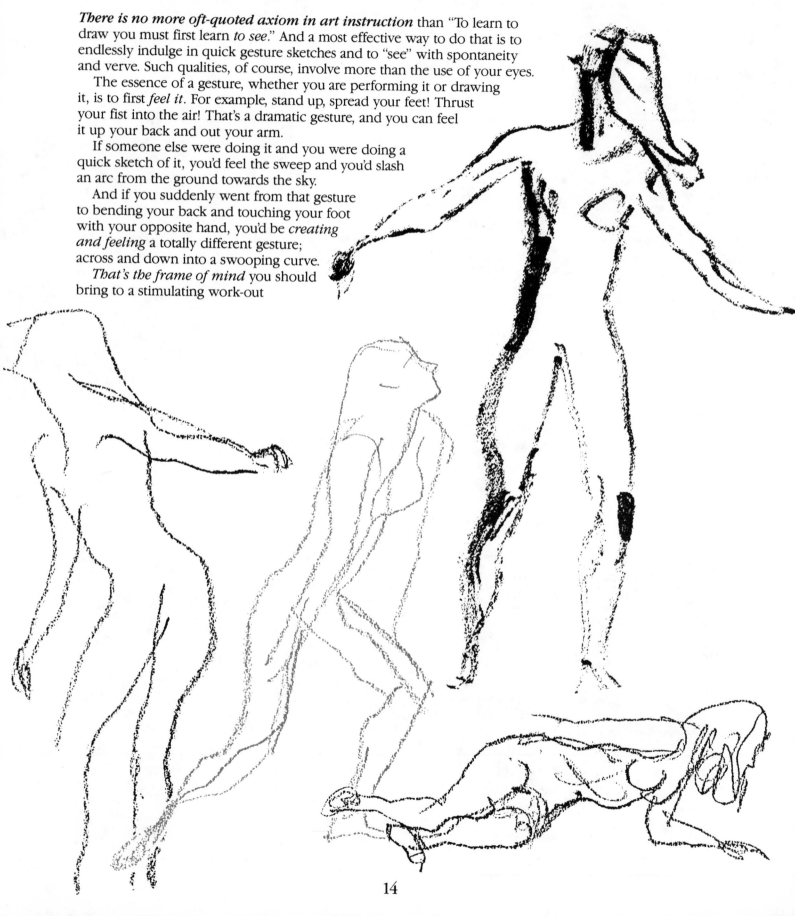

There is no more oft-quoted axiom in art instruction than "To learn to draw you must first learn *to see*." And a most effective way to do that is to endlessly indulge in quick gesture sketches and to "see" with spontaneity and verve. Such qualities, of course, involve more than the use of your eyes.

The essence of a gesture, whether you are performing it or drawing it, is to first *feel it*. For example, stand up, spread your feet! Thrust your fist into the air! That's a dramatic gesture, and you can feel it up your back and out your arm.

If someone else were doing it and you were doing a quick sketch of it, you'd feel the sweep and you'd slash an arc from the ground towards the sky.

And if you suddenly went from that gesture to bending your back and touching your foot with your opposite hand, you'd be *creating and feeling* a totally different gesture; across and down into a swooping curve.

That's the frame of mind you should bring to a stimulating work-out

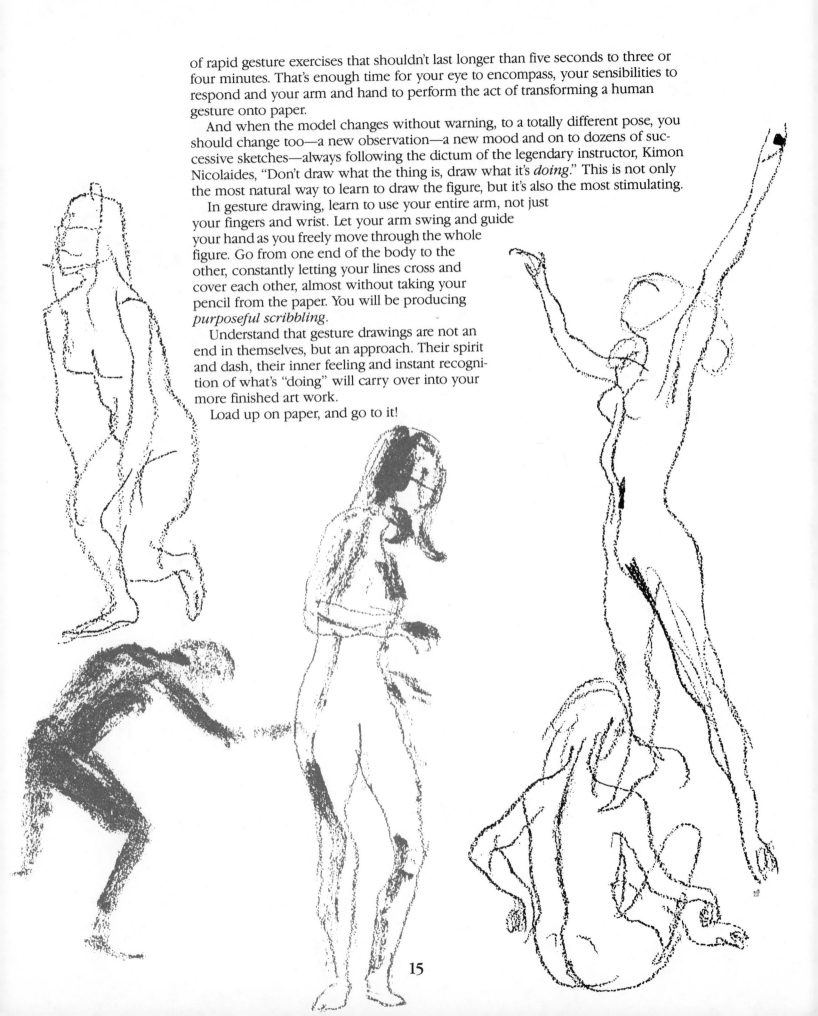

of rapid gesture exercises that shouldn't last longer than five seconds to three or four minutes. That's enough time for your eye to encompass, your sensibilities to respond and your arm and hand to perform the act of transforming a human gesture onto paper.

And when the model changes without warning, to a totally different pose, you should change too—a new observation—a new mood and on to dozens of successive sketches—always following the dictum of the legendary instructor, Kimon Nicolaides, "Don't draw what the thing is, draw what it's *doing*." This is not only the most natural way to learn to draw the figure, but it's also the most stimulating.

In gesture drawing, learn to use your entire arm, not just your fingers and wrist. Let your arm swing and guide your hand as you freely move through the whole figure. Go from one end of the body to the other, constantly letting your lines cross and cover each other, almost without taking your pencil from the paper. You will be producing *purposeful scribbling*.

Understand that gesture drawings are not an end in themselves, but an approach. Their spirit and dash, their inner feeling and instant recognition of what's "doing" will carry over into your more finished art work.

Load up on paper, and go to it!

The importance of gesture
...it cannot be emphasized too strongly

An artist's definition of gesture should include such words as movement, pose, attitude, and purpose. In fact, gesture drawing means more than just expressing the action of a figure. It has to do with capturing the inner meaning, the essence of the subject, and what is happening at that moment.

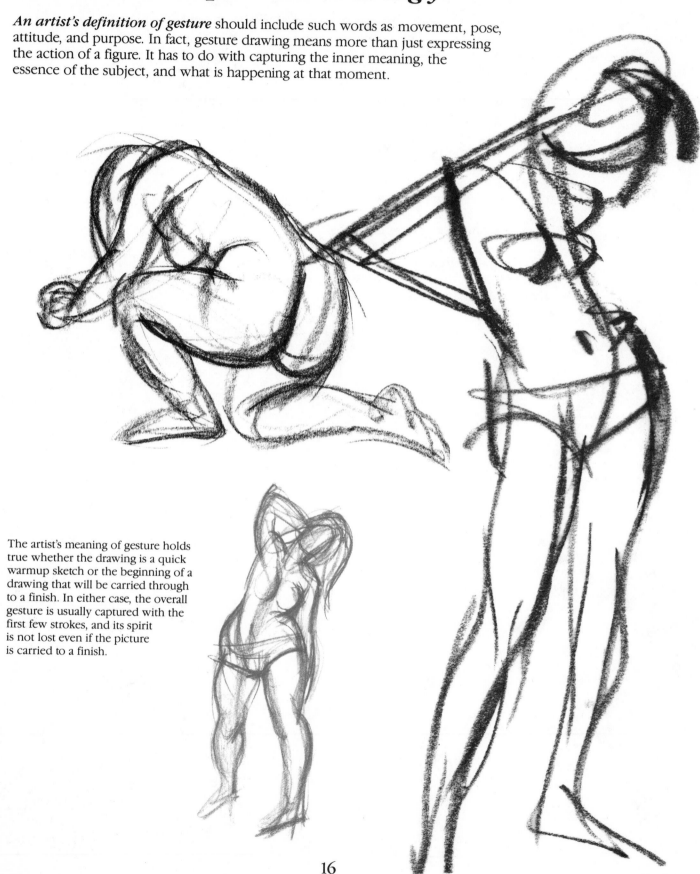

The artist's meaning of gesture holds true whether the drawing is a quick warmup sketch or the beginning of a drawing that will be carried through to a finish. In either case, the overall gesture is usually captured with the first few strokes, and its spirit is not lost even if the picture is carried to a finish.

Figure drawing... *step by step*

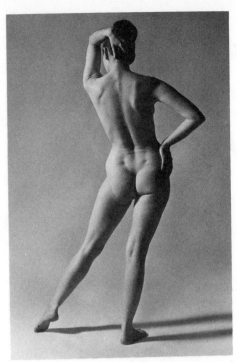

Here are three stages in the development of a figure drawing by Austin Briggs, one of the founders of Famous Artists School. The model was the girl in the photograph at the left. Before he started to draw, Briggs carefully observed the pose, the *gesture* and the basic action of the figure.

1 As he began to draw, the artist concentrated his first effort on the simple lines that suggested the gesture—the angle of the shoulders, the thrust of the hip, the curve of the spine, the position of the legs supporting the weight—and indicated these simply, quickly, and decisively.

2 In Step 2, he began to develop the solid form of the figure and indicated the shadow side with tone.

3 In the third stage, Briggs strengthened the total drawing to emphasize the gesture as well as the form. Finally, he added the refinements that completed the drawing.

Austin Briggs

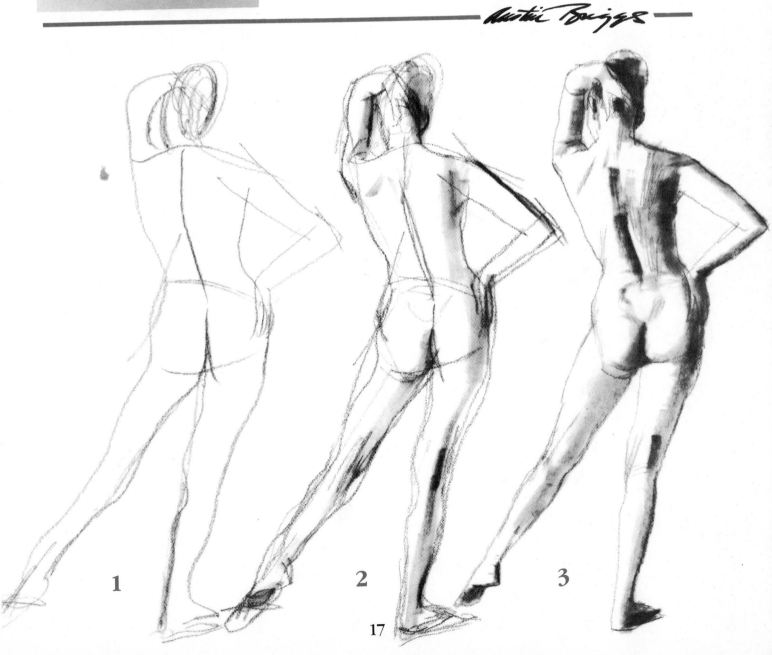

1 2 3

Rhythms…*and counter rhythms*

Look for and emphasize large, rhythmical movements in the figure. Notice that the movements tend to occur in alternating, interlocking sequences, as indicated by the arrows that accompany the drawings on these pages. The major rhythms have been emphasized here, but if you look closely at your model you will see the same interlocking pattern in the minor forms of the legs, arms, and torso.

As you begin your gesture drawing, establish an important movement in the body with free, flowing lines. Then immediately look for an opposing, or counter, rhythm to the first. Once you've added this to your drawing, continue the search for supporting rhythms.

Draw freely, moving your whole arm, and don't be afraid to work large. Remember, you're not trying to make pretty drawings—this is an exercise.

In the drawing at the right, a major rhythm is started by the strong right-to-left thrust of the torso. It is continued by the opposing thrust of the pelvis, while a supporting movement is created by the raised position of the arms.

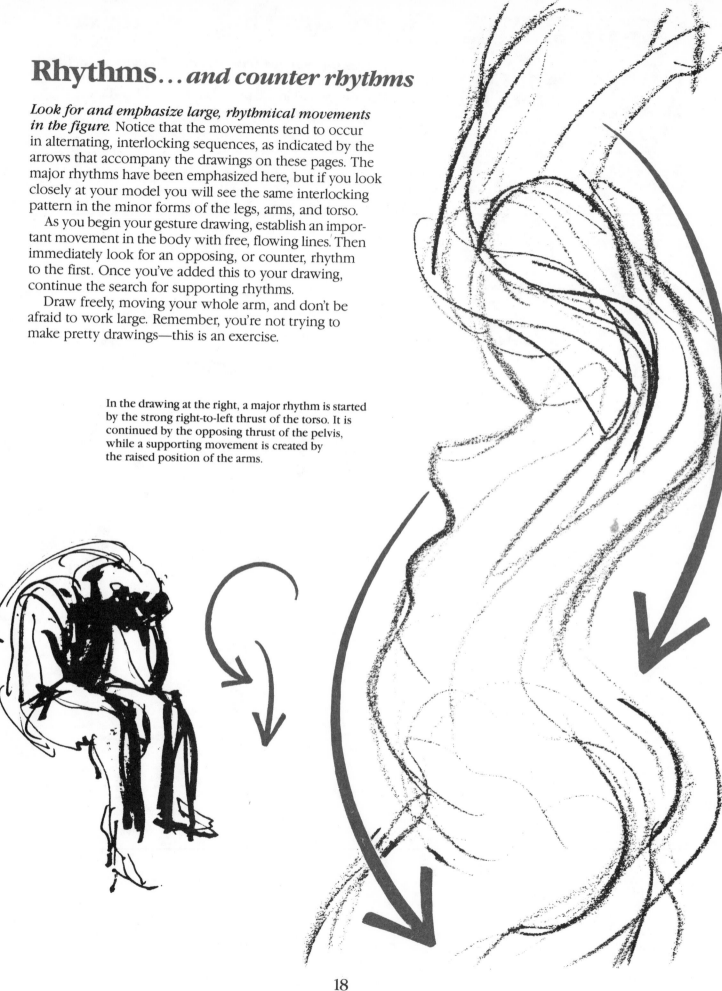

18

Draw repeated movement

Start off doing gesture sketches with a time limit. Speed is the key here! Allow five seconds to catch a fleeting impression of each pose your model takes. You'll barely have time to indicate every part of the body. After you've made many of these very brief sketches, give yourself a little more time—about ten to fifteen seconds. Have the model take the same poses. Notice now that although the figure begins to emerge more clearly, the essential gesture is the same as suggested in the five-second sketches.

Slavish copying of the figure is not really drawing; "absolute resemblance" can be uncreative and static. As a creator, the artist must seek out and emphasize those qualities which best spark aliveness: rhythm, balance and movement. He has license to strengthen the rhythm, the flow of lines, to change curves and angles to make a design of his own. He can control balance and inject movement until he feels confident that his figures do have that magic that makes them live.

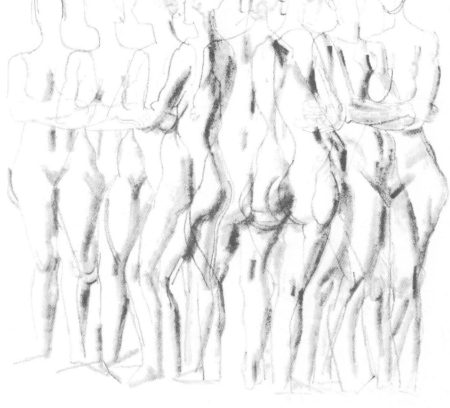

Look at Robert Fawcett's drawings here and see how he has made use of these contrasts to bring grace to each figure—though they were recorded in seconds. As you approach your work, remember that you have the freedom, too, to emphasize or modify these elements which make good design, which make your figures transcend diagrams and spring alive.

Have your model perform some simple action—even just bending over, then standing up straight, again and again. Keep drawing the repeated action over and over. Your lines will build up and your drawn figures will have real movement.

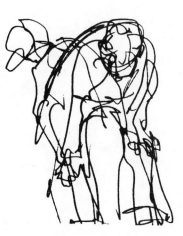

19

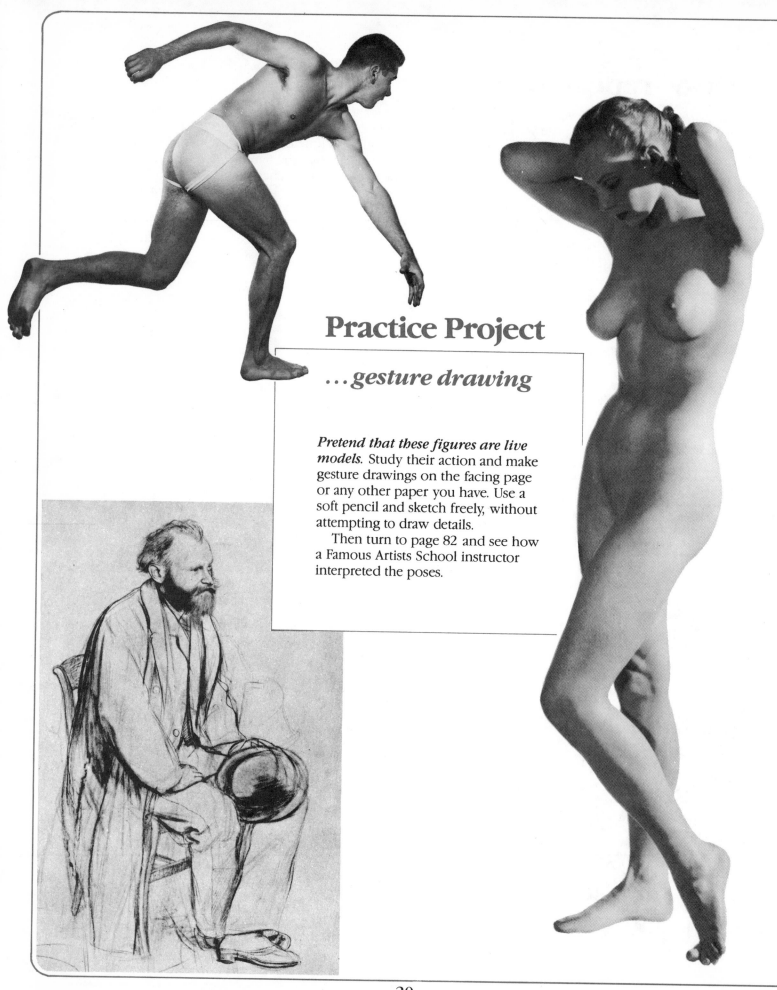

Practice Project

...gesture drawing

Pretend that these figures are live models. Study their action and make gesture drawings on the facing page or any other paper you have. Use a soft pencil and sketch freely, without attempting to draw details.

Then turn to page 82 and see how a Famous Artists School instructor interpreted the poses.

Section 2
The Basic Forms

The vigorous drawing on the right shows you the simple basic forms that make up the larger form of the human body. These are the head and neck; upper torso and lower torso; upper arms, lower arms and hands; upper legs, lower legs and feet. Think of each form as if it were carved out of something solid. Remember that form has three dimensions and that it occupies space.

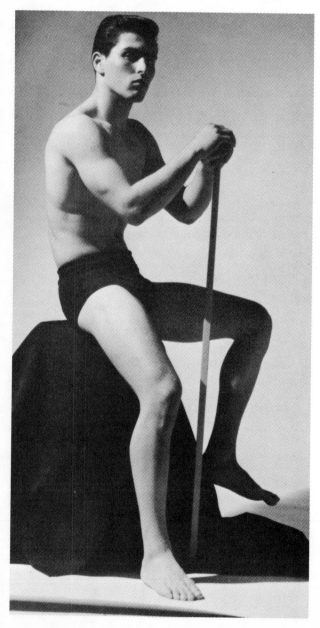

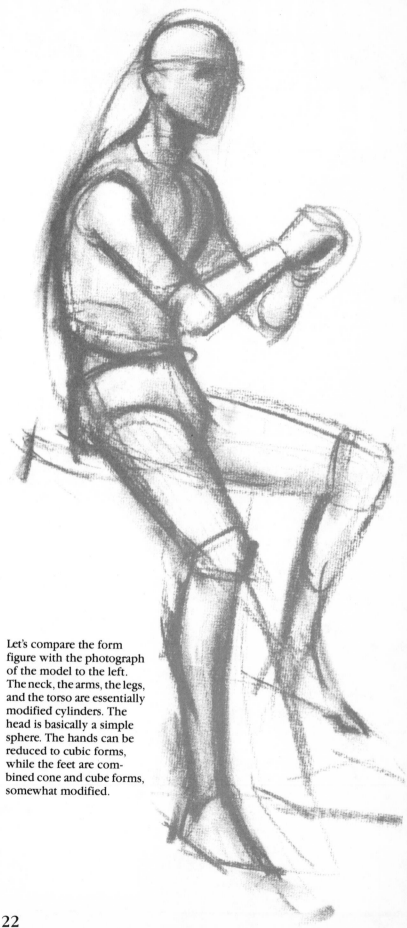

Let's compare the form figure with the photograph of the model to the left. The neck, the arms, the legs, and the torso are essentially modified cylinders. The head is basically a simple sphere. The hands can be reduced to cubic forms, while the feet are combined cone and cube forms, somewhat modified.

22

REMODEL YOUR KITCHEN
FOR WARMTH, LIGHT, AND A $1400 PAYOFF

Here's a solar kitchen you're not supposed to notice.

If you were to visit Mike and Lynne Burke of Minneapolis, you'd see a lovely, turn-of-the-century Tudor-style home. Nothing "solar" about it. Yet the Burkes' remodeled kitchen was solar enough to qualify for the Minnesota state income-tax credit. "We got $1369 back," says Mike Burke. A nice payoff. But there are other "payoffs," too: free heat, loads of sunlight, lots of cabinet and counter space, and a new window seat that helps make this kitchen a family gathering spot.

How do you solarize a Tudor home without destroying its architecture? You get help. The Burkes got architects Peter Pfister and Sarah Susanka of Architectural Alliance. "Our primary concern was that it not look like an addition," says Lynne. "We didn't want something that shouted, 'These people are trying to do this here.' So Peter and Sarah worked with us. First, they showed us five separate ideas. We narrowed them down to two. Then one. And, as you can see, the result fits in so well—better than what was before, in fact. That's what an architect can give you."

The Burkes longed for a new kitchen because their old one was so cold. Mike recalls finding a heat lamp under the kitchen sink upon moving in in 1976. It didn't take long to find out why the lamp was there—the previous owner had used it to keep the pipes from freezing on the worst winter nights.

Accordingly, part of architect Pfister's job was an energy remodeling. Because the kitchen is located above an unheated garage, the first step was to insulate the garage ceiling with cellulose. Then urethane insulation was put down on the kitchen floor, followed by a 3-inch-thick poured concrete slab and quarry tiles as finish flooring. The tiles and concrete provide thermal mass to soak up the sun that pours through the 60 square feet of south-facing windows. The state energy tax credit was figured against the cost of the floor's mass, the windows, the insulation (including fiberglass wall insulation), and labor costs.

"We were always fighting the weather before," says Lynne. "Now we're *using* the weather."

The energy remodeling was so successful, the kitchen virtually heats itself. On cold winter mornings when a boost is needed, the Burkes turn on a unique aux-

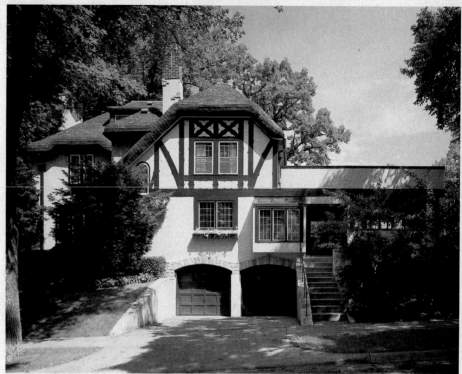

Believe it or not, this Tudor home is solarized. The remodeled kitchen is directly above the garage.

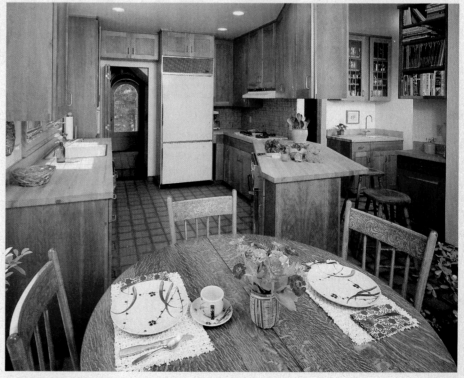

An angled counter, tile flooring, and other new kitchen trends are blended into a remodel that doesn't clash with a fine old home.

Photos by Franz Hall

As easy as 1, 2, 3... 4 and 5.

1 It's a 10" Table Saw with 3-1/4" depth-of-cut and huge 48" ripping capacity.

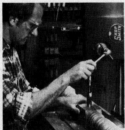
2 It's a 16-1/2" Vertical Drill Press with locking quill feed for accurate depth control.

3 It's a Horizontal Boring Machine that makes doweling operations a snap.

4 It's a 34" Lathe with 16-1/2" swing capacity for turning table and chair legs, or large bowls.

5 It's a 12" Disc Sander with 113 sq. in. of sanding surface to reduce stock up to 6" thick in a single pass.

The MARK V combines these five major power tools in one space-saving, economical unit. You can perform changeovers in less than 90 seconds.

Plus, the MARK V's 5-in-1 versatility and built-in accuracy make it easy to achieve professional results on all your projects.

The MARK V is the tool to start with... the system you grow with. You'll find a full range of MARK V Accessories to help you do the most sophisticated woodworking operation with ease.

The Shopsmith® Difference

With Shopsmith® you get a dedication to woodworking, education, and buyer protection. We believe in the virtues of quality, value, pride and craftsmanship, which show in our educational training and products.

Your Special "Bonus"

Learn how the MARK V can help you do more projects more professionally. Send for your FREE MARK V Information Kit today! Included in the kit is "How To Determine Your Best Power Tool Buy".

You'll also receive a FREE one-year subscription ($6.00 value) to HANDS ON, our Home Workshop Magazine packed with project ideas and helpful tips. You are under no obligation. So mail your card today!

Phone Toll Free: 1-800-821-2101
In Nebraska: 1-800-642-8778

Shopsmith Inc.
The Home Workshop Company
750 Center Drive
Vandalia, Ohio 45377

Quality woodworking tools made in the U.S.A.

©Shopsmith, Inc., 1983
Shopsmith® is a registered trademark of Shopsmith, Inc.

Mail this valuable coupon TODAY!

☐ **YES!** Please send me a Free MARK V Information Kit including the informative booklet "How To Determine Your Best Power Tool Buy". And enter my name for a FREE one-year subscription to HANDS ON magazine. I understand I am under no obligation.

Name _____

Address _____

City _____

State _____ Zip _____

☐ I currently own a Shopsmith power tool. Dept. 365M

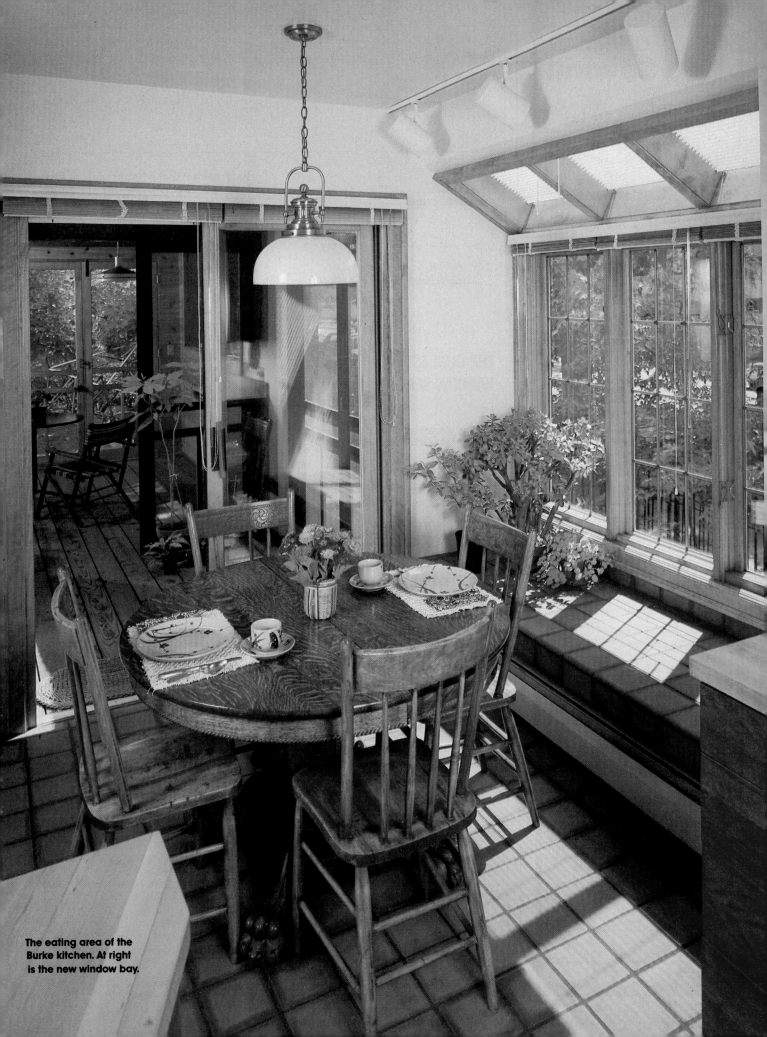

The eating area of the
Burke kitchen. At right
is the new window bay.

ONE-MAN Sawmill

The Only ONE-MAN PORTABLE SAWMILL Of Its Kind In The World!

If you need good, high-quality lumber, don't let inflated lumber prices stop your important building projects. The Foley-Belsaw goes right to the trees and turns out smooth, true-cut lumber . . . even beginners get excellent results. Just one man (no crew needed) can easily cut enough on weekends to save hundreds of dollars over high lumberyard prices. For power use tractor PTO or other low HP diesel or electric unit. Factory-direct selling keeps price low, and convenient time payments may be arranged.

Send for FREE BOOK! Just mail coupon below for "How To Saw Lumber" booklet and complete facts on the One-Man Sawmill. There is NO Obligation and NO Salesman Will Call on you. Do It TODAY!

Foley-Belsaw Co.
30292 Field Building
Kansas City, Mo. 64111

Please send all facts and details in your FREE BOOK "How To Saw Lumber". I understand there is No Obligation and that No Salesman will call on me.

Name _____
Address _____
City-State _____ Zip _____

BEST BUY!

EASY-TO-ASSEMBLE-KITS

In Stock for Immed. Shipping or Pick-up.

ONLY **$425** for 3'6" diam.
F.O.B. Broomall, PA

Comparable savings on diams. from 4' to 7'. All kits adjust to floor-to-floor hts. of 8' 11½" to 9'6". Other hts. can be ordered.

Now! Showroom & Warehouse locations in:

Pomona, CA
(714) 598-5766
Sarasota, FL
(813) 923-1479
Houston, TX
(713) 789-0648
Chicago, IL
(Opening April '84)

© The Iron Shop 1977, '82

People who've looked everywhere tell us there isn't another spiral stair around that touches our combination of price and quality of materials and workmanship. We believe it!

CALL OR WRITE FOR FREE BROCHURE:

To: The Iron Shop, Dept. NS 14 Box 128, 400 Reed Road, Broomall, Pa 19008 Our Tel: (215) 544-7100.

Name _____
Street _____
City _____ State _____ Zip _____

We accept MasterCard, VISA and AMEX.

THE IRON SHOP
MANUFACTURERS

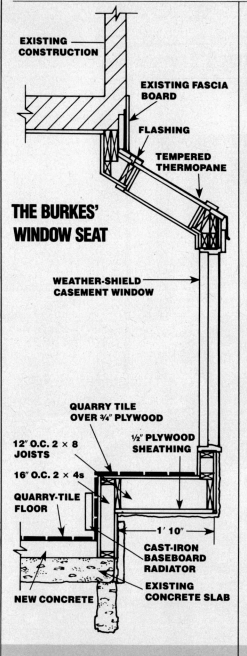

THE BURKES' WINDOW SEAT

EXISTING CONSTRUCTION

EXISTING FASCIA BOARD

FLASHING

TEMPERED THERMOPANE

WEATHER-SHIELD CASEMENT WINDOW

QUARRY TILE OVER ¾" PLYWOOD

½" PLYWOOD SHEATHING

12" O.C. 2 × 8 JOISTS

16" O.C. 2 × 4s

QUARRY-TILE FLOOR

1' 10"

CAST-IRON BASEBOARD RADIATOR

EXISTING CONCRETE SLAB

NEW CONCRETE

iliary heater that's flat enough to fit in under a base cabinet, within the 3-inch-high toespace created by the plinth that elevates the cabinet off the floor. The heater's grille pours hot air at your feet. The unit, a Beacon-Morris Twin Flo heater "is not typical for residential construction," says Pfister, "but any plumbing and heating supplier should be able to get it for you."

The Burkes are avid gardeners, and their new kitchen suits their avocation. There's a sea of countertop space, all of it butcher block—perfect for chopping vegetables. Their stove has widely spaced burners for fall canning, and there's a big cabinet nearby to house the canning kettle. The kitchen sink is single-bowl and oversized to accommodate major produce cleaning. There's no garbage disposal: "We put everything into our compost piles," says Lynne.

The Burkes say they didn't want a "sleek" new kitchen that would have clashed with the rest of the house. Certainly the wooden cabinets and lead-mullion windows see to that. But Pfister and Susanka somehow managed to blend a traditional ambience with new styling trends. For one, a stretch of counter runs at an angle through the middle of the floor area. For another, there's a projecting window seat (sometimes known by the odd word, "bumpout"). Many a magazine these days contains photos of projecting window bays, and many of them appear in a fairly useless spot: above the kitchen sink. They end up being nothing but a fancy kitchen-sink window, an expensive way to give your cookbooks some sun.

But in the Burke kitchen, the projection is a pleasant nook in the eating area. It gets plenty of use. When I visited the Burkes, their daughter, Alex, sat there the entire time, entertaining a neighborhood boy . . . and us.—**Larry Stains**

WHERE THE MONEY IS

If you do as the Burkes did and incorporate solar design into your next remodeling project, you could get money back from your state—provided you live in one of the following 19: Alabama, Arizona, Arkansas, California, Florida, Indiana, Kansas, Maine, Michigan, Minnesota, Montana, Nebraska, New Mexico, New York, North Carolina, Ohio, Oregon, Rhode Island, or Utah.

Each state differs in the amount it refunds you and in when the credit expires; be sure to contact the energy office in your state capital for details.

Unfortunately, you cannot get the same payoff on your federal income tax return. According to the IRS, the federal energy tax credit applies only to solar systems that do not double as living space—in other words, only active water-and space-heating systems. —**L.R.S.**

AN INDOOR SEED STARTER

Build our seed starter, and you can start your gardening season in early March. Plant your seeds in it for the slower-growing crops—tomatoes, peppers, eggplant. Then, after you've set the first crop outdoors in early June, start a second crop of seedlings to plant out for a fall harvest. Come September, use the seed starter for herb seeds you'll transplant to pots at your kitchen window. Finally, through the winter season, the starter is great for propagating house plants.

We've designed our seed starter to blend with the decor of any room of your house: bedroom, living room, dining room, or kitchen.

The project is made of pine and plywood. Its clear acrylic doors keep in humidity and let you keep an eye on your plants. The seed tray is adjustable, so the plants can be kept the correct distance from the built-in lamp as they grow. The lamp provides all the light your plants will need. In fact, we advise you not to keep the starter near a window; sunlight, along with fluorescent lighting and closed doors, may cause overheating.

The total cost to build the seed starter is only $100.

Styled by Janet Vera

Carl Doney

MATERIALS LIST

ITEM	DESCRIPTION
Cabinet	
End panels (2)	¾ × 15⅞ × 36-inch A–C plywood
Side panels (2)	¾ × 15⅞ × 49¾ inch A–C plywood
Bottom	¾ × 15⅞ × 48¼-inch A–C plywood
Wheel skirts (2)	¾ × 2½ × 49¾-inch #2 pine
Edge fillers (4)	¾ × ¾ × 11⅞-inch #2 pine
Light support	¾ × 5½ × 49¾-inch #2 pine
Position pins (2)	¼ × 1¾-inch hardwood dowel
Shelf support pins (4)	¼-inch shelf pins
Light	2-tube 48-inch fluorescent-light fixture and tubes
Cord (9 ft.)	16–2 wire and plug
Switch	In-line switch
Light reflector	7½ × 46½-inch aluminum flashing
Doors (4)	¼ × 8 × 24¾-inch clear acrylic

ITEM	DESCRIPTION
Door pulls (4)	1-inch-diameter porcelain pulls
Hinges (4 pr.)	1¼ × 3¼-inch brass surface-mounted hinges
Hinge bolts (24)	6–32 × ⅜-inch brass bolts and nuts
Casters (4)	2½-inch swivel casters
Seed Tray	
Sides (2)	¾ × 5½ × 47⅝-inch #2 pine
Ends (2)	¾ × 5½ × 13½-inch #2 pine
Bottom	¾ × 15 × 47⅝-inch A–C plywood
Handles (2)	1-inch-diameter × 15-inch-long hardwood dowel
Lining	24 × 60-inch 6-mil polyethylene sheet
Fasteners	6d finish nails
	#8 × ½-inch sheet-metal screws
Adhesive	White vinyl glue
Undercoat	1 pt. oil-based primer
Surface coat	1 pt. latex enamel

Protect your family from carbon monoxide!

Your kerosene heater, wood burner, fireplace, even your furnace or hot water heater can cause carbon monoxide poisoning. Today's energy-efficient homes are more vulnerable to the cumulative effects of carbon monoxide. Now ToxAlarm™ provides a safe, inexpensive warning of this odorless poison. ToxAlarm's non-toxic indicator tablets turn color in the presence of carbon monoxide at levels low enough to allow your family to escape unharmed. ToxAlarm provides protection for the entire heating season and can be mounted on nearly any surface.

ToxAlarm
carbon monoxide indicator

$9.95

ToxAlarm Saves Lives:
☐ *In the family room*
☐ *In the basement*
☐ *In bedrooms*
☐ *In the garage*
☐ *In your automobile*

Send $9.95 (postage included) for one, $16.95 for two, or $21.95 for three with the coupon below, or call TOLL FREE at 1-800-543-7037. Ohio residents call 1-800-582-4277. Allow three weeks for delivery. Ohio Residents add 5% Ohio State Sales Tax. MAIL TO: ToxAlarm, 4108 Spring Grove Avenue, Cincinnati, Ohio 45223.

| Please rush ____ ToxAlarm(s) to: |
| Name _____ |
| Address_____ |
| City_____ |
| State _____ Zip _____ |
| I have enclosed: $_____ |
| Please bill: ☐ MasterCard ☐ VISA |
| Card No.: _____ |
| Expiration Date: _____ |

Design by Phil Gehret

CUTTING DIAGRAM

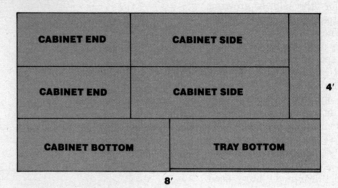

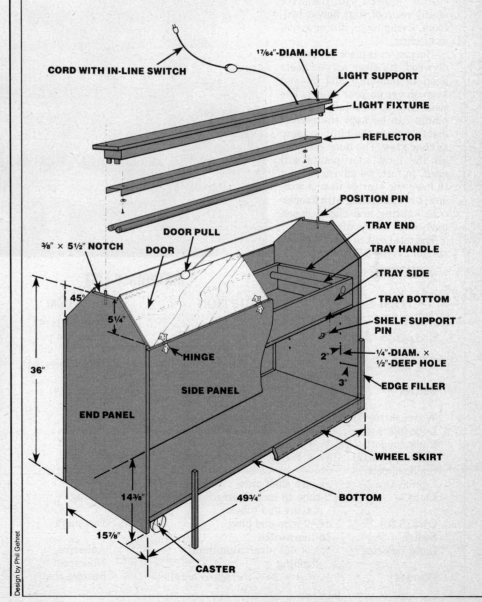

CONSTRUCTION

(All plywood parts can be cut from a single sheet of plywood.)

1. Cut the cabinet's end panels to size. Shape each top corner on a 45° angle, and cut a notch, ⅜ inch deep and 5½ inches long, in the top edge of each end panel to accept the light support. Lay out and drill sixteen holes, ¼ inch in diameter and ½ inch deep, in each end panel to accept the shelf support pins.

2. Cut the cabinet's side panels, bottom, wheel skirts, and edge fillers to size. Assemble the cabinet, using glue and nails. Fasten casters to the cabinet's base.

3. Cut the light support and position pins to size. Lay the light support in the notches you cut in the end panels, and drill a hole, ¼ inch in diameter and 1¾ inches deep, through both ends of the light support into the end panels. Remove the light support. Glue the position pins into these holes in the end panels. Next, enlarge the diameter of the holes in the light support to ¹⁷⁄₆₄ inch. Set the light support on the position pins, checking that the pins are flush with the top surface of the light support. Trim the pins if necessary.

4. Cut the seed tray's bottom, sides, ends, and handles to size. Lay out and drill two holes, 1 inch in diameter, through both tray sides to accept the tray handles. Assemble the tray, using glue and nails.

5. Sand all wooden parts of the assembled cabinet and tray and break all sharp edges. Finish with two coats of paint, and decorate to your taste.

6. Cut the doors to size. Attach the doors to the cabinet with hinges, bolting the hinges to the doors and screwing them to the cabinet sides. Install a door pull on each door.

7. Attach the light fixture to the bottom of the light support, using #8 × ½-inch sheet-metal screws. (Optional: A small reflector can be installed to diffuse light in the seed starter. We made our reflector from aluminum flashing.)

8. Wire the light fixture. Drill a hole through the light support for the cord. Wire an in-line switch in the cord to turn the light on and off.

9. Position the tray lining inside the seed tray.

ATTENTION KEROSENE HEATER OWNERS!

15 DAYS FREE TRIAL!

IF THE ALADDIN® KEROSENE HEATER FAN DOESN'T MAKE YOUR ROOM FEEL MORE COMFORTABLE, WE'LL REFUND EVERY PENNY!

Warm air is circulated outward for greater comfort... and you still save energy!

Next to your kerosene heater, the new Aladdin heater fan may be the best investment in home heating you'll ever make! If you're not completely satisfied within 15 days, we'll refund the purchase price—including handling and shipping.

JUST $39⁹⁵ *Aladdin*

Call Toll-Free 1-800-251-4535, Ext. 57
In Tennessee Call Collect 615-748-3693, Ext. 57

Name _____

Address _____

City _____ State ____ Zip ____

☐ VISA ☐ MasterCard Expiration Date ____

Card No.
[][][][][][][][][][][][][][]

Signature _____
(Required for all credit card purchases)

Amount: $39.95 per fan, add $5.50 handling and shipping per fan, plus sales tax (Tennessee residents add 6¾%) and mail to Aladdin, Dept. 57, P.O. Box 100960, Nashville, Tennessee 37210.

E-Z STACKER

FOR: WOOD, PIPE, FENCE POSTS, LUMBER, ETC.

SIMPLE EFFICIENT ANY WIDTH ANY LENGTH

JUST USE **2x4's**

WELDED STEEL CONSTRUCTION

U.S. Patent No. 4,355,725
Corresponding Canadian Patent

- - - ORDER NOW! - - -

SET OF **4** $14⁹⁵ + $3.00 SHP. & HADLG. TOTAL $17⁹⁵

Wisconsin Residents Add 5% Sales Tax — Prices Subject to Change

NAME _____

ADDRESS _____
Include House Number and Street or Road

CITY _____

STATE _____ ZIP _____

Expiration Date [][][][]

Account — All Digits

[][][][][][][][][][][][][][][][]

MAIL TO: **E-Z STACKER Rt. 5 Box 798 N Lake Geneva, WI. 53147**

THE DOME
SINCE 1957

Efficiency Can Be Beautiful

Enjoy the stunning beauty of vaulted domed ceilings while reducing energy bills 30-50%. Interlocking triangles bolt together in 2-3 days and have been tested to withstand tremendous wind and snow loads. Build your own home, church, duplex, office, recreation hall, and more, at significant savings. Send for literature from a leader in the dome industry with over 25 years of dome manufacturing experience.

Write To: **GEODESIC DOMES, INC.**

10290 Davison Rd.
Davison, MI
48423
313-653-2383

Rt. 1, Box 257C
Ponchatoula, LA
70454
504-386-5686

Rush me the following marked items:
☐ New 90 page color booklet (25th Anniversary Edition) with your best residential plans. Enclosed is $8.00.
☐ For right now just send me a flyer and price list at no charge. NS

Name _____
Address _____
City, State, Zip _____

SOAPSTONE
300% more Heat-Life™ than cast iron or steel

Now independent laboratory tests prove that the Soapstone in a Hearthstone stove offers 300% more Heat-Life than the finest metal stoves.

THE HEARTHSTONE

See back cover for full details.

SEND $1.00 TODAY FOR COMPLETE HEARTHSTONE INFORMATION PACKAGE INCLUDING HEAT-LIFE COMPARISON REPORT

Name _____
Address _____
City _____ State ____ Zip ____

HearthStone

AMERICA'S QUALITY SOAPSTONE STOVE
3733A Hearthstone Way, Morrisville, VT 05661

BUILD THE WORLD'S BEST GREENHOUSE

And pluck great salads in January—Kathy Kukula

The word "fresh" is very popular these days. We're lured into restaurants and supermarkets with promises of fresh vegetables, fresh meats, and even fresh pasta. But for Ray Wolf and Linda Gilbert, "fresh" in the middle of January means a mere 20-foot walk through winter to a building in their yard where it's always spring. The food there is truly fresh—and not a single gallon of fuel is used to put it on the table! All the work is done by the sun, with a little help from Ray and Linda.

The solar greenhouse in their yard isn't just any greenhouse. It's the product of eight years of work by Rodale research teams. The result is a reliable producer of food all year long, in almost any climate. It's safe to say this is the best residential freestanding greenhouse in the world.

Ray, who helped design the greenhouse as part of his job at Rodale Press, agrees with that statement. "In its universe of residential freestanding solar greenhouses, I don't know of any other that grows plants as well for the money," he says. How well does it grow? Its 100 square feet of growing beds can produce 300 pounds of vegetables a year, for an initial cost of $4300 and an annual operating cost of under $30 (electricity for the fans). Most other greenhouses don't even *make* claims about food production.

The secret is *how* it grows: "If we have a breakthrough here, it's that there's no visible heat storage to compete with the plants for light," Ray says. "We learned that light levels are more important to the plants than air temperature." In fact, it's because the Rodale researchers thought more about the *green* aspect of the greenhouse than about the solar aspect that it works so well.

Plants like three things: warm soil, plenty of light, and good drainage. Researchers devised the Rodale freestanding greenhouse to deliver all three economically.

First of all, warm soil. The air in the greenspace is heated passively; as in a sunspace, the sun's energy is trapped behind glazing. The soil, however, is heated actively. Fans draw the hot air that collects at the greenhouse peak and push it through rock beds under the growing beds. At night, the heat rises from the rock storage directly into the growing-bed soil, where it does plants the most good. "The lowest the soil temperature got last winter was forty-two degrees," Ray says. That's low enough to slow or perhaps even to stop plant growth, but not cold enough to kill the plants.

Next, the light. With the mass hidden under the growing beds, the interior of the greenhouse can be given over to a bright white surface that makes the most of the light coming in and bounces it around to the plants. In fact, Ray says, it can actually be brighter inside the greenhouse than outside, because of the greenhouse's reflective north wall.

Finally, the drainage. The sloped concrete cap that separates the soil from the rock beds (see the diagram on page 92) serves as a drainage surface. Drainage tubes through the rock bed and slab ensure that water doesn't sit in the soil and deposit salts. "We'll only have to change about one-third of the soil every four years," Ray says. Soil in closed, undrained beds normally should be changed once a year.

As well as developing a greenhouse that would grow enough food to keep the average family of four in fresh veggies all year 'round, Rodale researchers found foods that would grow in it. No marvels of genetic engineering, mind you, but leafy greens, like Chinese cabbage, celery cabbage, and Chinese broccoli, that are a bit hardier than most garden vegetables. The Rodale Test Kitchens spent five years making sure that what the greenhouse grows best is also what people like to eat. The Test Kitchen staff developed recipes for the hardy vegetables and also incorporated them in traditional recipes, so that greenhouse owners wouldn't have to develop exotic tastebuds as a prerequisite to self-reliance.

But the research didn't stop there. While monitoring plant growth in 30 test greenhouses, Rodale researchers looked at what the plant-friendly greenhouse environment was doing to the structure.

"The greenhouse," Ray says, "is a very destructive environment. You've got high levels of heat, moisture, and light, and daily fifty-degree temperature swings." Certain materials deteriorated quickly under such stress, and the final greenhouse building specs call for only the most durable building materials—tempered low-iron glass, pressure-treated lumber for all structural members, high-density extruded polystyrene, and $35-a-gallon two-part epoxy paint. The greenhouse is estimated to have a life span of at least 25 years.

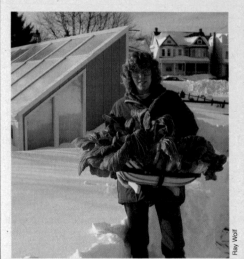

Ray Wolf

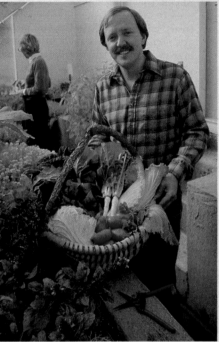

Christie Tito

Winter or summer, Ray and Linda's solar greenhouse adds food to their table. Leafy bok choy, hardy root vegetables, fragrant herbs, and even snow peas grow well all year round; tender vegetables, such as tomatoes and melons, do best in the warmer spring and summer months.

How, then does the final building cost remain under $5000? "It's also designed for efficiency of materials," Ray says. "For example, we knew that the single biggest expense would be the overhead glazing,

Ray Wolf and Linda Gilbert built this proto-type freestanding greenhouse for $4300. It produces 300 pounds of vegetables a year with no fuel and little maintenance.

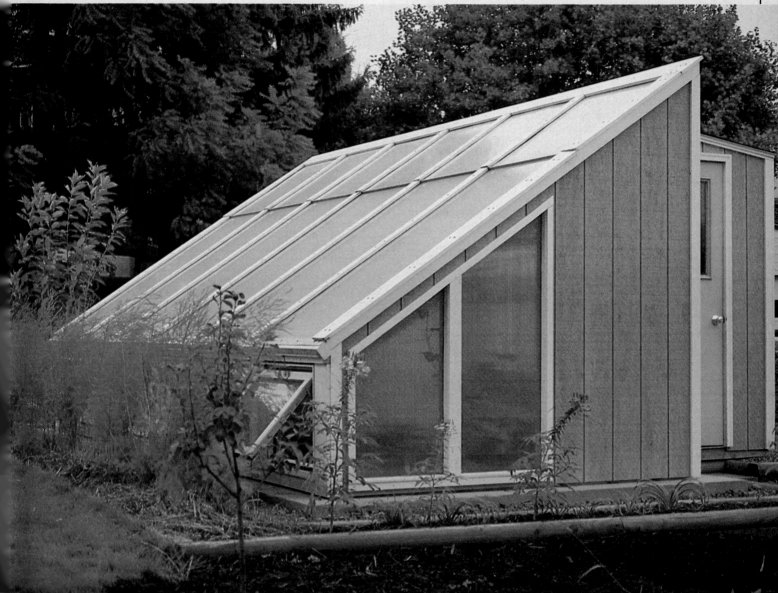

Mitch Mandel

so we figured out the cheapest way to get that—standard sliding door replacements—and designed the greenhouse around them."

Standard sizes are used whenever possible. The vertical glazing under the sloped overhead glazing is standard awning windows. More expensive but easily cut acrylic glazing fills in the few odd-sized glazed areas. The back of the greenhouse is 7 feet 11 inches tall, requiring just a single piece of plywood for sheathing.

The potting shed on the north side of the greenhouse does triple duty, serving as potting shed, airlock entry, and structural buttress. "Without it," Ray says, "the greenhouse wouldn't be structurally sound. The front wall would soon bow."

Why a freestanding greenhouse? "In almost all cases," Ray says, "the climatic features that plants thrive on are not the features that people like to be around, and if a greenhouse is attached to a house, plant growth will take a back seat to human comfort." The greenhouse is also designed to be built either above ground or sunk into the ground about 3 feet. Ray and Linda's sunken model has the advantage of a lower profile for a suburban setting.

A Solar Thing, a Food Thing

When Ray and Linda bought their house two years ago, food-growing was central to their landscape design plans. They knew they were going to build the greenhouse, so they planned the yard around it. "It affected things like how big we made the vegetable garden," Linda says. "We made it smaller because we don't have to grow our vegetables for the whole year in it. We gave some vegetable space to fruit trees, bushes, and flower gar-

dens." Ray and Linda also allotted more space in their freezer to annual purchases of beef and pork, rather than a frozen summer harvest.

Once the researchers at Rodale were satisfied with the design of the greenhouse, the step-by-step build-it plans needed "real people" testing before they could be published. And so Ray and Linda started their first big construction project as guinea-pig do-it-yourselfers.

"We contracted out the most time-consuming work," Ray says. "I figured our time was better spent at work earning the money to pay people to do certain tasks than actually doing them." Such jobs as digging the foundation with a backhoe, laying up the cinderblock walls, sorting crushed stone, and doing trim painting were contracted out.

But when it came to framing, insulating, and caulking the structure, it was hands-on DIY all the way. "The toughest part was disciplining ourselves to pay painstaking attention to detail. If you change some small details or ignore some

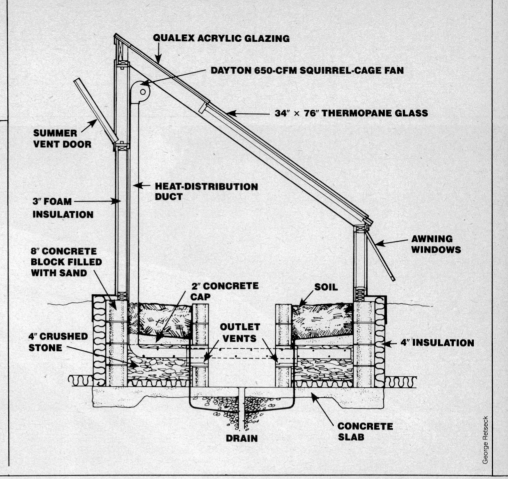

QUALEX ACRYLIC GLAZING

DAYTON 650-CFM SQUIRREL-CAGE FAN

34" × 76" THERMOPANE GLASS

SUMMER VENT DOOR

HEAT-DISTRIBUTION DUCT

3" FOAM INSULATION

8" CONCRETE BLOCK FILLED WITH SAND

2" CONCRETE CAP

SOIL

AWNING WINDOWS

4" CRUSHED STONE

OUTLET VENTS

4" INSULATION

DRAIN

CONCRETE SLAB

George Retseck

FREE BOOK!

How to drill your own water well

Discover All The Pure Fresh Water You Will Ever Need in Your BACKYARD!

SIMPLE The Hydra-Drill is as easy to operate as a power lawn mower. Tested and proven by thousands of homeowners from coast to coast and around the world.

ECONOMICAL You can SAVE money even if you drill only one water well for your home. You can MAKE money if you drill wells for others.

GOES EVERYWHERE No backyard is too small for a Hydra-Drill well. The Hydra-Drill can be transported easily to locations where commercial well drilling equipment can't go.

ABSOLUTELY FREE You can get a big information package about the Hydra-Drill absolutely free. Write today! Or just call the toll-free number.

Call Toll Free **1-800-821-7700**

(Ask For Extension 261)

*Call anytime including Sundays

USED WORLD-WIDE TO DRILL 100,000 WATER WELLS SINCE 1962

OR CLIP AND MAIL COUPON TODAY!

DeepRock

SINCE 1962

261 Anderson Road
Opelika, Alabama 36802

Please mail your free information kit with Hydra-Drill prices.

PRINT NAME

ADDRESS

CITY STATE ZIP

☐ I'm in a hurry. I have enclosed $1. Rush the FREE information package by FIRST CLASS MAIL.

©1984 DeepRock Mfg. Co.

small things, you can easily throw the structure off, and it won't work as well," Ray warns. "It may be ninety degrees out and you don't really feel like taking the time to put up a second sheet of polyethylene because you poked a hole in the first, but you've got to do it." Other time-consuming but important tasks were using aerosol foam to caulk around all of the windows and preparing all of the surfaces properly to ensure a ten-year paint job.

The soil was mixed (⅓ leaf mold, ⅓ garden soil, ⅓ vermiculite) and put in the beds, and the beds were planted. It had taken 2½ months of mostly weekend work to build the greenhouse. The only thing left for Ray and Linda to do was water and wait for the harvest.

And harvest they do. "Shopping is so boring now," Linda says. "All I buy is laundry soap, toilet paper, and paper towels." The fun stuff, that's out in the greenhouse. Even though Linda, as manager of product development at the Rodale Test Kitchens, was very familiar with the oriental vegetables that grow best in the greenhouse, she'd never grown them before.

"Ray and I were starting from knowing nothing," she said, "and we're learning things like the fact that plants inside a greenhouse need more daily attention than plants outside. If there is a problem in the greenhouse, it'll become a big problem much faster." Problems like whiteflies and mildew have appeared, but have never wiped out a whole crop. Believe it or not, flowers help take care of the insects. "The gnat-sized wasps whose larvae eat whitefly eggs need nectar to stay alive," Linda explains, "so we plant alyssum."

The greenhouse is situated strategically between the driveway and the house, so Ray and Linda have to pass by it at least twice a day. That's also the perfect time to open the thermal curtains and pick off any yellowing leaves. On the whole, about 10 minutes' attention a day is all that's needed. The result is more than enough fresh vegetables for Ray and Linda, who give some away to friends and neighbors. Says Ray, "Bringing a basket of fresh vegetables to a party makes a bottle of wine look pretty boring."

"You can use these vegetables any place you'd use spinach," Linda says, planting young lettuce plants in among mature mustard greens. "They're great in quiches, soups, fillings, and salads."

"This greenhouse has changed the way I think about greenhouses," Ray says, taking in a basketful of vegetables for the evening meal. "I used to think having one would be a luxury. Now I think it's practical." ∎

A book containing complete plans for Rodale's freestanding residential solar greenhouse will be available in mid-February, 1984, for $14.95 from: Rodale Press, Plans Department, 33 East Minor Street, Emmaus, PA 18049. Ask for "Gardener's Solar Greenhouse."

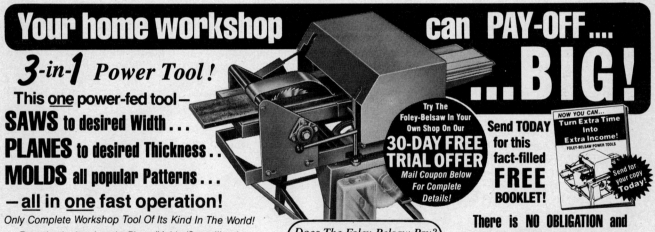

Your home workshop can PAY-OFF.... ...BIG!

3-in-1 Power Tool!

This <u>one</u> power-fed tool —
SAWS to desired Width...
PLANES to desired Thickness..
MOLDS all popular Patterns...
— <u>all</u> in <u>one</u> fast operation!

Only Complete Workshop Tool Of Its Kind In The World!

From the day it arrives the Planer/Molder/Saw will make and save you money. With shortages and inflation driving lumber prices skyhigh, this versatile power tool quickly pays for itself by easily converting low cost rough lumber into high value finished stock. Make your own quarter-round, base mold, door and window stop, casing, tongue-and-groove... all popular patterns. Other operators turn out picture frames, fencing, clock cases, furniture, bee hives, bed slats, surveyor's stakes... all kinds of millwork. Handles tough oak and walnut as easily as pine using only one small motor, and so simple to operate even beginners can use it.

Try The Foley-Belsaw In Your Own Shop On Our
30-DAY FREE TRIAL OFFER
Mail Coupon Below For Complete Details!

Send TODAY for this fact-filled **FREE BOOKLET!**

NOW YOU CAN...
Turn Extra Time Into Extra Income!
FOLEY-BELSAW POWER TOOLS
Send for your copy Today!

There is **NO OBLIGATION** and **NO SALESMAN Will Call—ever!**

If coupon has been removed, just send postcard with name and address to:
FOLEY-BELSAW CO.
90395 FIELD BLDG.
KANSAS CITY, MO. 64111

YOUR OWN BUSINESS Part Time or Full Time — Right At Home!

Men and women everywhere are using this one low-cost power-feed machine to start and build their own new businesses...*and YOU can do the same.* Supply lumberyards, carpenters and contractors in your area with door and window trim...base shoe...bed mold...cove and quarter round...ALL of their trim. You can sell picture frame to custom framing shops, paint stores, department stores and direct to users. All patterns available or design your own. **Get FREE Booklet with facts and full details... RUSH COUPON TODAY!**

Does The Foley-Belsaw Pay? YOU BET!
READ WHAT OWNERS SAY:

"I bought a batch of walnut in the rough, and after planing it on the Foley-Belsaw I figured I saved enough money to pay for two-thirds the cost of the Planer. It really does a good job."
R.S. Clark — Springfield, Ohio

"This machine pays for itself making money out of scrap boards. It is a very well built machine and I confess it is more than I really expected for the price. It does everything you say it will."
Stephen Schultz — Orangeville, Penna.

"I've been a planer man for years and am now retired. The Foley-Belsaw has earned me $60,000 in eleven years... it's the best investment I ever made."
Robert Sawyer — Roseburg, Oregon

"I recommend the Foley-Belsaw as the most useful shop tool any craftsman could own. We use one every day in the Workbench model shop... couldn't get along without it."
Jay Hedden, Editor Workbench Magazine

FOLEY BELSAW
Foley-Belsaw Co.
90395 Field Bldg.
Kansas City, Mo. 64111
FREE BOOK

☐ **YES**, please send me the FREE Booklet that gives me complete facts about your Planer-Molder-Saw and full details on how I can qualify for a 30-Day Free Trial right in my own shop. I understand there is No Obligation and that No Salesman will call.

Name_____

Address_____

City_____

State_____ Zip_____

A PERFECTLY STUPID SHED

In this article, I'm going to explain how to build a geodesic storage shed that will be the talk of your neighborhood, to the point where you will be afraid to answer the door. I'll just give you a rough idea of how you would build this shed; those of you who wish to see detailed plans may send in a self-addressed, stamped envelope and wait until hell freezes over.

Why do you need a storage shed? Safety. Just think for a moment: What would happen to your loved ones if a fire were to break out amongst the deadly substances stored in your basement? And if you try to tell me you have no deadly substances stored in your basement, my reaction will be to laugh in the sneering, condescending manner adopted by French waiters when you try to pronounce *fromage*.

According to the United States Department of Explaining Things for the Benefit of Consumers Who Have No More Sense Than a Plate of Mashed Beets, virtually *everything* stored in everybody's basement is a highly toxic explosive. This includes all the cans of old paint that you are saving in case we have a worldwide economic collapse, and you have to survive by living in your basement and eating paint that has congealed to the consistency of snow tires.

In recent experiments on the Utah Salt Flats, government scientists used a remote-control device to drop a six-year-old, one-quarter-full can of old latex paint (Eggshell White) from a height of 7 feet, and the resultant explosion destroyed every living creature in an area the size of Botswana. Of course,

you don't get a great many living creatures down in the salt flats, so what we're really talking about here is six, maybe seven poisonous lizards of the variety that starred in so many Japanese science-fiction films in the 1950s. But the damage to your house could be much more serious. So you really do need a shed.

I realize, of course, that you have seen ready-made metal sheds on display in such places as home centers, and perhaps you are tempted to buy one. Don't be a fool! These come in kits consisting of thousands and thousands of parts, many of them invisible to the naked eye. It takes a team of crack home-center employees as many as eight consecutive days and nights without any sleep to assemble such a shed, which is why they always appear so listless.

So what I am suggesting is that you construct this modern shed that I have conceived of, because I am dying to find out whether it will work. It utilizes the famous "geodesic" principle, under which you get tremendous strength and rigidity by making everything into a pentagon. At least I think it's a pentagon; it could be a triangle. Whatever it is, the important thing is that it gives tremendous strength and rigidity, which will be darn useful when your paint explodes.

Your first problem is going to be getting the pentagons to stand up without falling over while

you nail them together. Here I have come up with a rather clever idea, which is to heap up a great big pile of dirt in the shape of a shed, then lean the pentagons against it while you nail them together. Of course, then you will have a shed full of dirt, but personally, I view that as a safety measure.

Another problem is going to be how you get into the shed. I advise against installing a door, for two reasons: 1) neighborhood youths could use it to get into your shed and steal your dirt, and 2) I gather, from reading home-handyperson articles, that, to install a door, you must engage in "mortising." I am not sure what this means, but it sounds dirty to me ("WASHINGTON—A United States Senator was arrested today in a seedy downtown hotel and charged with attempted mortising").

So I suggest you enter your shed via a tunnel. For detailed instructions on tunnel building, refer to the fine educational World War II POW escape movie *The Great Escape*, starring Charles Bronson. The trick is to hide the tunnel dirt in your pants and scatter it surreptitiously around your yard during the exercise period. If the guards figure out what you're up to, your best bet is to lob a can of Eggshell White at them and make a break for it.
—**Dave Barry**

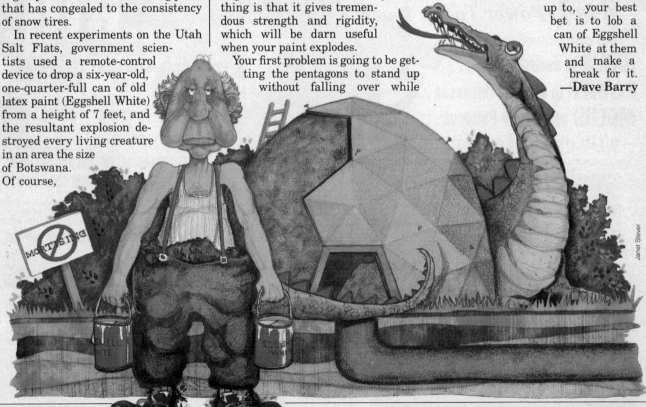

FREE HEAT FROM YOUR DRAINS

If you're an advanced D-I-Y-er,
here's a smart way to save money—Ron Yingling

What a great idea: recapturing free heat from used hot water in your home's drain lines and putting this heat—upward of 7 million Btus per year—back indoors before it is forever lost down the drains.

That's exactly what a graywater heat recovery system does, in spades. A well-built unit can capture enough otherwise wasted heat to pay for itself in a short time. And the saving never stops: A good graywater heat reclaimer can cut your home's winter heating bills by anywhere from $50 to $200 every year, depending on what fuel you use.

Graywater heat recovery sounds high-tech and intimidating, but it's really quite simple—an ideal do-it-yourself project. I know, because I've built a couple of systems. The first was in the EER-2 Research House (featured in "The Most Energy-Efficient Home in America," in the February 1983 issue of NEW SHELTER). The idea of graywater heat recovery apparently tweaked NEW SHELTER's interest, because the editors asked me to construct and write about an improved, "second generation" system, especially for do-it-yourselfers.

And the new system is a gem. It has only one moving part, it can be assembled with just basic tools and skills, it isn't expensive, and it starts paying for itself almost immediately.

How It Works

As you can see in the illustration on this page this graywater heat recovery system is so simple, it *has* to work. Warm graywater (the relatively clean waste water from showers, tubs, and sinks—nothing from the toilet or the garbage grinder) is routed to a holding tank enclosed in a small, closetlike box. A small fan draws air across the tank, removing heat. The warmed air is then delivered into the home, to help with the space-heating load. Neat.

The heart of the system is the tank itself. In the EER-2 design, we used a 90-gallon fiberglass tank; we needed a tank with a removable lid so we could watch for any significant buildup of grease or crust in the tank. (Buildup turned out not to be a problem.) Although the fiberglass tank worked, it was expensive—the prototype system cost $700.

My new system uses a galvanized steel tank, which improves heat transfer, has a more efficient airflow pattern for better heat removal from the tank, gives more design flexibility, and uses a simplified plumbing arrangement that permits a smaller enclosure. But I've saved the best for last: it has *twice* the heat output of the original unit, and costs less than half as much to build!

Performance

I tend to be conservative, so my performance figures are, if anything, a bit low. In any case, my system put out an average of 1,245 Btus per hour, or a total of 7,163,000 Btus during an eight-month heating season.

The only expense was for running the

DRAIN HEAT RECOVERY SYSTEM

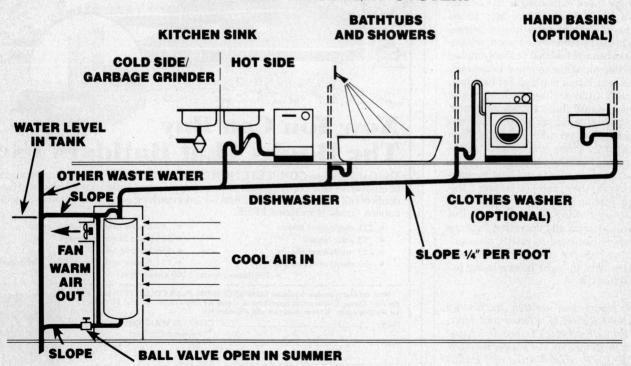

KITCHEN SINK

BATHTUBS AND SHOWERS

HAND BASINS (OPTIONAL)

COLD SIDE/ GARBAGE GRINDER — HOT SIDE

WATER LEVEL IN TANK

OTHER WASTE WATER

SLOPE

DISHWASHER

CLOTHES WASHER (OPTIONAL)

FAN WARM AIR OUT

COOL AIR IN

SLOPE ¼" PER FOOT

SLOPE — BALL VALVE OPEN IN SUMMER

Illustrations by George Retseck

The Mountain Energy Resources MER-150 is a central unit, with a heat-exchanger core made up of heat pipes and aluminum fins. Heat pipes are high-tech devices that use the evaporation and condensation of a special fluid within a sealed tube to move heat from one end of the tube to the other. The unit measures 7 × 31 × 27 inches. It is made by Mountain Energy and Resources, Inc., 15800 West Sixth Avenue, Golden, CO 80401, and retails for about $675.

the unit. The larger units come with drains or fittings to dispose of this water. The colder or more humid your climate, the more important this feature is.

Some of the units also have a means of automatic defrosting. In bitter-cold weather, condensed water can freeze inside the unit, blocking the airflow. The more sophisticated units are able to melt the ice and restore airflow.

Our Recommendations

Before you think of buying an air-to-air heat exchanger, be sure you really need extra ventilation. Realistically speaking, few homes are tight enough to warrant serious concern. If you *do* need extra ventilation, follow these guidelines: In Canada and in the coldest parts of the United States, consider using an air-to-air heat exchanger if you're heating with electricity or a similarly expensive fuel. In all other cases (such as solar-heated homes, homes heated with low-cost wood, or similarly inexpensive fuels), it probably makes more economic sense to use a lower-cost, simpler ventilation method. For example, check out tight-sealing bathroom and kitchen exhaust fans. Or, simply crack open a pair of windows at opposite ends of your home or on different floors, from time to time. These are low-tech methods, for sure, but they work and are cheap.

To summarize: Air-to-air heat exchangers do work; they really do recover a significant portion of the heat in the stale exhaust air flowing through them. But their initial price and operating expense make their use hard to justify economically anywhere but in very cold climates and then only in tight homes using expensive fuels. ∎

This report was written by Energy Consultant Robert G. Flower and Managing Editor Frederic S. Langa. It is based on tests performed by Mr. Flower for NEW SHELTER's Product Testing and Evaluation Department, with the assistance of Mark Kern.

DIESEL GENERATOR
OWN YOUR OWN ELECTRIC COMPANY!

ENGINE IS OLD FASHIONED . LOW SPEED . HEAVY . ECONOMICAL . GENERATOR IS MADE IN AMERICA BY **WINCO** THE WINNCHARGER PEOPLE . RELIABLE . SUPERIOR QUALITY . ENGINE IS BUILT TO LAST A MILLION MILES* (WITH PROPER CARE) AND THEN THE FIRST OVERHAUL IS **FREE!** SAVE BY BUYING DIRECT FROM THE IMPORTER 30 DAY MONEY BACK GUARANTEE - FREE SPARE PARTS & TOOLS

● LOW COST ● NO MIDDLE MEN ●
8000 WATT 110-220 WITH ELECTRIC STARTER - RETAIL VALUE $6,000

$1,995

ORDER NOW
(619) 464-6030
LARGEST DIRECT SUPPLIER OF DIESEL POWERED GENERATORS SINCE 1977.

*Same as running 50 mph for 20,000 hours. Prices and specifications subject to change. Prices do not include shipping, no sales tax except Calif. residents add 6%.

CHINA DIESEL IMPORTS

CALL NOW OR SEND COUPON TODAY FOR INFORMATION NS
NAME
ADDRESS
CITY STATE ZIP PHONE ()

15749 Lyons Valley Road, Jamul, Calif. 92035

Now You Can Buy The Books That Builders Use

The Garlinghouse COMPLETE HOME PLAN COLLECTION contains hundreds of innovative new home designs to help you plan and build your new home. Hundreds of full color illustrations!! And our informative Energy Conservation Specifications Guide is included FREE.

- 331 single-level homes
- 53 solar homes
- 249 multi-level homes
- 52 multi-unit designs
- 99 homes over 2500 square feet
- 374 three bedroom homes
- 155 hillside homes
- 151 homes with four or more bedrooms
- 236 homes under 1700 square feet

□ Send the Garlinghouse 6-volume **COMPLETE HOME PLAN COLLECTION** plus the **free** Energy Conservation Specification Guide for only $15.00 . . . Plus $1.75 for for mailing costs. Kansas residents add 4% sales tax.

Name
Address
City
State Zip

CHARGE YOUR ORDER
□ Payment Enclosed
□ VISA □ MC
Exp. Date
No.

Satisfaction Guaranteed or return within 30 days for prompt refund. No questions asked! 8802
THE GARLINGHOUSE CO., 320 S.W. 33rd St., P.O. Box 299, Topeka, KS. 66601-0299

Only Way Left For Little Guy To Get Rich

Here Is the Uncensored Message My Wife Asked Me Not to Write

I love my wife. And I understand why she wants me to keep my mouth shut. She just wants to protect me from the IRS.

But I can't be quiet any longer. I'm angry. We are really getting jerked around. And I'm tired of it.

The government says one thing. Then does the opposite. Especially Reagan. And I even voted for him. One of my biggest mistakes.

First the feds talk tax cuts. Then they pass the biggest tax increase in history. Who are they kidding?

Average taxpayers, you and I, are getting screwed.

The new law doesn't bother the rich fat cats much. They still have loopholes galore. Let's face it. They always will.

But recently I ran across a workable angle. It's cheap. And it's legal. It's meant for the rich. But it's perfect for us little guys. You don't need any money. And we can get the same breaks the rich get.

I can hardly believe it. Catch this. I formed a corporation. Of my own. For peanuts.

It's my way of fighting back.

Now I have a small, one-man corporation. I operate out of my apartment. My work? I'm a commercial designer. Freelance. Brochures, fliers—stuff like that. On my income, I didn't think I could save much. But I'm paying almost zero taxes. And it's legit. Just like the fat cats do it. I have no guilt. Uncle Sam already gets plenty. Too much from all of us.

One thing the feds didn't bother much under the new tax laws—corporate tax goodies. Guess they figured right. Burden business too much. Result? No jobs for anybody. Including them. Not to worry. They know better.

From a buddy, I heard about this unusual book. It's called **How to Form Your Own Corporation Without a Lawyer for Under $50**, by Ted Nicholas. Damnedest book I've seen. Has the forms right in it. Pages are perforated. You just fill in some blanks and rip 'em out and mail them in. A couple of days later you've got a corporation. No wonder it's a best seller. (They tell me over 650,000 copies have been sold.)

No need to bring in other people. You can be President, Vice President, Secretary, Treasurer all by yourself. Just like me.

You know, lawyers charge $300 to $2,500 for incorporation. Talk about rip offs! And their secretary fills in the form—a single page with two blanks. Now you don't need a lawyer. And there is no hassle at all. It's simple. No wonder lawyers like you to think everything is so complicated.

You don't have to employ anyone either. Just by your lonesome. And I always thought corporations had to have lots of employees.

Oh well. Now I know.

Let me tell you something. I'm a skeptic. I like to shop by mail. But I've been ripped off in mail order. So, before I sent my check, I checked out the company. Called consumer and business bureaus. And the Chamber of Commerce. Found out publisher has a good record. And the book is guaranteed. So, what the hell. I spend that much on a few beers. That's how come I ordered it.

Damned if it didn't come in a couple of weeks.

I expected a shlocky-type mail order book. What a shock. Instead the book was typeset. Has a silver cover. And it's big. 8½ x 11.

I've had it for only three months. Already I've given myself all kinds of fringe benefits. Kind employer I am! Put in a medical reimbursement plan. A one-page form did it. Makes all my doctor, dentist and medical bills tax deductible—for me, my wife *and* my kids.

Now, my wife has been seeing a shrink. Guess living with me is no picnic. We deducted over $600 in the last two months alone. Also just got myself new teeth. Caps, I should say. Cost me $2,500. My son's braces figure to cost $2,000 next year. I can deduct it. Right off the top. And my wife and I are into special vitamins. Heavy. Those pills cost over 400 bucks. Couldn't get into them before because of cost. Tax-deductible now. Imagine this too. Right off the top!

Savings have been scarce for me. I have a helluva time saving bread anyway. But, with this little corporation, I'm really socking it away. How? First, I tax deduct any cash I don't need. A corporation makes this easy to do. And then I invest it. Interest and dividends are completely tax-free. Until I retire. In the meantime, I can even borrow the money back. So I don't lose the use of it like in an IRA or Keogh. This gimmick is called a Pension/Profit Sharing Plan. Again, I just filled in a couple of blanks on a standard form.

Now, I'm no financial genius. But I'll tell you this. I'll be a fat cat myself soon at this rate. It may not be as bad as I thought. Incorporation is the only way left. Now little guys like me have a shot at the big money.

This little corporation even covers my rear end. I could get sued. Everybody likes to sue these days. Something for nothing. And some judge might not like me. But you know what? The only thing anyone can get is what's in my little corporation. Big deal. A drafting table. A desk. And a little paper. Nobody can touch the real bucks. My home, cash, cars—even benefit plan monies are protected.

Maybe you've got some little business deal going. Or maybe you can get something started. Even a part-time business. This book can help. It can make the difference between just making it or operating just like the big boys. Even better, since you don't have their expenses.

For a real shot at big bucks, isn't it time you looked into incorporation?

It worked for me. So well that I wrote a fan letter to the company. They asked me to write this message. In my own words. But I did ask them not to print my name. Who knows? Maybe my wife is right. You can't be too careful. The IRS might want to hassle me. Even though everything is 100% legal. They may not like my message.

If you order now, the publisher will throw in a free bonus. A report called *The Income Plan*. Worth 10 bucks by itself. Shows you how to turn most jobs into a corporation. Outlines how to operate as an independent contractor instead of an employee. You can increase take home pay up to 40%. Taxes will no longer be withheld before you get your hands on the money.

Here is how to get your copy of **How to Form Your Own Corporation Without a Lawyer for Under $50**. And remember. Get the book. Look it over for 30 days. It will give you ideas. Lots of them. If you don't want to keep it for any reason, return it for a full refund. And keep your bonus. No questions asked.

Please rush me a copy of **How to Form Your Own Corporation Without a Lawyer for Under $50,** by Ted Nicholas, at $14.95. I have up to 30 days to look it over. If, for any reason, I don't feel it's for me, I can return it for a fast refund. And the bonus *Income Plan* is mine to keep, regardless.

☐ Enclosed is my check. Charge to my credit card: ☐ American Express
☐ Master Charge ☐ Visa ☐ Diners Club ☐ Carte Blanche

Card Number ＿＿＿＿＿＿＿＿＿＿＿＿ Exp. Date ＿＿＿＿＿

Signature ＿＿＿＿＿＿＿＿＿＿＿＿

Name ＿＿＿＿＿＿＿＿＿＿＿＿

Address ＿＿＿＿＿＿＿＿＿＿＿＿

City ＿＿＿＿＿＿＿ State ＿＿＿＿ Zip ＿＿＿＿

Send to:
Enterprise Publishing, Inc., 725 Market Street, Dept. *SH-41C*
Wilmington, Delaware 19801

© Enterprise Publishing, Inc. MCMLXXXIII C1172

Send me Burpee's free 1984 garden catalog!

It's packed with over 400 vegetables and 650 flowers—including new varieties and Burpee exclusives! Plus fruits, shrubs, garden aids, and more! Send for yours *now!*

Clip and mail today!
W. Atlee Burpee Co.
2554 Burpee Building
Warminster, PA 18974

Name _____
(Please print)
Address _____
City _____
State _____ Zip _____
(If you ordered from Burpee in 1983, your new Catalog will be sent to you automatically in January.)

© W. Atlee Burpee Co. 1983

Do It Yourself DOMES

Build your attractive, energy-efficient dome using our complete, fully-engineered kit. Or, you can save money by purchasing just our plans and heavy-duty, easy-to-use connector system, and cut your own lumber. Catalog, $5.

Timberline Geodesics, Inc. - NS1
2015 Blake, Berkeley, CA 94704
(415) 849-4481

HARDY NUT TREES
Disease Resistant–A Lifetime of Enjoyment

Chinese Chestnut, Filbert, Pecan, Walnut, etc. Rapid growing, young bearing trees will provide fine shade and delicious nuts for many years. Send for free catalog. **LOW PRICES.**

EMLONG'S Box 613
Stevensville, Mich. 49127

SAVE!
Install Your Own Alarm System

PROTECT YOUR LIFE, HOME, BUSINESS, AUTO AGAINST FIRE, THEFT, VANDALISM.

Installation manual and catalog shows you how.
Shows latest equipment, accessories. LOW PRICES.

Send $1.00 (Refundable)

Burdex Security Co. Box 82209-NS Lincoln, Ne 68501

system's small, 40-watt blower: I get more than 9 Btus out of the system for every one Btu used by the fan. You could say the system is over 900 percent efficient.

To put the system's performance in more everyday terms, my graywater heat reclaimer produces roughly enough Btus to heat a well-insulated 10 × 12-foot room containing one high-quality double-glazed window. In operation, the system delivers air at a temperature ranging from about 72° to 82°F. While these temperatures aren't hot enough to toast marshmallows, they're about the same as the range produced by a heat pump in midwinter. Also, the heat production is almost continuous; the result is a lot of extra Btus over the heating season.

Construction Details

There are four phases to construction of the system: obtaining materials, planning, replumbing house drains to accommodate the new system, and actual construction of the unit.

I listed "obtaining materials" first because it takes the longest. Here's what you'll need:

MATERIALS

80-gal. pneumatic tank (John Wood part #JVP612007)*	$160.00
10-in. fan (W. W. Grainger part #20222)	30.00
2-in. PVC ball valve (Plastic Piping Systems of Maryland, Inc., P.O. Box 156, Baltimore, MD 21263 part #PVSBM032; can be ordered direct)	20.00
PVC plumbing 3 DWV 2-in. san tees 2 DWV 2-in. male adapters 2 two-in. street elbows, 90° 2 two-in. street elbows, 45° 7 ft. of 2-in. DWV pipe (Buy 20 ft.; you'll need it for repiping.) 1 pt. PVC cement Two 1¼-in. galvanized plugs One 1-in. galvanized plug	45.00
Lumber Six 2 × 3 × 8-ft. studs Two ⅜ × 4 × 8-ft. sheets plywood	36.00
Small hardware, wiring, nails, and misc.	5.00
	$296.00

Optional Items

16-in. tank stand (John Wood part #JBRR63024— made for a larger tank)	$45.00
Bulb thermostat (Honeywell part #T6031A with Honeywell #112630AA immersion well)	40.00
10-in. insulated flexible duct for remote outlet (CertainTeed Certaflex G25)	$2.00/ lin. foot
4 × 12-ft. register	5.00

NOTE: Brand names are listed only as a guide; order your materials through local suppliers.

*Order a tank with a loose 2-inch plug in the top (no extra charge). Otherwise, the plug will be machine-tight and very difficult to remove.

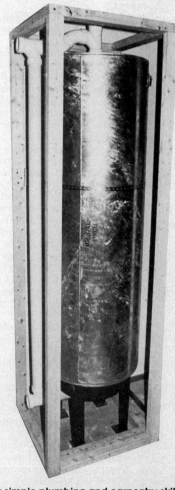

Ron Yingling

Only simple plumbing and carpentry skills are needed to construct the graywater heat reclaimer.

In addition to the materials listed, you'll need extra plastic pipe and fittings to connect your present drains to the graywater unit. These plumbing supplies could cost anywhere from next to nothing to big bucks, depending on the layout of your home. More on this in a moment.

The cost to build a graywater heat recovery system will vary depending on local prices and availability of components. Most items will be available from local plumbing and heating suppliers. (The costs I listed are approximate trade prices, not rock-bottom super-discounted, but well below retail.) While many such suppliers will claim to be wholesale only, they will sell to you on a one-time basis.

As a horseback figure, most people can probably buy everything they need for under $400. Whatever your final cost, remember that the system qualifies for the 40 percent federal tax credit; state tax credits also may apply. In any case, you can figure on a two-to-three-year payback in most areas. Not bad.

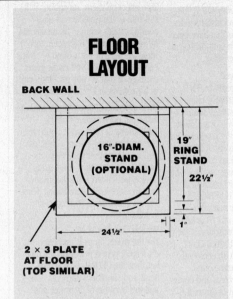

FLOOR LAYOUT

BACK WALL

16"-DIAM. STAND (OPTIONAL)

19" RING STAND

22½"

24½"

1"

2 × 3 PLATE AT FLOOR (TOP SIMILAR)

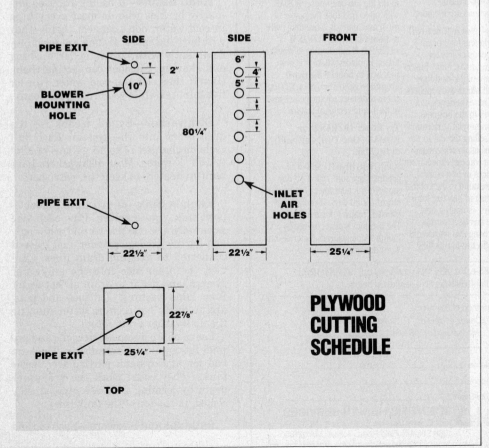

PIPE EXIT

SIDE

SIDE

FRONT

2"

BLOWER MOUNTING HOLE

10"

6"

4"

5"

80¼"

PIPE EXIT

22½"

22½"

25¼"

INLET AIR HOLES

22⅞"

PIPE EXIT

25¼"

TOP

PLYWOOD CUTTING SCHEDULE

FREE FACT KIT

30-DAY, NO-RISK TRIAL OFFER

LIFETIME SECURITY IN YOUR OWN BUSINESS

Call **1(800) 845-3000**

(Utah residents call 1 (800) 662-8666)

We will rush you your FREE Fact Kit that tells how you can make $12.00 to $18.00 an hour!

Earn $12.00 to $18.00 an hour in your own Foley Full-Service Saw and Tool Sharpening Business. The FREE Fact Kit explains how you can be your own boss; work full time or part time at home. Do work you enjoy and not have to worry about layoffs and strikes. And it's a CASH business where 90¢ of every dollar is CASH profit.

And there's plenty of business where you live sharpening all types of saws, garden and shop tools for home, farm and industry. Age is no barrier and no experience is necessary.

But you've got to get the FACTS before you get started. So call NOW or if you prefer, mail the coupon below.

Foley

FREE LIFETIME SECURITY FACT KIT

The Foley Company
20097, Field Bldg.
Kansas City, MO 64111

☐ **YES,** I want to know more! Please rush my FREE Lifetime Security Fact Kit. No obligation and no salesman will call.

NAME _____

ADDRESS _____

CITY _____

STATE _____ ZIP _____

NEW 24½ inch 3-Speed **BAND SAW** 30 DAY FREE TRIAL

Now, a pro-size, band saw priced for the home shop! Big 24½-in. throat easily handles large scrollwork, complex curves, 4 x 8 sheets. 9-in. vertical cut makes it easy to resaw valuable hardwoods. Ball bearing construction. **Easy Terms.** Send for complete facts today!

Phone Toll Free 1-800-824-7888 Oper. 642

Woodmaster, Dept. SH5
2849 Terrace, Kansas City, Mo. 64108
YES ☐
please send me the **FREE BOOK** that gives full details.
Name _____
Address _____
City/State _____ Zip _____

no power or plumbing required kits from under $1000
free brochure write or call anytime **1-800-962-6208**
3150 N Elliott Ave. Seattle, Wa. 98121
(206) 283-5701

wood fired **HOT TUB** snorkel stove, co.

NOW You Can Get Rid of RATS, MICE, SQUIRRELS, BATS, ROACHES, and OTHER PESTS *THIS EASY WAY!*
... (We Guarantee It)

Scientific Health Services Ultrasonic Pest Repellers are electronic generators of high frequency sound. The sound is audible and painful to pests but inaudible and harmless to humans and pets. The pests will leave the area of ultrasound.

No Poisons, Chemicals, Traps, Or Sprays are required. Pests are eliminated in a humane manner without mess or unpleasantness. Thousands of satisfied customers use our ultrasonic machines in homes, apartments, vacation homes, businesses, schools, hospitals, nursing homes, warehouses ... wherever pests are a problem.

Two Distinctly Different Models

Dispersal Ball 360°
Transducer
Indicator Light

The ULTRAS II Pest Repeller is a really new development in ultrasonic technology. It is *omnidirectional*. The ultrasound is emitted by a powerful ultrasonic transducer (122dB), not a speaker, and is dispersed in a 360° circle. Most other repellers (including our RODAR) are directional and take advantage of sound reflections from walls and hard objects in the area. ULTRAS II is designed primarily for home use. It is rated at 2,000 square feet coverage, which means that under normal conditions it will drive pests from an open area of that size. ULTRAS II has a natural wood finish and is 4½" in diameter and 6½" high. Although low in price, the ULTRAS II should not be compared with the many low-cost units now being advertised. Those units have speakers (often noisy and bothersome) and are considerably less powerful than the ULTRAS II. *And*

power is what makes the difference between a successful product and the cheap units that have been discredited by such 'authorities' as the 20/20 television show.

RODAR "One-Two"
RODAR, manufactured by THE MONADNOCK COMPANY, is the established professional/commercial repeller. It is one of the most powerful units on the market at any price. Only recently did it become available to individual consumers and the price has been reduced by more than one-third because of SCIENTIFIC HEALTH SERVICES' agreement to mass market it. *Nothing has been cut in quality.* Its *two* powerful transducers each emit more than 128 decibels of sound pressure. In an enclosed area the powerful ultrasound bounces off all surfaces and covers the entire area. Out-of-doors the directional beam may be aimed at loading docks, doorways, and other specific areas to be protected. It is housed in a handsome walnut-veneer hard-board cabinet 4⅞" wide x 6⅝" high x 4⅛" deep. Both repellers plug into standard 110 volt AC outlet (220 volt available). Detailed instructions are included.

Ultrasonics — Not A "Cure-All."
Too many marketers have been making outrageous claims for their inferior products. Many buyers have been disappointed and have decided that all ultrasonic repellers are a racket. Our experience of a number of years in the business, both at the commercial (exterminator) level and selling directly to the consumer, gives us an understanding of just what you can expect from ultrasonic devices in pest control. The use of ultrasound in the control of pests, although in practice for a number of years, is really a new science. There has been formal research indicating that ultrasound can be quite effective in repelling

rats and mice. But official documentation concerning its effect on squirrels, bats, chipmunks and insects is yet to come. However, we have sold ultrasonic devices to thousands of satisfied customers and we base many of our claims on their reports.
Don't buy ultrasonic devices (ours or anyone else's) to eliminate flying insects. Although there is a noticeable effect on them, mosquitos will still bite in the presence of ultrasound ... flies seem to be unaffected in the short range. Ants seem to leave the area of ultrasound — but carpenter ants will still cause great damage. If that is your problem, call in a professional exterminator.

Over a period of time, ultrasound of sufficient power will eliminate infestations of rats, mice, squirrels, chipmunks, bats, cockroaches, as well as some other insects. In the usual home situation, most users have experienced remarkable success in completely eliminating pests. This is also true in commercial installations.

Which One for You?
For the price, there is no better ultrasonic pest repeller on the market than the ULTRAS II. It stands head and shoulders above its competitors because of its power and omnidirectional feature. It will do an outstanding job in most home and many commercial installations.

RODAR "One-Two" is, of course, the CADILLAC of ultrasonic machines. When you buy one for your home, you know that you have the power to do the job, and more. RODAR, with up to 60 times the power of most machines, is more than twice as powerful as the ULTRAS II. ULTRAS II is outstanding in smaller areas. In places where it is not practical to bounce the signal around to get coverage the ULTRAS II has a distinct advantage because of its omnidirectional feature.

Try Either ULTRAS II or RODAR "One-Two" (or both) at No Risk.
SCIENTIFIC HEALTH SERVICES products are sold with a 30-day money-back guarantee. Try one (or more) for 30 days. If you are not pleased, return it for a full refund. The product is also covered by a 12-month Manufacturers Materials and Workmanship Guarantee.

TO ORDER: Call **TOLL FREE 1-800-334-0854**, Ext. 883 (N.C. residents call 617-783-3187.)
OR fill in form and mail to Scientific Health Services at address below.

ORDER FORM
Please send me:
_____ ULTRAS II @ $69.95 $ _____
_____ RODAR "ONE-TWO" @ $99.95 $ _____
Shipping and handling @ $4.00 per unit $ _____
Mass. residents add 5% sales tax $ _____
TOTAL $ _____

Method of Payment:
☐ Check enclosed. ☐ Money order enclosed.
☐ MasterCard or VISA No.: _____
_____ Expir. Date: _____
Name _____
Address _____
City/State/ZIP _____

ShS SCIENTIFIC HEALTH SERVICES
Pest Control Division, Department NS1
1266 Soldiers Field Road, Boston, MA 02135

The unit is designed to recycle cool room air, warm it, and return the warm air to the room. Ideally, to enhance its thermal efficiency, the unit should be located in or near the *coolest heated or semiheated space* in your home. (*Do not* draw air for the unit from a totally unheated space, such as outdoors, or from an unused basement. Nothing is gained.) If the unit must be located in an unconditioned space, you will have to run a cold-air return duct from the room to be heated, as well as a warm supply duct back to a different part of the room. The unit and ducts should then, of course, be insulated. If you need ductwork, figure on a supply 10 inches in diameter and a return 12 inches in diameter, and limit runs to about 20 feet. If the unit, more typically, is located adjacent to the room to be heated, allow for some means of return-air circulation back to the unit, such as trimming the bottom of a door by about 1¼ inches.

Now look at each type of plumbing fixture that drains hot water, and figure out how you'll get the warm waste water to the unit. Here's what to consider.

Hand Basins—If basins are used primarily by kids who do most everything in cold water, don't connect them—they will hurt the cause. If they are used predominantly with hot water for washing and shaving, consider connecting them. (Don't, then, let the cold water run for five minutes while you brush your teeth.)

Dishwasher—By all means tie the dishwasher into the system. Each full cycle discharges 14 to 18 gallons of 130° to 160° F water. Most dishwashers have built-in heaters to keep the water hot.

Kitchen Sink—If you have a double-bowl sink, you're golden. Pipe each side separately. Use one side for cold water only and for the garbage grinder, and leave it connected to existing drain lines. Connect the other side into the graywater system, and use it to drain all hot water from hand-washing of dishes and pots, and to dump hot cooking water into; tie the dishwasher drain into it.

Learn not to dump cooking oils and animal fats into the kitchen sink. They are bad for any system, particularly septic tanks. They could block the graywater drain by forming a grease plug, if they cooled, in the top of the tank inlet.

Bathtubs and Showers—Each tub and

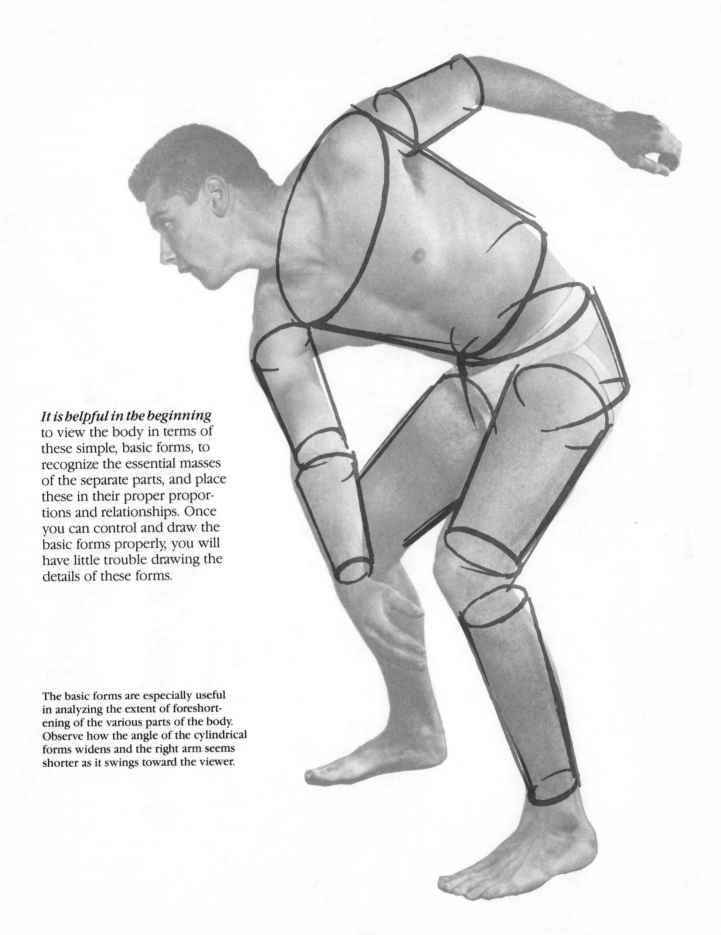

It is helpful in the beginning to view the body in terms of these simple, basic forms, to recognize the essential masses of the separate parts, and place these in their proper proportions and relationships. Once you can control and draw the basic forms properly, you will have little trouble drawing the details of these forms.

The basic forms are especially useful in analyzing the extent of foreshortening of the various parts of the body. Observe how the angle of the cylindrical forms widens and the right arm seems shorter as it swings toward the viewer.

Construction of the figure...

The device of using a manikin is employed here to help you understand the basic forms of the figure for the simple units they are. It's easier, in the beginning, to understand "wooden people" than it is to deal with personality, looks and physique. Besides, our whittled woman never moves and never needs a rest period or a fee.

Another advantage of viewing the figure this way is that you can readily visualize the three-dimensionality of the separate forms better than you can on a human whose skin covers all clues.

The arms and legs are cylinders. The head is a sphere resting on the cylinder of the neck. The torso is separated in two parts, both cylindrical. The separation at the waist is important in helping to establish convincing action. Turn the figure around and you have a front view of the same three-dimensional geometric forms. Notice that the direction of the form is now reversed. The leg that thurst away from us in space now comes toward us. Note the photograph of the curvacious nude model. She's graceful and beautiful, but see how her muscles and curves obscure the basic forms that the crude manikin reveals so clearly.

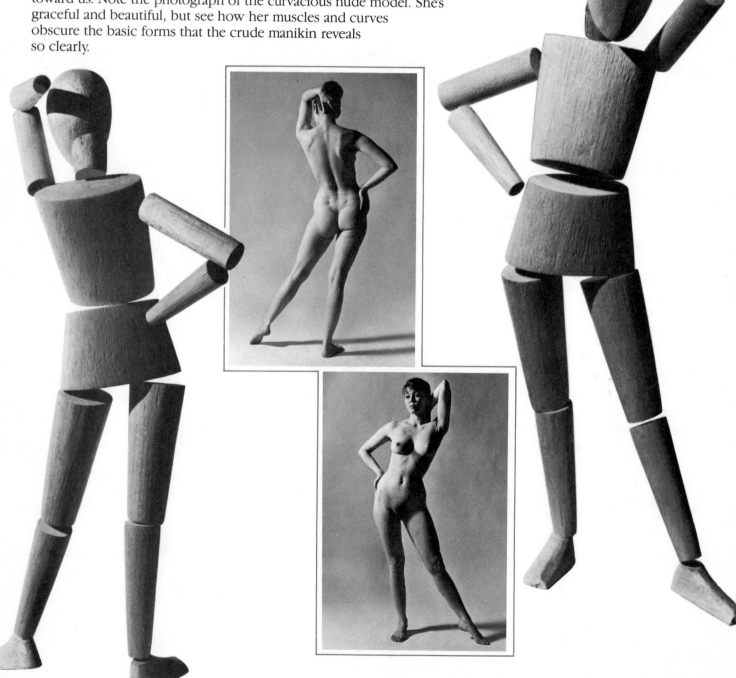

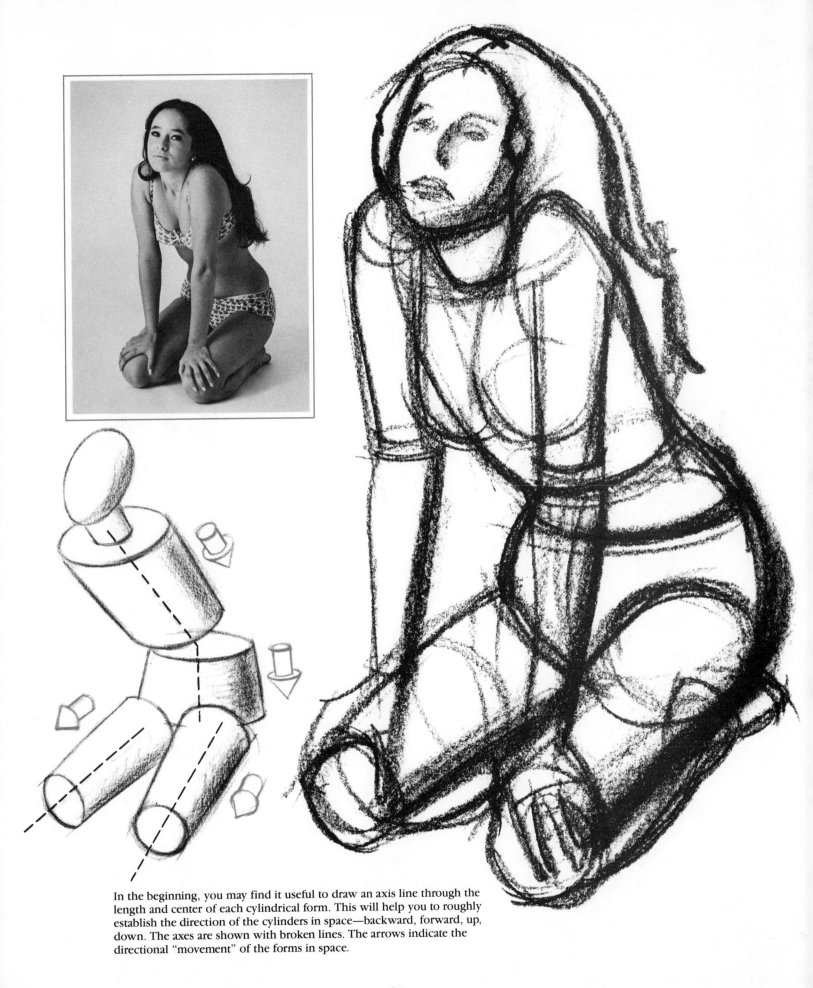

In the beginning, you may find it useful to draw an axis line through the
length and center of each cylindrical form. This will help you to roughly
establish the direction of the cylinders in space—backward, forward, up,
down. The axes are shown with broken lines. The arrows indicate the
directional "movement" of the forms in space.

Since the purpose of gesture drawing is to freely and instantly capture an impression of what the model *is doing* rather than *how it's made*, one must then build into that exuberant sketch the engineering that holds it together and allows it to function.

Begin by doing a spirited gesture drawing; then, on a sheet of tracing paper placed over your gesture drawing, draw the basic forms.

Feel out and build up the solid cylinders of the torso, arms, legs and head.

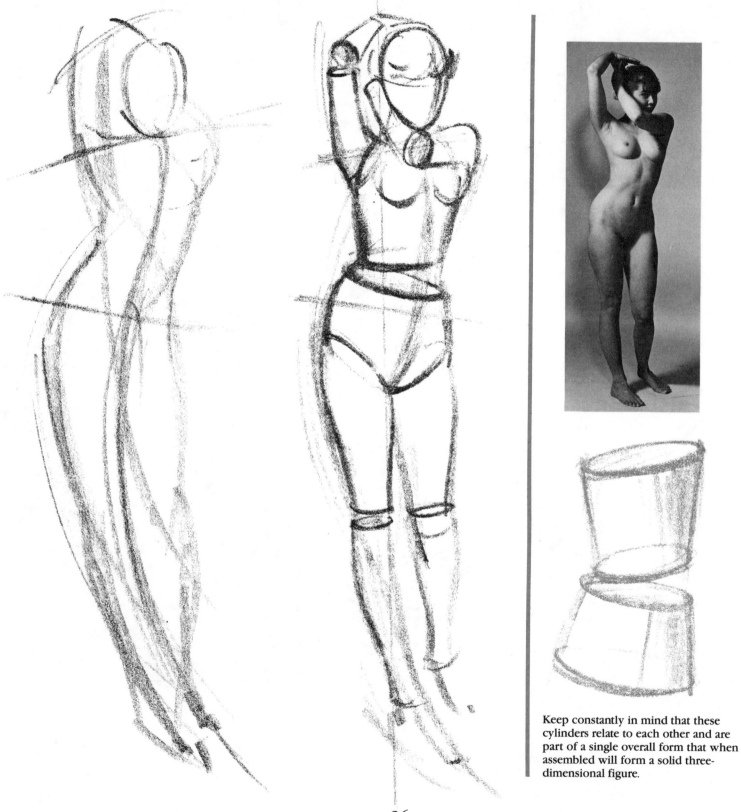

Keep constantly in mind that these cylinders relate to each other and are part of a single overall form that when assembled will form a solid three-dimensional figure.

26

Developing the form figure from the gesture drawing

Foreshortened figures are not easy to draw, since many parts of the body recede from the eye or come forward at an extreme angle. Building a basic figure over the initial gesture drawing is an effective way to work out the construction of a foreshortened pose. These simpler forms are much easier to visualize—and draw—than the complex anatomy of the figure we see in the photo.

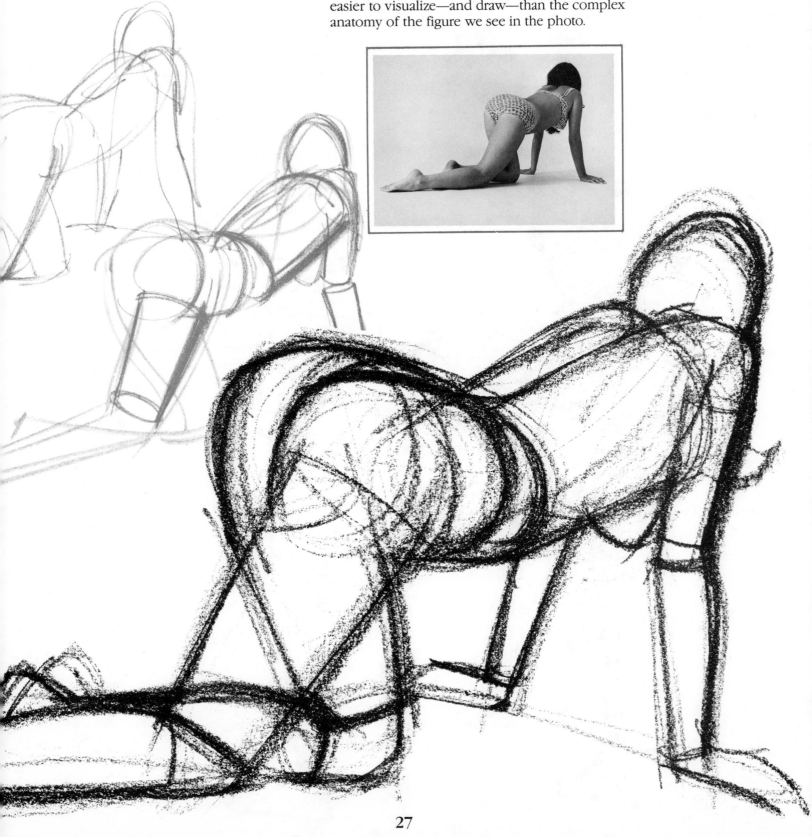

Practical Uses of the Basic Form Figure

Now that you've drawn the basic form cylinders over a gesture drawing, try doing something a little different.

Start with a photo of a person as nearly nude as you can find. Study it. Then make a drawing alongside the photo using only cylinders to express the forms and the proportions.

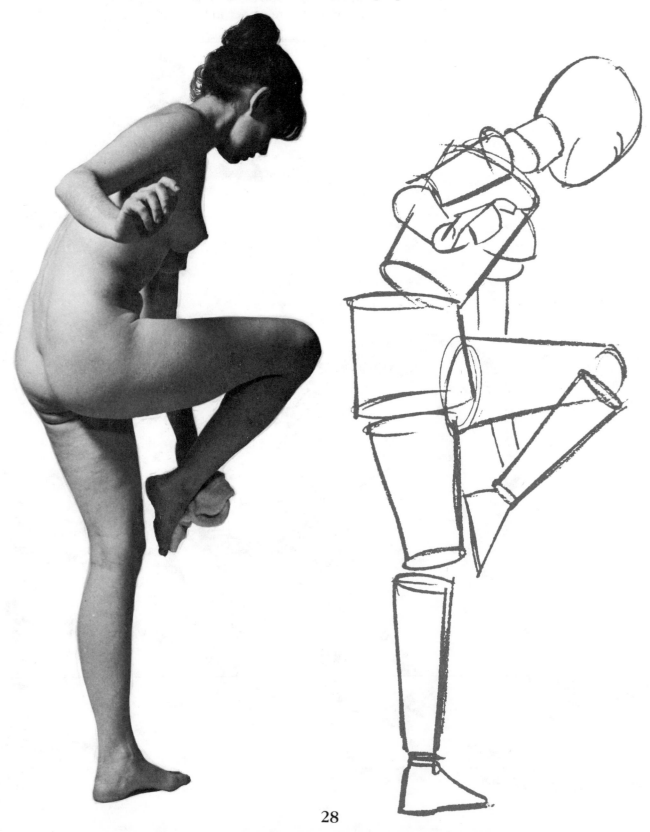

Don't imitate the lighting or shadow patterns of the model. Do line shapes using a soft pencil and drawing freely and searchingly. Build the logical construction in the same way you would if you were joining shapes of clay.

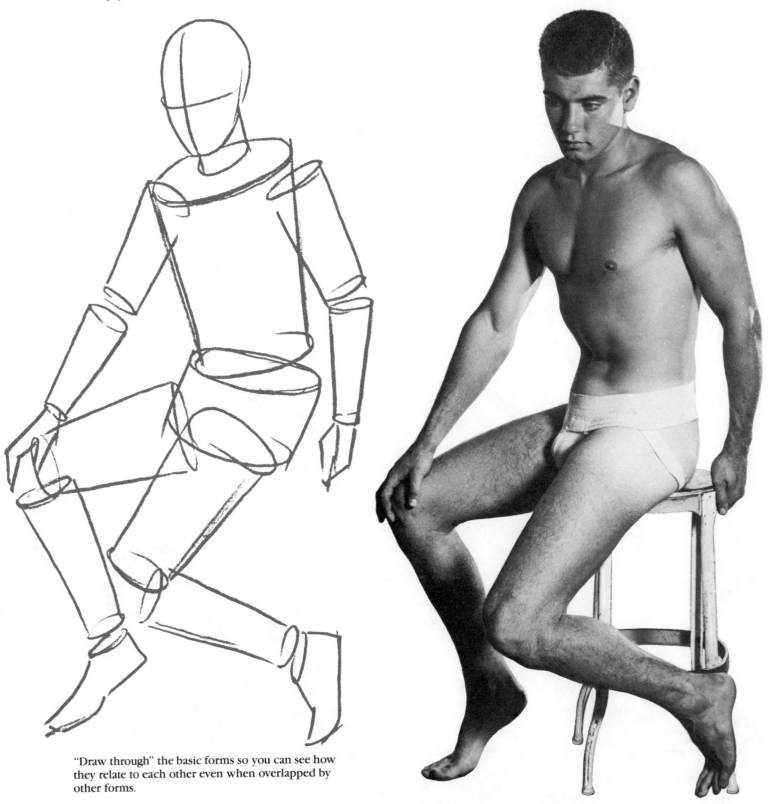

"Draw through" the basic forms so you can see how they relate to each other even when overlapped by other forms.

29

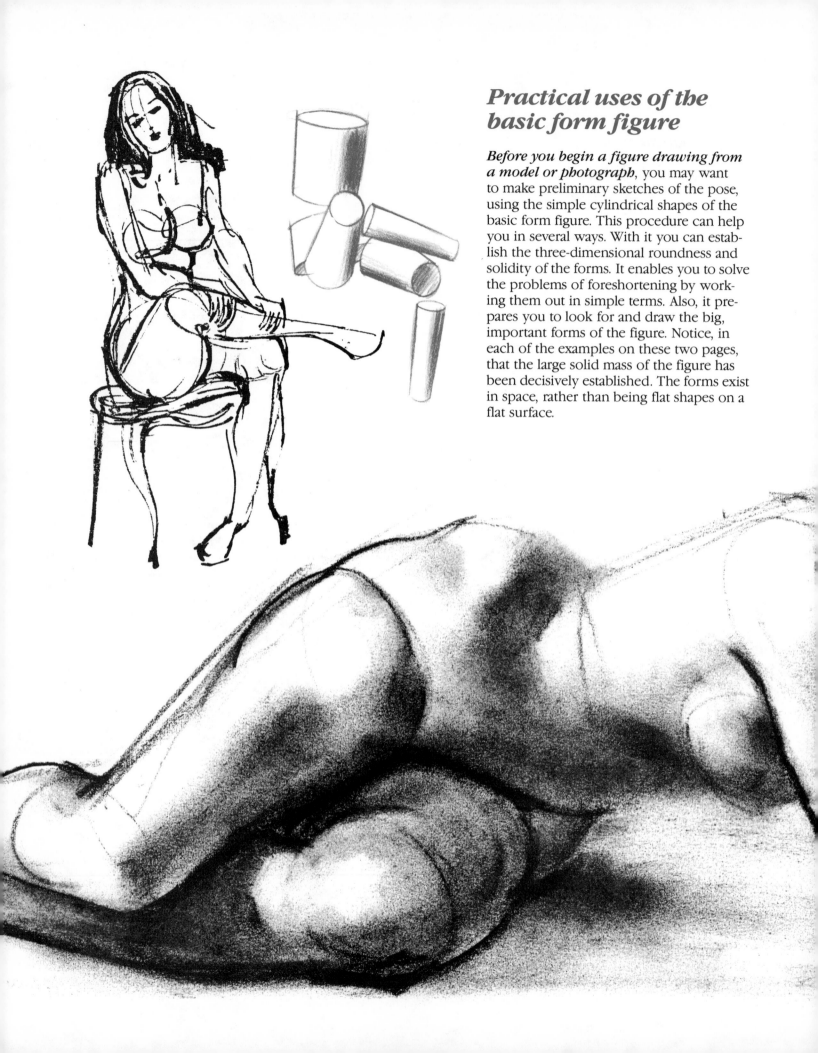

Practical uses of the basic form figure

Before you begin a figure drawing from a model or photograph, you may want to make preliminary sketches of the pose, using the simple cylindrical shapes of the basic form figure. This procedure can help you in several ways. With it you can establish the three-dimensional roundness and solidity of the forms. It enables you to solve the problems of foreshortening by working them out in simple terms. Also, it prepares you to look for and draw the big, important forms of the figure. Notice, in each of the examples on these two pages, that the large solid mass of the figure has been decisively established. The forms exist in space, rather than being flat shapes on a flat surface.

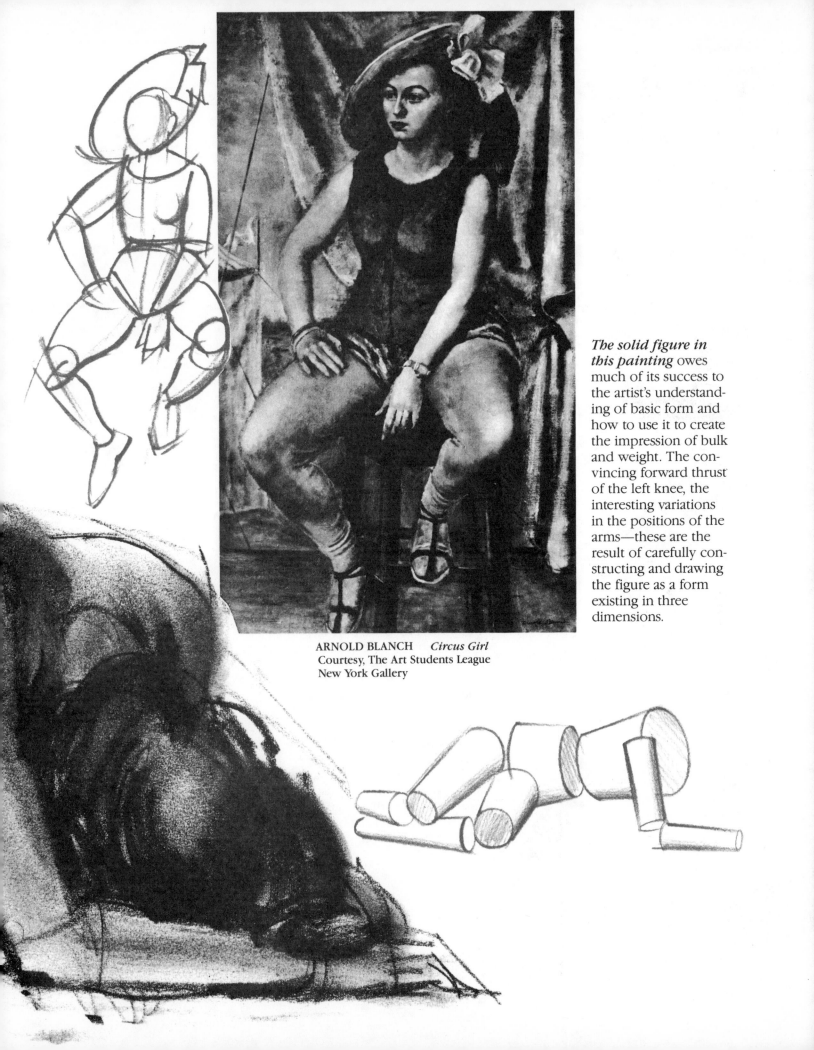

The solid figure in this painting owes much of its success to the artist's understanding of basic form and how to use it to create the impression of bulk and weight. The convincing forward thrust of the left knee, the interesting variations in the positions of the arms—these are the result of carefully constructing and drawing the figure as a form existing in three dimensions.

ARNOLD BLANCH *Circus Girl*
Courtesy, The Art Students League
New York Gallery

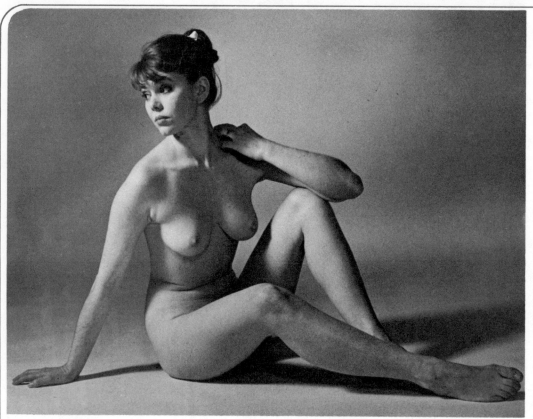

Practice Project
the basic form figure

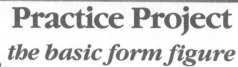

Carefully study each of these figures before you start to draw. Notice how the cylinder-like body forms move in and out of space—sometimes pointing toward you and sometimes pointing away. Now, following the step-by-step method shown on page 24, make basic form figures of these models. Draw them on the facing page (or other sheets of paper), sketching lightly at first and gradually firming up the forms. You may wish to place tracing paper over your first steps, using the method shown on page 80.

The self-correcting overlay, page 83, shows how a Famous Artists School instructor drew these figures. Remove that tissue and place it over your drawings for comparison.

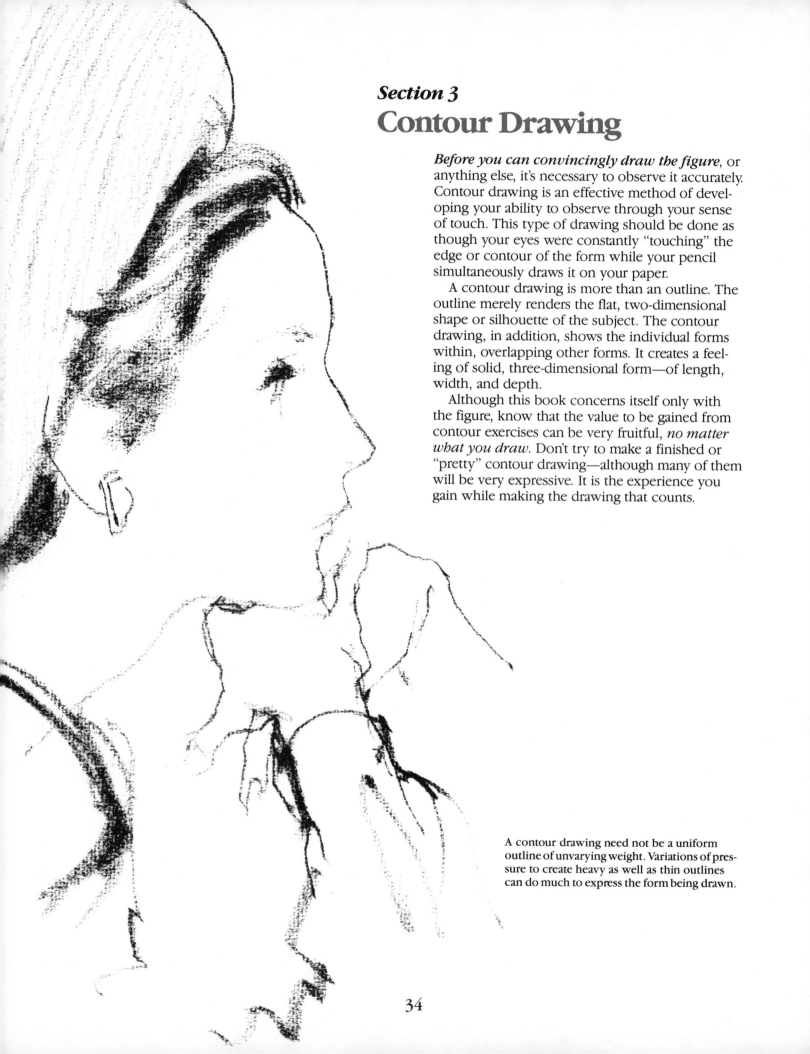

Section 3
Contour Drawing

Before you can convincingly draw the figure, or anything else, it's necessary to observe it accurately. Contour drawing is an effective method of developing your ability to observe through your sense of touch. This type of drawing should be done as though your eyes were constantly "touching" the edge or contour of the form while your pencil simultaneously draws it on your paper.

A contour drawing is more than an outline. The outline merely renders the flat, two-dimensional shape or silhouette of the subject. The contour drawing, in addition, shows the individual forms within, overlapping other forms. It creates a feeling of solid, three-dimensional form—of length, width, and depth.

Although this book concerns itself only with the figure, know that the value to be gained from contour exercises can be very fruitful, *no matter what you draw*. Don't try to make a finished or "pretty" contour drawing—although many of them will be very expressive. It is the experience you gain while making the drawing that counts.

A contour drawing need not be a uniform outline of unvarying weight. Variations of pressure to create heavy as well as thin outlines can do much to express the form being drawn.

34

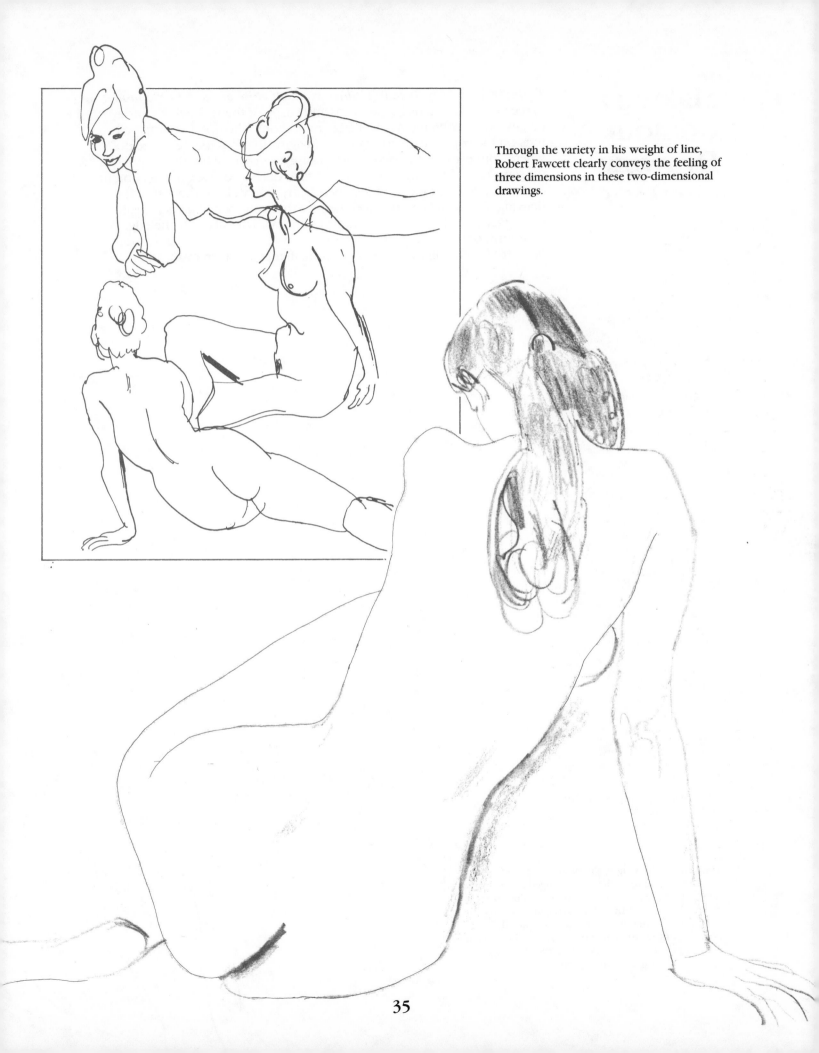

Through the variety in his weight of line, Robert Fawcett clearly conveys the feeling of three dimensions in these two-dimensional drawings.

Making a Contour Drawing
...an exercise

To make a contour drawing, place yourself close enough to the model to see all the variations in the forms and shape of the figure. Fix your eyes on any point along the model's edge or contour. The tip of your pencil rests on the paper, ready to draw, but imagine that it is touching the point where your eyes are focused. Move your eyes slowly along the contour, at the same time slowly moving your pencil to draw a corresponding contour on the paper. Don't look at the paper! Don't worry about the rest of the drawing! Keep concentrating on the idea that your pencil tip is actually in contact with the edge that your eyes are following. Follow the edge of each form of the figure until you come to where it ends or changes direction. At times it will leave the edge of the figure and turn inside, there to

Henri Matisse *Nude Kneeling*
Collection, The Museum
of Modern Art

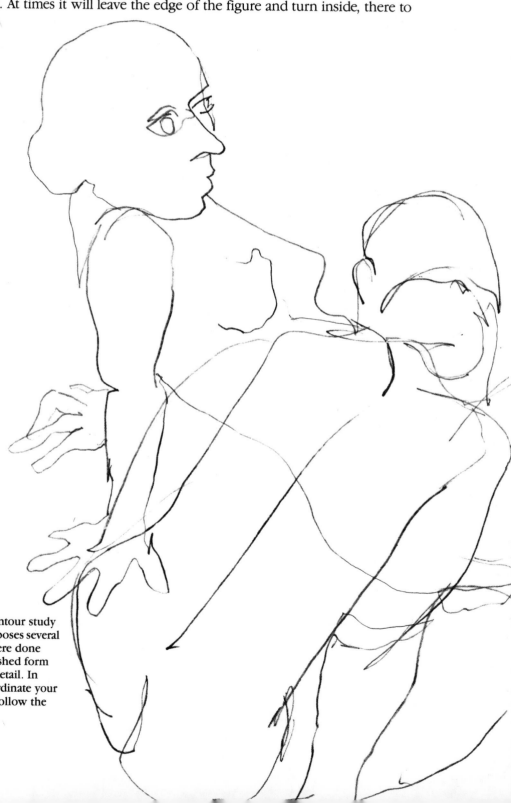

The student drawing at the right is a contour study made from a nude model who changed poses several times during the session. The figures were done with a flowing but firm line that established form and mass without attempting to show detail. In doing a contour drawing you must coordinate your eyes and the tip of your pencil as they follow the edge of the form in front of you.

meet another form or appear to end. When this happens, glance down at the paper to establish a new starting point; then look back at the model and continue to draw the contour as it proceeds in the new direction.

Make sure that you don't let your gaze move faster than your pencil. Your attention should be concentrated on the point where your eyes are focused, while you are drawing that same point. You need not be concerned about the accuracy of the overall drawing. It's practically impossible to make an accurate drawing if you are following the method we have described. Avoid a vague or sketchy line. Work slowly and deliberately, taking as much time as you need—the visual experience is what you're after.

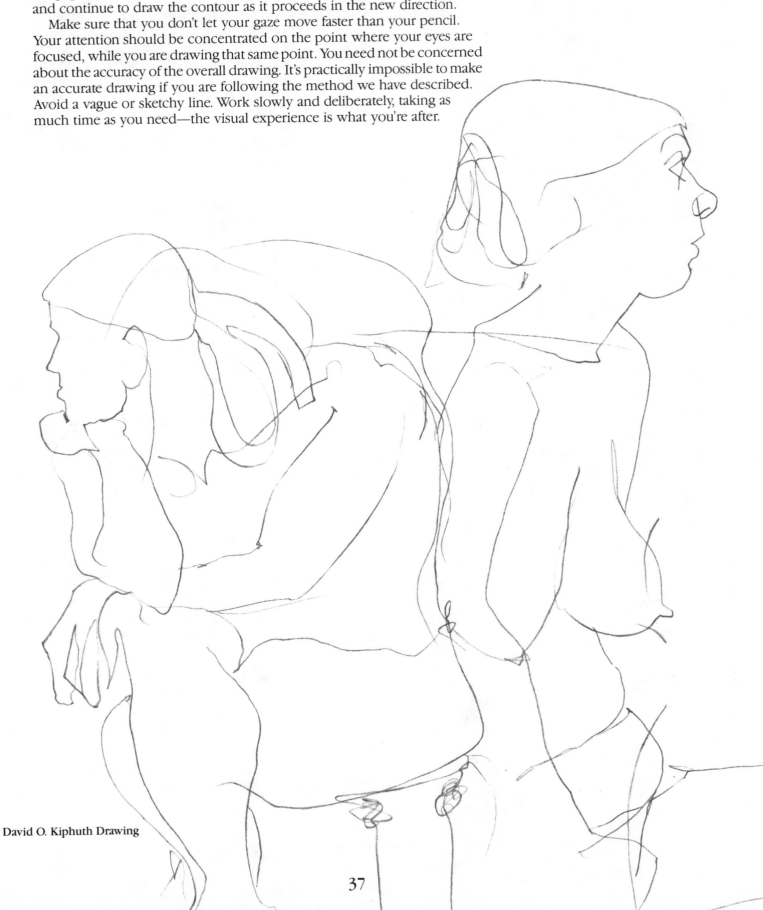

David O. Kiphuth Drawing

37

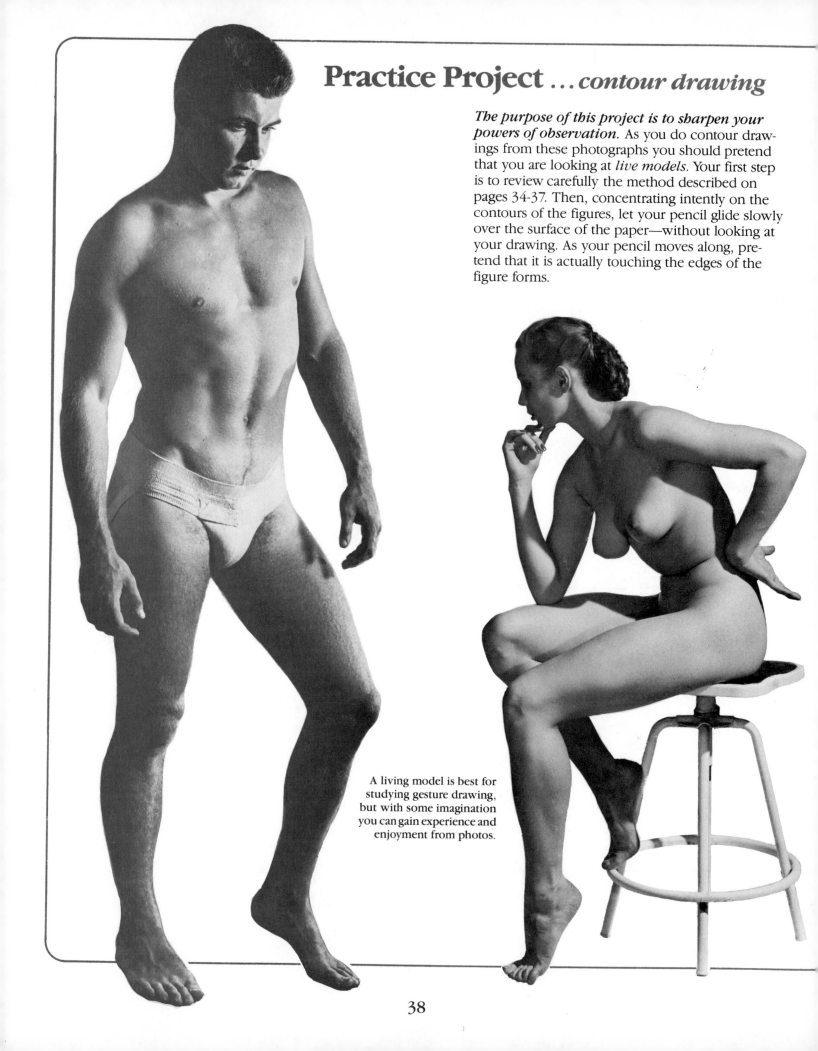

Practice Project ... *contour drawing*

The purpose of this project is to sharpen your powers of observation. As you do contour drawings from these photographs you should pretend that you are looking at *live models*. Your first step is to review carefully the method described on pages 34-37. Then, concentrating intently on the contours of the figures, let your pencil glide slowly over the surface of the paper—without looking at your drawing. As your pencil moves along, pretend that it is actually touching the edges of the figure forms.

A living model is best for studying gesture drawing, but with some imagination you can gain experience and enjoyment from photos.

38

When you've completed your drawings, remove the self-correcting overlay, page 84, and place it over your drawings to see helpful suggestions from a Famous Artists School instructor.

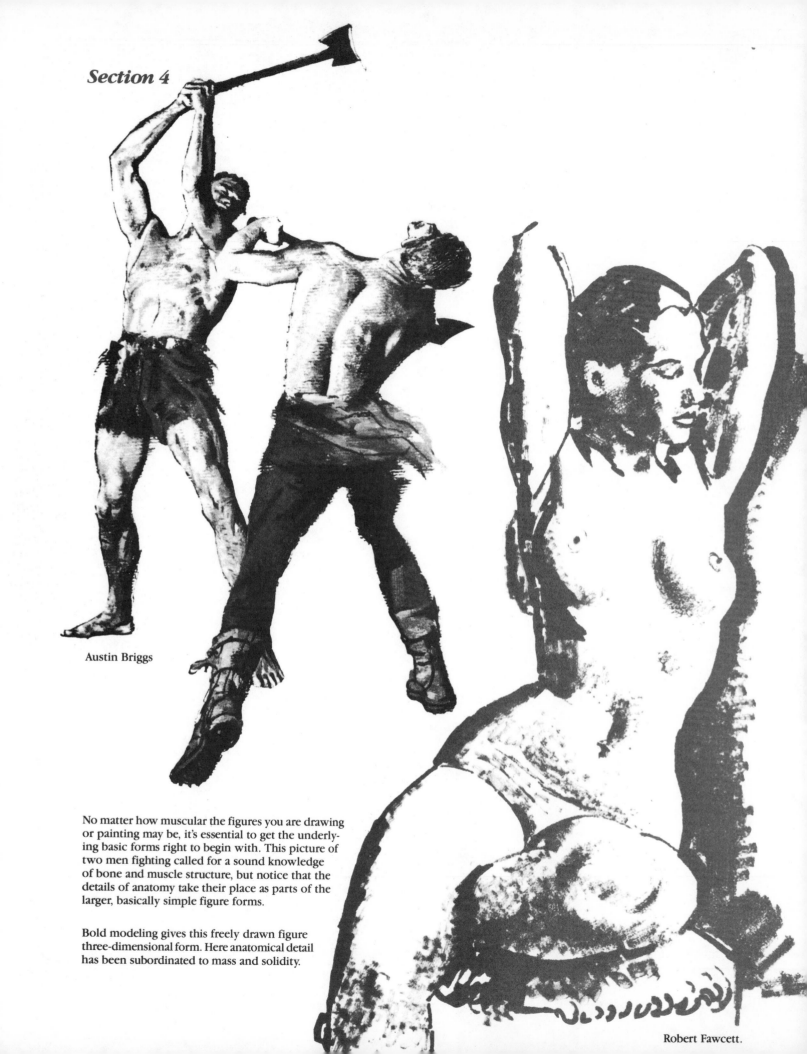

Section 4

Austin Briggs

No matter how muscular the figures you are drawing or painting may be, it's essential to get the underlying basic forms right to begin with. This picture of two men fighting called for a sound knowledge of bone and muscle structure, but notice that the details of anatomy take their place as parts of the larger, basically simple figure forms.

Bold modeling gives this freely drawn figure three-dimensional form. Here anatomical detail has been subordinated to mass and solidity.

Robert Fawcett.

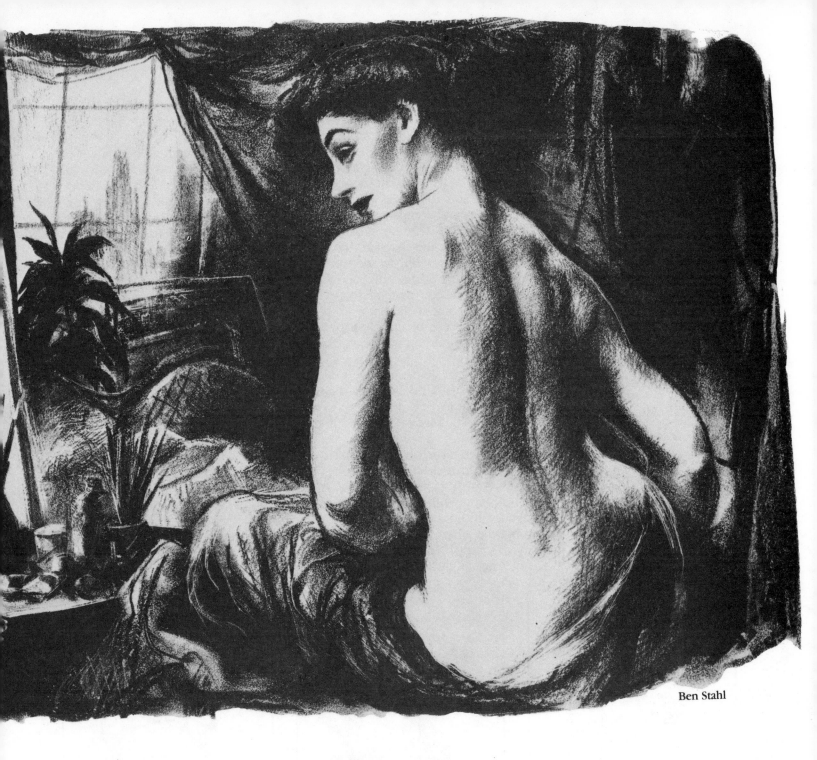

Ben Stahl

The Figure as a Solid Form

The human figure is a solid form. It has bulk and weight, as a rock has bulk and weight. The figure has depth and thickness as well as height and width. It exists in three dimensions.

So far we have looked at the figure in several different ways, each planned to build on the next. From the gesture for the overall attitude of the figure, to the basic figure as a means of establishing proportions, on to contour drawings to see the shapes, we now come to the consideration of form and bulk.

Whether the artist constructs the human body out of clay or stone or draws it on a flat surface, he or she must always think of it as a three-dimensional object. Paper lacks the third dimension of depth, but we can still create the feeling of depth in the figure we draw on it.

In each of these drawings the artist has achieved a feeling of bulk and weight. Each is characterized by the strong "plastic" or structural quality of the form. Study these drawings carefully. Copying them will also be helpful.

Form and Bulk

Until you learn to have a feeling for form, your drawings, despite their attributes, will always fall short of truly portraying the figure because they won't suggest bulk, weight or volume.

To understand form, you must first *sense it*—sense its three-dimensional shape, and then sense the *weight of that shape*.

You cannot fully represent those qualities in line. Line is really a slender bent graphic wire, and you're seeking to render *bulk and mass*. Hence you must do it with density and compactness. Only the use of tone will give you that.

Understand that we're not talking about superficial light and shadow *on the surface*, but rather the shape and weight of limbs, the torso, the head. This is accomplished by *starting at the core* and describing its form and bulk with light tones for that portion that comes forward and dark tones to make something turn and recede. Imagine that you are rendering it *all around*—not just the surface that faces you.

You will, in effect, be upholstering a gesture and a contour drawing. Imagine, too, that you are starting with a wire armature at the core and padding the figure in the appropriate places at the same time as you are broadly rendering its three-dimensional shape in space.

Practice this with the flat of your chalk and *find your way out to the edge* with no interest in local details.

Don't make the mistake of thinking that bulk applies only to hefty, chunky figures. *All bodies have bulk*—and your drawings should indicate how, where, and how much, even on slim people.

Ignore the artificial light and shade on your model, determining only how the mass of the body exists. *Feel that mass* in your mind's eye and then interpret it by indicating, with light tones, those planes and shapes that come towards you, and with bold darker tones, those portions that recede. As these tonal areas build up they will form masses of varied tone and *a solid human* will begin to occupy its place in space.

Forget details. Strive only for rounded and blocked volumes for now.

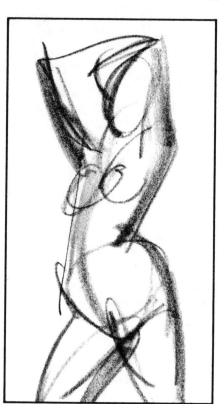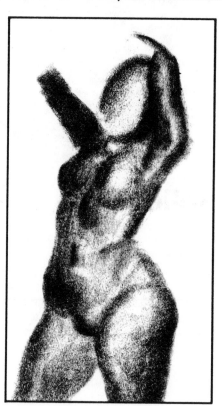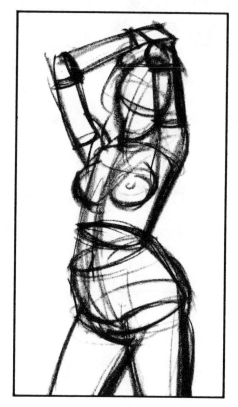

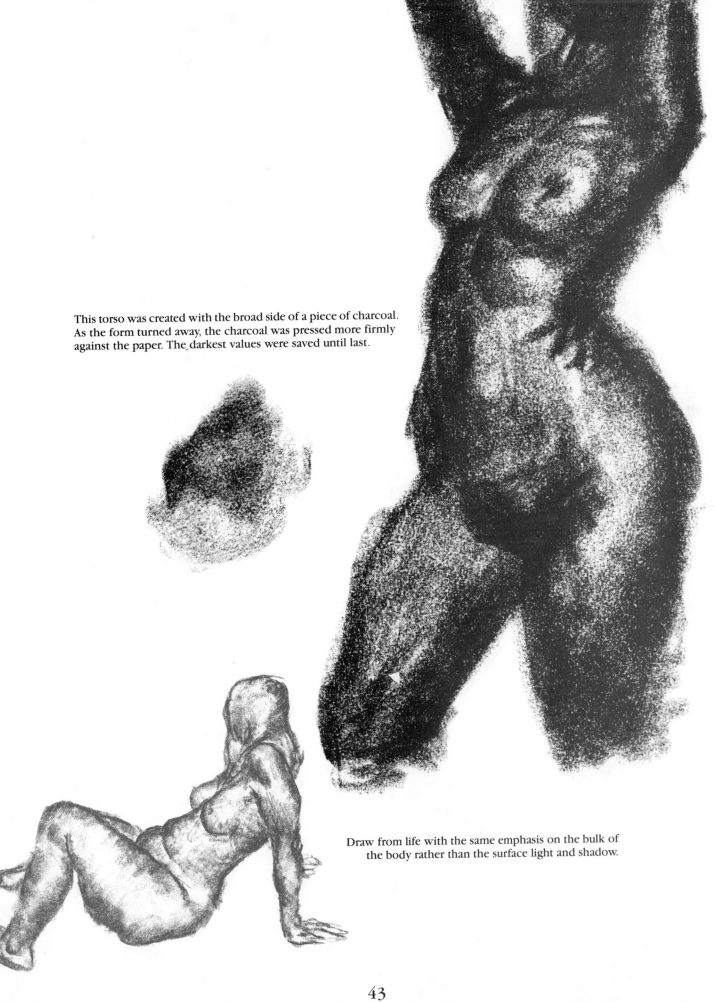

This torso was created with the broad side of a piece of charcoal. As the form turned away, the charcoal was pressed more firmly against the paper. The darkest values were saved until last.

Draw from life with the same emphasis on the bulk of the body rather than the surface light and shadow.

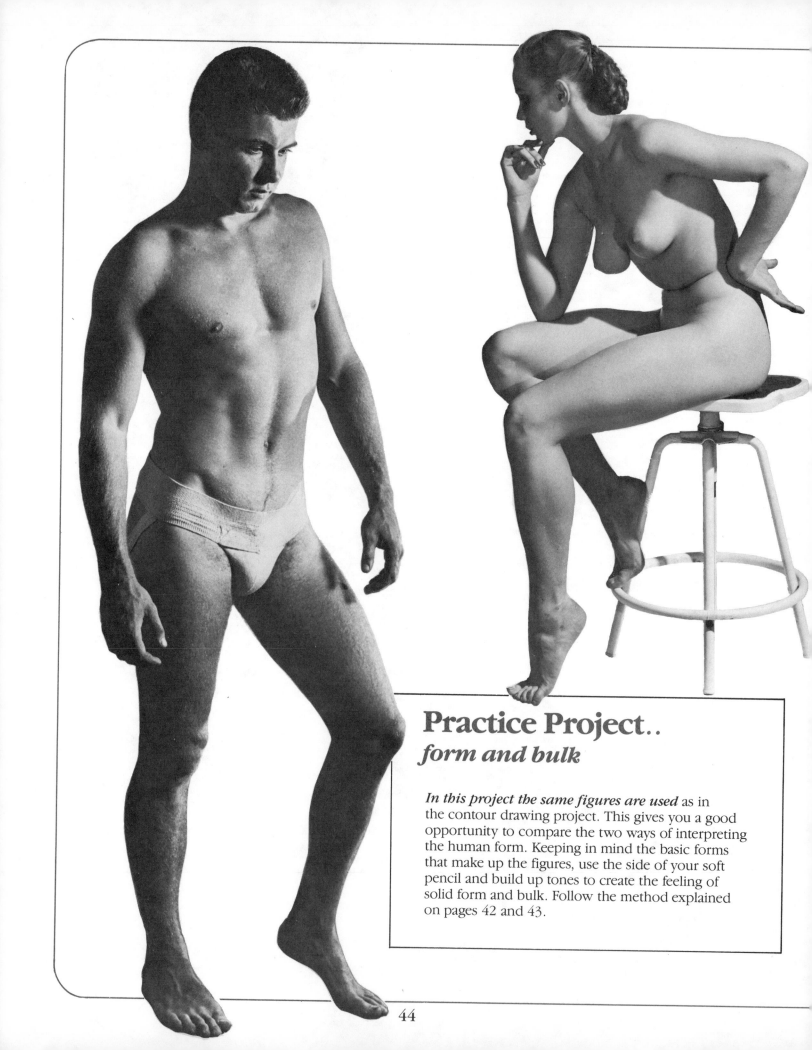

Practice Project..
form and bulk

In this project the same figures are used as in
the contour drawing project. This gives you a good
opportunity to compare the two ways of interpreting
the human form. Keeping in mind the basic forms
that make up the figures, use the side of your soft
pencil and build up tones to create the feeling of
solid form and bulk. Follow the method explained
on pages 42 and 43.

When you've completed your drawings remove the transparent Instructor
Overlay, page 85. Lay it over your work for comparison and helpful suggestions.

45

Section 5
Artistic Anatomy... *relative proportions*

The artist uses the human head as his basic unit of measurement for the entire human figure. The head can be viewed in two ways. The height of the head from chin to top of skull is "the ruler" by which all *vertical measurements* are made. When the artist speaks of an "eight-head figure," he means that the figure is *eight vertical heads high*. Use *the width of the head* in making horizontal measurements. The shoulders, for instance, are *three head widths* across.

 If you look at the people around you, you will realize how much they differ in proportion. One has a head which is large for his body, another has a head which seems smaller than normal. The majority of people, however, are reasonably similar in proportions and shape at any given age. This is why clothing manufacturers can design "ready-made" suits and dresses.

 Artists have always sought to discover *the ideal, the perfect* figure. The Greek sculptors established a "canon" for the human figure. Later, Leonardo and Dürer set up their own. Rubens' hefty, voluptuous beauties were once much admired, when women were considered beautiful only if they had monumental propor-

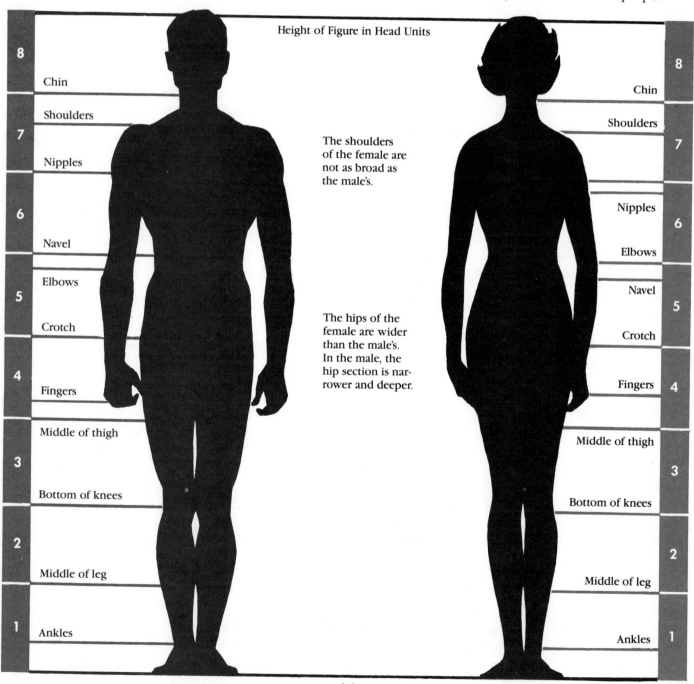

Height of Figure in Head Units

The shoulders of the female are not as broad as the male's.

The hips of the female are wider than the male's. In the male, the hip section is narrower and deeper.

Male		Female
8		8
Chin		
Shoulders		Chin
7		Shoulders
Nipples		7
6		Nipples
		6
Navel		Elbows
Elbows		Navel
5		5
Crotch		Crotch
4		
Fingers		Fingers
		4
Middle of thigh		Middle of thigh
3		3
Bottom of knees		Bottom of knees
2		2
Middle of leg		Middle of leg
1		1
Ankles		Ankles

tions. Today popular taste has swung in the opposite direction: thin is in.

Hence, the eight-head figure has become the standard for the virile male in modern illustrations.

Often, however, in commercial work or in cartooning, you will need to portray people who are neither average nor ideal. You can do this easily by retaining *the same width measurements* used to draw the eight-head figure, but reducing the height to five or six heads, or increasing the height to nine or ten heads, as in the case of a modern basketball player.

Rely on your eyes for correct proportion. The head as a unit of measure is convenient and helpful when you are first learning figure proportions. You must realize, however, that you should not make figure drawings with dividers or a ruler. You make them with your pencil and your eyes! Therefore, the only way to gauge proportions is by sight. If it looks right it is right. Study these charts and fix in your mind the size of one part of the body compared with another. Remember that skillful drawing is skillful seeing, transferred to paper.

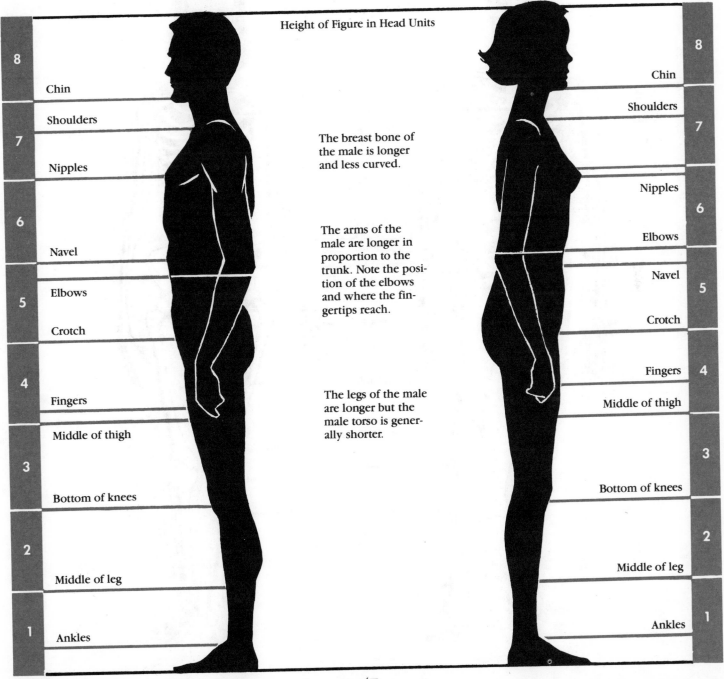

Height of Figure in Head Units

The breast bone of the male is longer and less curved.

The arms of the male are longer in proportion to the trunk. Note the position of the elbows and where the fingertips reach.

The legs of the male are longer but the male torso is generally shorter.

Male figure (left):
- 8 — Chin
- Shoulders
- 7 — Nipples
- 6 — Navel
- 5 — Elbows, Crotch
- 4 — Fingers, Middle of thigh
- 3 — Bottom of knees
- 2 — Middle of leg
- 1 — Ankles

Female figure (right):
- 8 — Chin
- Shoulders
- 7
- Nipples
- 6 — Elbows
- Navel — 5
- Crotch
- Fingers — 4
- Middle of thigh
- 3 — Bottom of knees
- 2 — Middle of leg
- Ankles — 1

Artistic Anatomy...*the skeleton*

These drawings show the differences between the male and female skeletons and explain why the surface forms are different in the sexes.

The bones of the female are smaller and smoother, and more heavily covered with fatty tissue. They are less apparent on the surface tha the larger, coarser bones of the male skeleton.

The female has a smaller, narrower rib cage with a shorter, more curved breastbone. The female's shoulders are not so broad as the male's and her collar bones are straighter and smaller.

The female has a longer torso and shorter legs than the male. Her pelvis is broader and shallower, and this makes the hips much wider. Note the greater distance from the top of the pelvis to the rib cage. The pelvis in the male is about the same width as the rib cage while *the female pelvis is wider* than the rib cage.

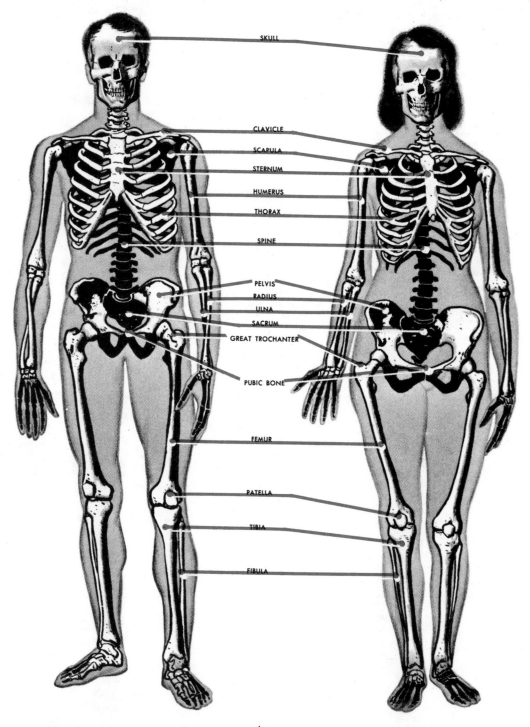

SKULL

CLAVICLE

SCAPULA

STERNUM

HUMERUS

THORAX

SPINE

PELVIS
RADIUS
ULNA
SACRUM
GREAT TROCHANTER

PUBIC BONE

FEMUR

PATELLA

TIBIA

FIBULA

... the muscles of the body

These front and rear view diagrams of the male figure show the main muscles that influence the surface appearance of the body. The female has exactly the same muscles, but they are smaller and are covered by a thicker layer of fat.

Learn the size, position and action of these muscle groups. Knowledge of the muscles and their action will make it easier for you to interpret what you see in a real model or a photo.

There is no need to memorize the names of all these muscles. It is much more important to know what they are, where they begin and end, and what they do.

Keep in mind that these are diagrams, not drawings of the appearance of the figure. Use them only for study. When you draw the figure, you should show no more anatomy than appears on the surface. This may be a large amount if you are drawing an athlete.

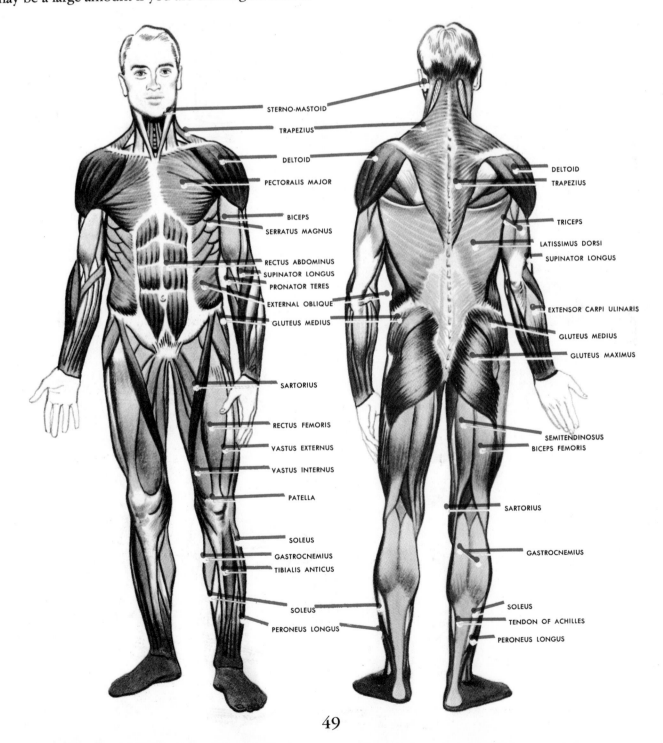

STERNO-MASTOID
TRAPEZIUS
DELTOID
PECTORALIS MAJOR
BICEPS
SERRATUS MAGNUS
RECTUS ABDOMINUS
SUPINATOR LONGUS
PRONATOR TERES
EXTERNAL OBLIQUE
GLUTEUS MEDIUS
SARTORIUS
RECTUS FEMORIS
VASTUS EXTERNUS
VASTUS INTERNUS
PATELLA
SOLEUS
GASTROCNEMIUS
TIBIALIS ANTICUS
SOLEUS
PERONEUS LONGUS

DELTOID
TRAPEZIUS
TRICEPS
LATISSIMUS DORSI
SUPINATOR LONGUS
EXTENSOR CARPI ULINARIS
GLUTEUS MEDIUS
GLUTEUS MAXIMUS
SEMITENDINOSUS
BICEPS FEMORIS
SARTORIUS
GASTROCNEMIUS
SOLEUS
TENDON OF ACHILLES
PERONEUS LONGUS

49

The Head

Each of us spends more time looking into the faces of other humans than at any other single sight. The attention of most people is invariably focused on reading expressions and emotions rather than on how a person's face or "head" (as artists refer to it) is constructed.

The head is basically egg-shaped, with the small end at the chin. To this add the protuberance of the nose. The eyes set in under a usually overhanging brow. With the positioning of ears and mouth, the transformation from egg to head is well under way.

Once the solid form of the head has been sketched in, the correct location of the features can be established as indicated below.

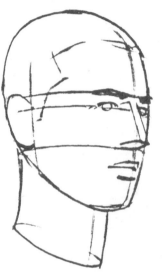

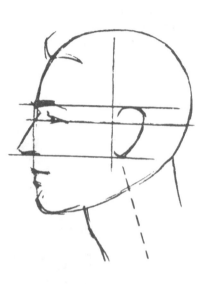

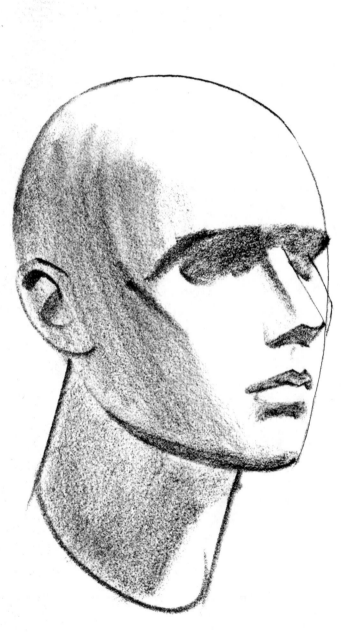

How to place the features

The eyes are on an imaginary horizontal line about halfway between the chin and the top of the head. The bottom of the nose is about halfway between eyebrows and chin. Place the mouth about one-third of the way between the nose and chin.

The side view shows the eye is placed *back* from the front of the face. Locate the ear just behind a vertical line halfway between the front and back of the skull.

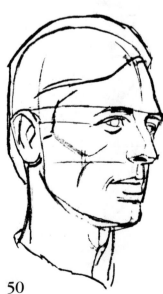

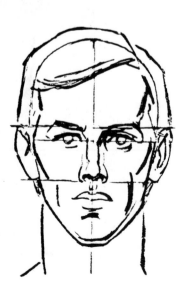

50

The Torso

The torso or trunk is the body's greatest mass. It is also many other things: the central core from which the neck and head and all four limbs emerge.

And because people's torsos take on so many different degrees of development, size, shape and character, they greatly determine the "look" of a person—posture, gait, age, fitness, etc.

Think for a moment of any person of either sex or any age that you know well on sight. Chances are that you can conjure up their appearance by your recollection of their torsos alone. That's how important the torso's cosmetic effect will be on your drawings.

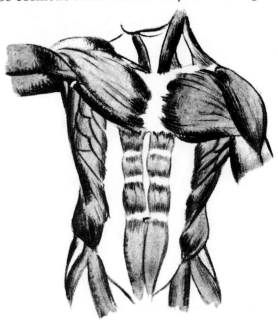

This diagram allows you to view the muscle structure that underlies the general shape of the torso and pelvic area.

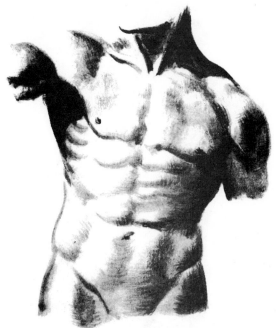

This drawing shows how the underlying structure, shown at the left, influences the surface appearance.

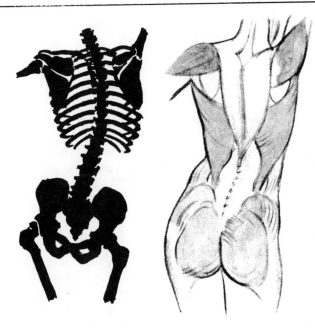

In back views, the shoulder and hip width varies between male and female and then varies within each sex as well.

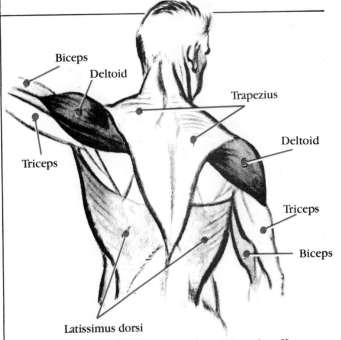

Here is the amazing structure of torso in action. Keep this construction in mind when you draw every pose. This will keep you from doing superficial surface drawings with no underlying foundation.

51

The Arm

The human arm is a remarkable machine that can lift, push, throw, punch, rotate and bend in a myriad of directions and angles. It begins at the shoulder and terminates in the hand —the universal symbol of toil, might, brotherhood, skill and artistic touch.

The simplified drawings on these two pages were chosen to show you the basic architecture of the arm: from the bone structure to the muscle arrangement to the skin-covered final product; which you can easily examine by taking off your shirt and feeling and looking.

Bear in mind that the muscular construction is the same in both the male and female figure—except that muscles are much less obvious in women.

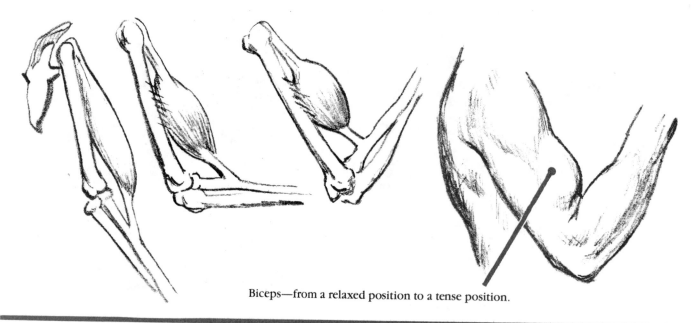

Biceps—from a relaxed position to a tense position.

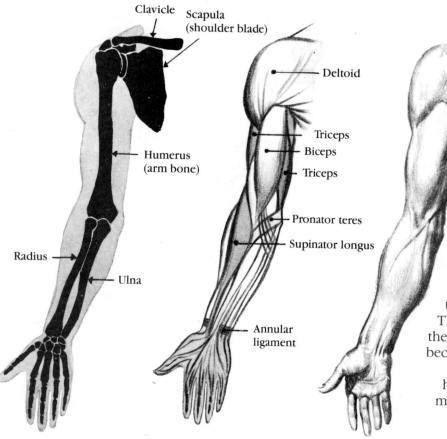

The mass of the shoulder, or deltoid, comes down as a wedge and sinks into the outer arm, halfway down. The muscle on the front of the arm is a two-headed one called the biceps; the muscle on the back of the arm is three-headed and is called the triceps. The biceps bends the elbow and flexes the forearm. When doing this the biceps becomes shorter and thicker. The triceps muscle runs the entire length of the humerus on the back of the arm. This muscle acts in opposition to the biceps and straightens the arm.

52

The muscles of the forearm may be divided into two groups, flexors and extensors. They operate upon the wrist and hand through tendons, which pass under the wrist band or annular ligament. The two most important muscles in the forearm are the supinator, the long outside muscle extending from the wrist to one-third up the humerus (upper arm bone); and the pronator teres, a short, round muscle which passes obliquely downward across the forearm from the inner condyle of the humerus to halfway down the outer border of the radius. These two muscles pull the radius with a rotary motion over the ulna and back again, carrying the thumb side of the hand toward or away from the body.

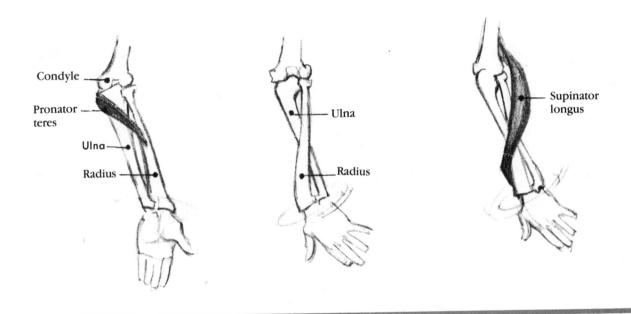

The hand does not join the arm directly, but joins the wrist, which in turn attaches to the arm and is seen as a wedge-shaped mass in any action. This wrist joint is universal in its scope, permitting it to move in a rotary, up-and-down or side-to-side movement. Its range of action is almost unlimited.

From the armpit, the arm gradually gets smaller in width to the elbow. This is more noticeable in profile than in the front view. The fleshy mass of the forearm near the elbow widens in excess of the breadth of the upper arm and in turn gets narrower again at the wrist.

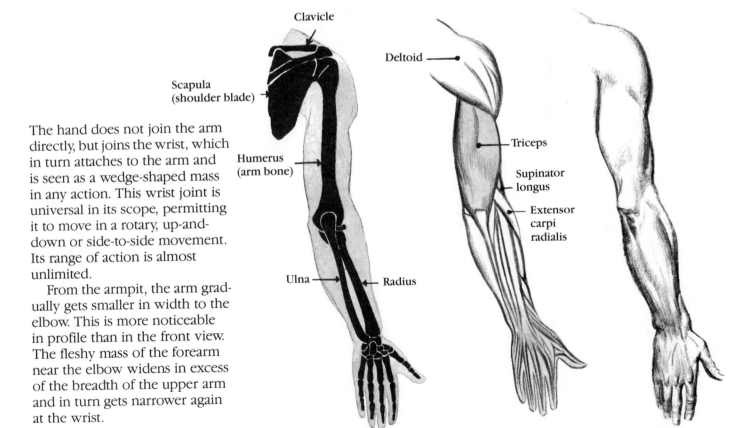

53

The hand and wrist—
their construction and action...

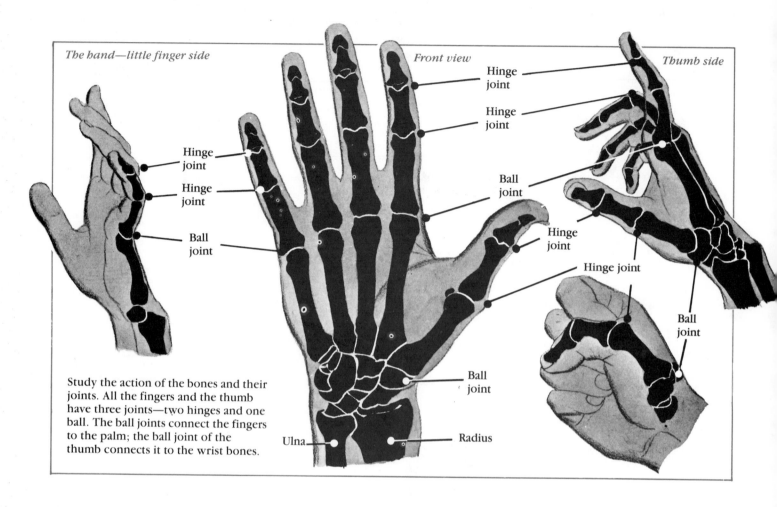

The hand—little finger side

Front view

Thumb side

Hinge joint

Hinge joint

Hinge joint

Hinge joint

Hinge joint

Ball joint

Hinge joint

Ball joint

Hinge joint

Ball joint

Hinge joint

Ball joint

Ball joint

Study the action of the bones and their joints. All the fingers and the thumb have three joints—two hinges and one ball. The ball joints connect the fingers to the palm; the ball joint of the thumb connects it to the wrist bones.

Ulna

Radius

Hands should always be drawn large enough. Many students tend to make them too small in relation to the rest of the figure.

To understand the action of the hand, study the movement of the wrist. As it transmits the action of the arm to the hand, the wrist enters into the large movements of the arm, giving it grace and power. The wrist can be called a universal joint, for it is capable of side-to-side and up-and-down movement as well as rotary movement. Study carefully the diagrams and try these movements out on your own hand and wrist.

It is helpful to think of the hand as being composed of three masses—the palm, the thumb part, and the mass of the fingers.

The palm has the form of a shallow bowl that is roughly rectangular in shape and well cushioned around the edges. A line across the wrist marks the lower limit of the palm. The upper limit is also definitely marked by lines across the base of the fingers. Measure the length of the palm and you will find it about an inch longer than the finger above that part of the palm. You will notice, too, that the palm is longer than the back of the hand. Except when the hand is clenched in a fist, the back of the hand is quite flat.

Most of the modeling in the palm of the hand is caused by a system of fleshy cushions and pads with which it is thickly upholstered. These cushions cover the bony framework of the palm. The same is true of the fingers on the palm side.

The thumb is the most active and powerful finger on the hand. It is set into the palm by the highly mobile "ball of the thumb," which gives it a great range of movement independent of the rest of the hand. The thumb moves in any direction.

Curved lines can be drawn across fingertips, through joints.

Fingers taper singly and as a mass.

When hand is closed, fingers point toward center.

Range of thumb movement.

Point of radiation of thumb.

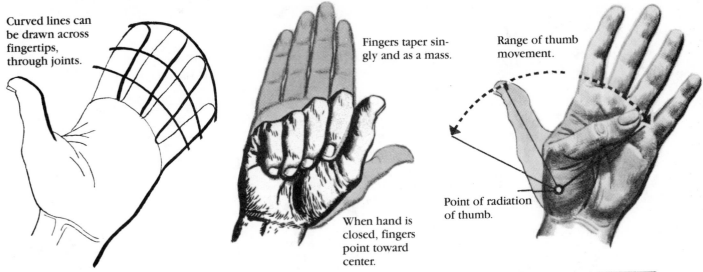

The three main masses of the hand.

Fingers

Palm

Thumb

Palm is larger on thumb side.

Wrist is twice as wide as thick.

Palm is thick near wrist, thinner near fingers.

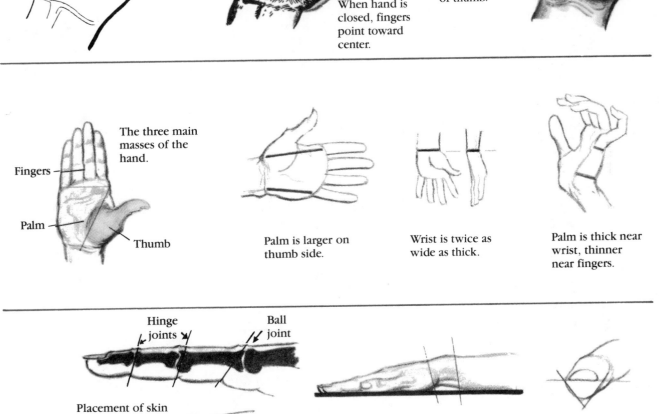

Hinge joints

Ball joint

Placement of skin folds in relation to joints.

When the hand and arm are placed flat on table, wrist slants down to hand, it does not touch table.

Fingertips are slightly triangular in shape.

Range of wrist movement up and down.

Range of wrist movement from side to side.

Think of the hand and fingers as cube forms—not cylinders.

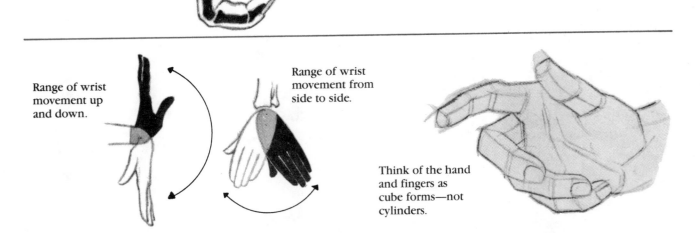

The upper part of the leg encases the body's largest bone: the femur. And it's attached as is the arm, by a ball and socket joint—which, because of its life-long heavy tasks, is larger and is set deeper.

The Leg and Foot

When we are in a normal standing position with the full weight of the body on the legs, our knee is *behind* a line dropped from the *front of the thigh*. The leg does not stand in a strictly *vertical position*. It slants back from the top of the thigh to the ankle.

From the side, we see a full curve at the front of the thigh while the back is fairly straight. In the lower leg the opposite is true; here the shin is flatter, the calf at the back is full and rounded. Whether we are looking at the leg from the front or back, it shows an *inward slant* from top to bottom.

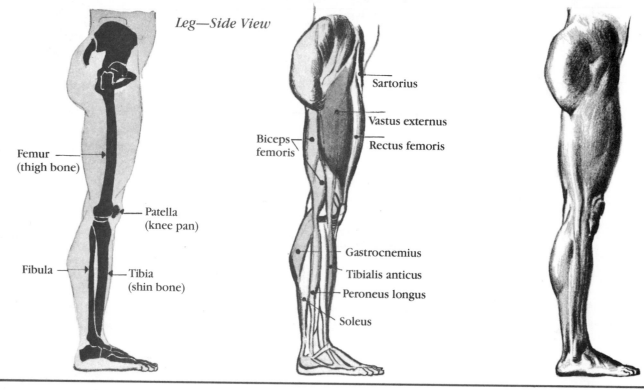

Leg—Side View

Femur (thigh bone)

Patella (knee pan)

Fibula — Tibia (shin bone)

Sartorius

Vastus externus

Biceps femoris

Rectus femoris

Gastrocnemius

Tibialis anticus

Peroneus longus

Soleus

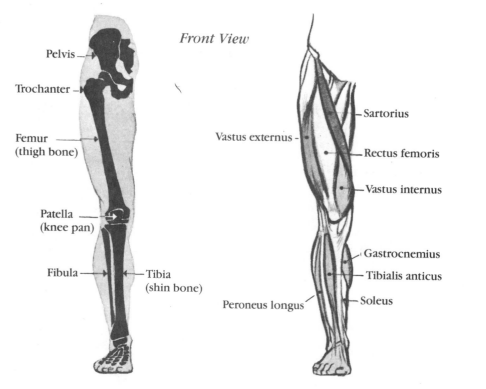

Front View

Pelvis

Trochanter

Femur (thigh bone)

Patella (knee pan)

Fibula — Tibia (shin bone)

Vastus externus

Sartorius

Rectus femoris

Vastus internus

Gastrocnemius

Tibialis anticus

Peroneus longus

Soleus

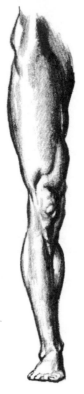

The thigh is well rounded, but as it tapers to the knee the planes become angular. Above each side of the knee they are quite flat. When the knee bends, we see its broad bony surface clearly. From the back, the hips and buttocks look square as they overhang the thighs. The backs of the calves are curved, rounding as they enter the flat surfaces on either side of the shinbone (tibia). The shaft of the leg just above the ankle is quite round but changes into more angular surfaces as it joins the foot. The Achilles tendon creates the broad flat plane at the back.

The outside line showing the contour of the thigh is the most varied. In profile, the fullness of the front of the thigh must be stressed; the most usual and more extreme actions in the thigh come from the *front group of muscles* and not from those on the back of the thigh. Below the knee, the reverse holds true.

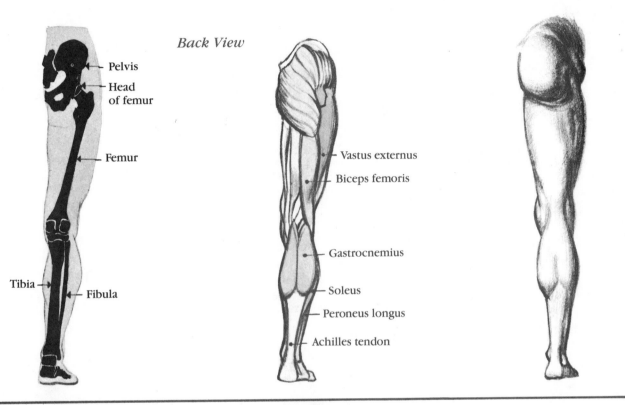

Back View

Pelvis

Head of femur

Femur

Vastus externus

Biceps femoris

Gastrocnemius

Tibia — Fibula

Soleus

Peroneus longus

Achilles tendon

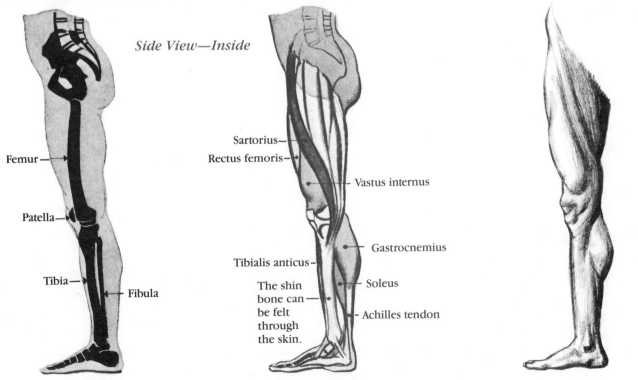

Side View—Inside

Femur

Patella

Tibia — Fibula

Sartorius—

Rectus femoris—

Vastus internus

Tibialis anticus—

The shin bone can be felt through the skin.

Gastrocnemius

Soleus

Achilles tendon

Practice Project... *the skeleton*

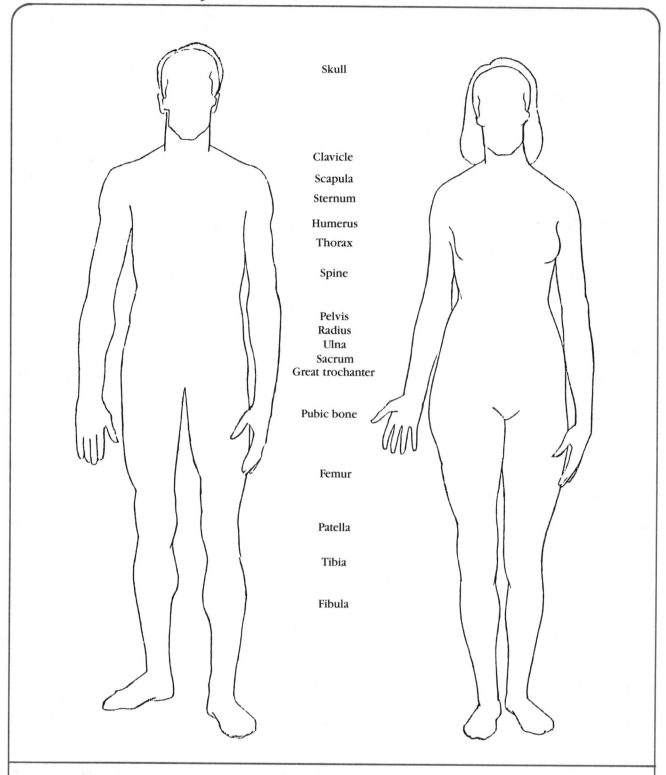

Skull

Clavicle

Scapula

Sternum

Humerus

Thorax

Spine

Pelvis
Radius
Ulna
Sacrum
Great trochanter

Pubic bone

Femur

Patella

Tibia

Fibula

The outline drawings on this page are the same as the figures on page 48. To familiarize yourself with the bone structure, carefully fill in the skeletons, referring to page 48 from time to time. When you have finished, rule lines from the printed names to the bones in your drawing. Then remove the transparent Instructor Overlay, page 86, and place it over your work for comparison and help.

Practice Project... *the muscles*

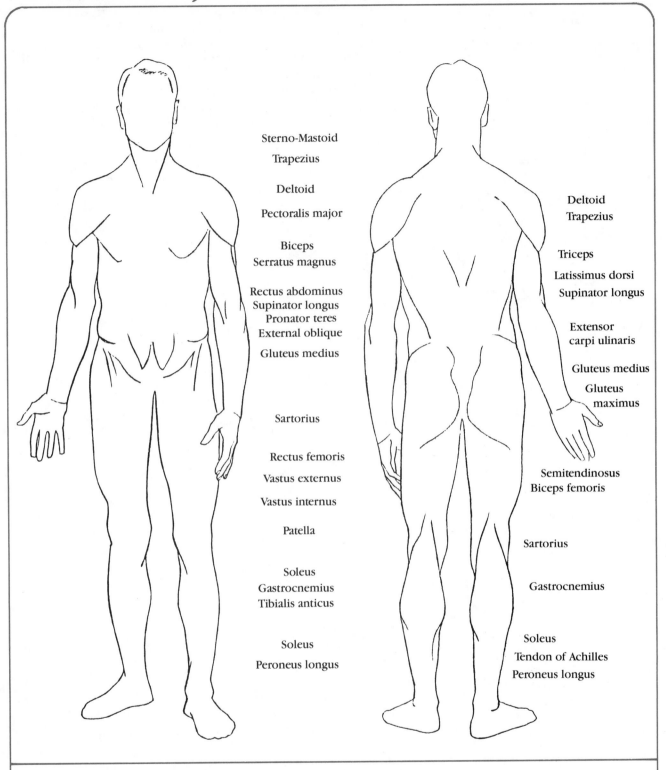

Sterno-Mastoid
Trapezius

Deltoid
Pectoralis major

Biceps
Serratus magnus

Rectus abdominus
Supinator longus
Pronator teres
External oblique
Gluteus medius

Sartorius

Rectus femoris
Vastus externus

Vastus internus

Patella

Soleus
Gastrocnemius
Tibialis anticus

Soleus
Peroneus longus

Deltoid
Trapezius

Triceps
Latissimus dorsi
Supinator longus

Extensor
carpi ulinaris

Gluteus medius
Gluteus
maximus

Semitendinosus
Biceps femoris

Sartorius

Gastrocnemius

Soleus
Tendon of Achilles
Peroneus longus

The outline drawings on this page are the same as the figures on page 49. To famili-arize yourself with the muscles, carefully draw them within the outlines, referring to page 49 from time to time. When you have finished, rule lines from the printed names to the muscles in your drawings. Then remove the transparent Instructor Overlay, page 87, and place it over your work for comparison and help.

Section 6
Humanizing the Basic Form Figure

When you have advanced to the point where you are able to view any pose and automatically see and sketch it in its *basic forms*—cylinders, cubes and spheres—you are on the brink of doing meaningful drawings with authority and conviction.

You have now only to join these forms together, and flesh them out with detail and personality, to create living, creditable human figures capable of any kind of gesture and activity, from calmly passive to wildly active.

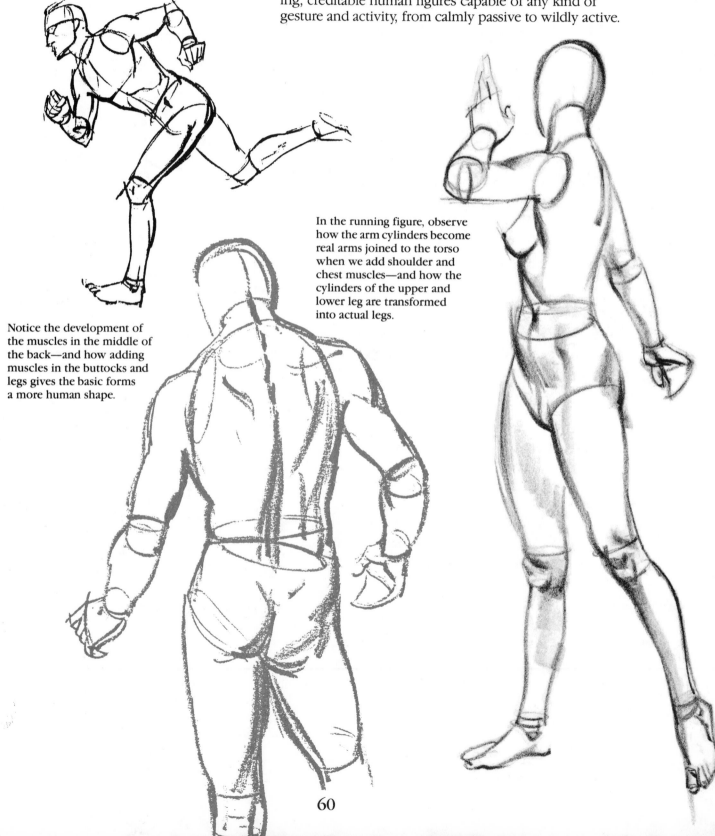

In the running figure, observe how the arm cylinders become real arms joined to the torso when we add shoulder and chest muscles—and how the cylinders of the upper and lower leg are transformed into actual legs.

Notice the development of the muscles in the middle of the back—and how adding muscles in the buttocks and legs gives the basic forms a more human shape.

As you develop your drawing from the gesture to the humanized figure, remember to visualize the parts of the form figure in terms of the cylinder, cube, and sphere. Use ordinary drinking glasses to help you see how the ellipses look in the simple cylinders of the upper and lower torso, the upper and lower arms, and the upper and lower legs. Think of the head as a simple sphere. Remember the law of balance and equilibrium. Draw all these forms through to the other side.

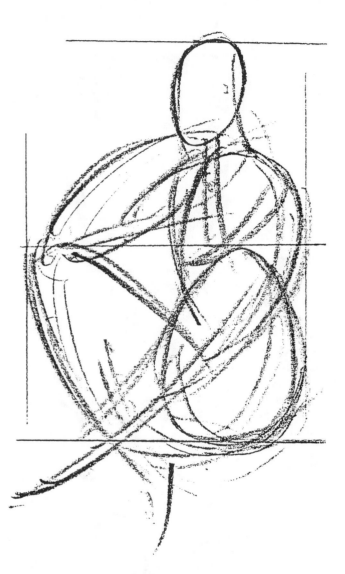

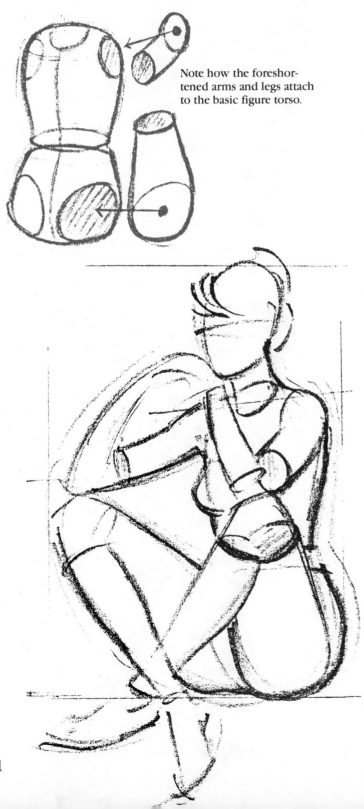

Note how the foreshortened arms and legs attach to the basic figure torso.

These three drawings progress from a rhythmic gesture sketch, to a basic form interpretation, to a diagram showing how the arm and leg cylinders join to the ball and socket joints of the shoulder and the hip.

The logic and simplicity of this method of learning is surprisingly simple compared to trying to draw the figure obscured by a maze of muscles, shadows, cosmetic detail and other superficialities that get in the way of seeing and understanding.

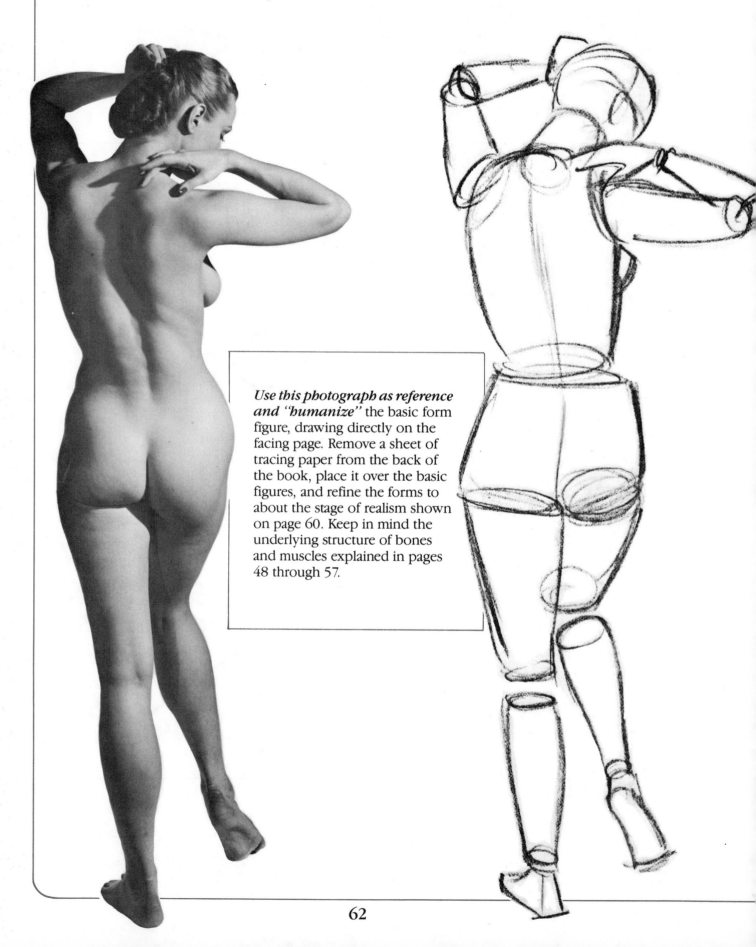

Use this photograph as reference and "humanize" the basic form figure, drawing directly on the facing page. Remove a sheet of tracing paper from the back of the book, place it over the basic figures, and refine the forms to about the stage of realism shown on page 60. Keep in mind the underlying structure of bones and muscles explained in pages 48 through 57.

When you finish, place the Instructor Overlay, page 88, over your work for comparison and help.

Section 7

Lighting the Figure

It's important when artificially lighting your model to emphasize the form and not to create stark melodramatic black shadows and odd angles that distort true form.

Learn to use your lights to create a positive light and shadow pattern that is both pleasing and plausible.

Keep the light coming from a single source to avoid confusing cross shadows.

Acquire a couple of inexpensive clamp-on reflector-type metal lamps. These are adjustable in all directions.

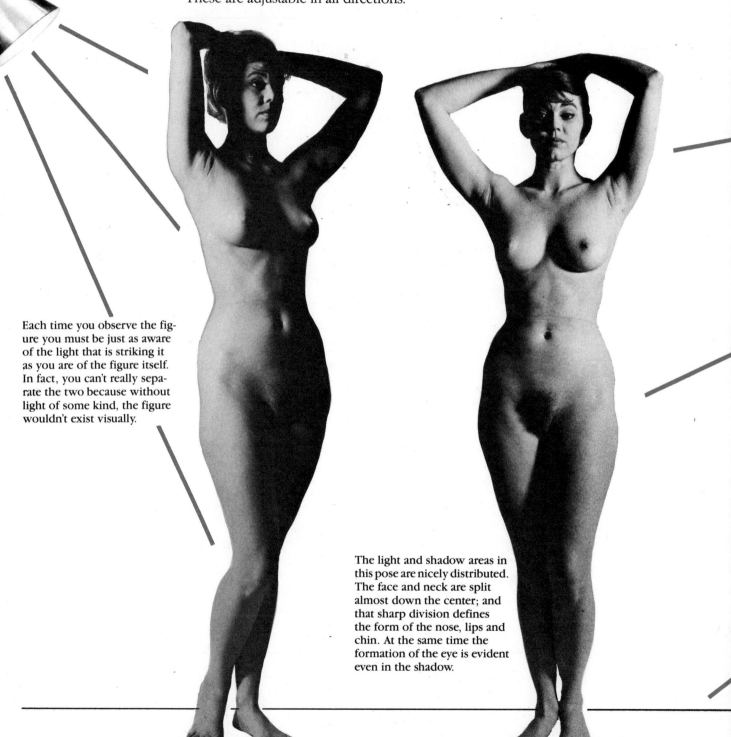

Each time you observe the figure you must be just as aware of the light that is striking it as you are of the figure itself. In fact, you can't really separate the two because without light of some kind, the figure wouldn't exist visually.

The light and shadow areas in this pose are nicely distributed. The face and neck are split almost down the center; and that sharp division defines the form of the nose, lips and chin. At the same time the formation of the eye is evident even in the shadow.

The light comes from the right on both of these poses. Notice how well the form reads in both the light and the shadow areas. Every part of the body is better defined because of the soft shadows that bring forth rises and depressions, curves and flattened planes.

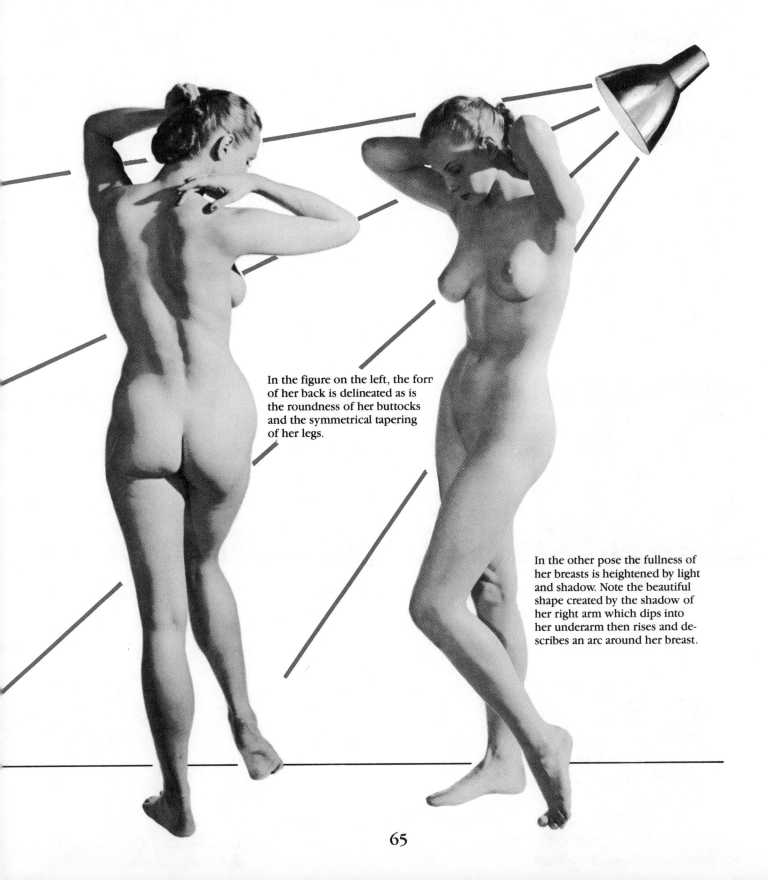

In the figure on the left, the form of her back is delineated as is the roundness of her buttocks and the symmetrical tapering of her legs.

In the other pose the fullness of her breasts is heightened by light and shadow. Note the beautiful shape created by the shadow of her right arm which dips into her underarm then rises and describes an arc around her breast.

Light and shade on the head...

Regardless of the kind of lighting, you should always be aware of the solid form of the head. This holds true even when you want to emphasize pattern or outline in your drawing. These pictures of the egg and the head demonstrate four basic types of lighting—front, three-quarter front, side, and rear. Every one of these photos shows a basic point you should remember when you draw the head: keep the light and shade simple. You see simplicity of lighting when you look at a head which is lighted from a single source; for example, by a lamp alongside a chair or the direct rays of the late afternoon sun. With such single light sources you can easily see two main tones—the tone of the lightstruck area and that of the shadow area. You'll also see some variation of tone within each area. The tones in the shadow will vary because some light will be reflected there by the surroundings. In the light areas the planes turned slightly away from the light source will be a bit darker. The edge of the shadow begins where the planes of the face turn decisively away from the light.

When you draw or paint a head lighted in this simple way, the modeling in the light area should not be so dark as to break up or confuse the overall light tone. The same principle applies to your modeling in the shadow. When students have trouble with their modeling, they often think the medium is causing the difficulty, but actually it may be the incorrect values with which they've broken up either light or shadow areas.

66

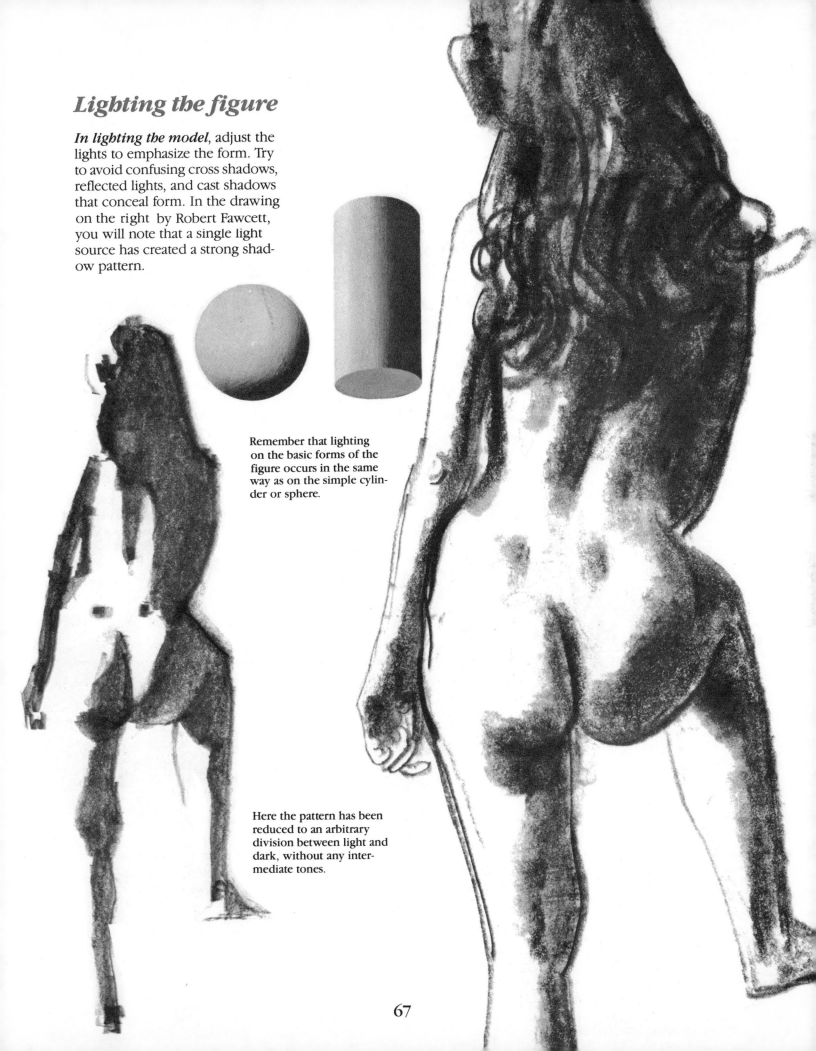

Lighting the figure

In lighting the model, adjust the lights to emphasize the form. Try to avoid confusing cross shadows, reflected lights, and cast shadows that conceal form. In the drawing on the right by Robert Fawcett, you will note that a single light source has created a strong shadow pattern.

Remember that lighting on the basic forms of the figure occurs in the same way as on the simple cylinder or sphere.

Here the pattern has been reduced to an arbitrary division between light and dark, without any intermediate tones.

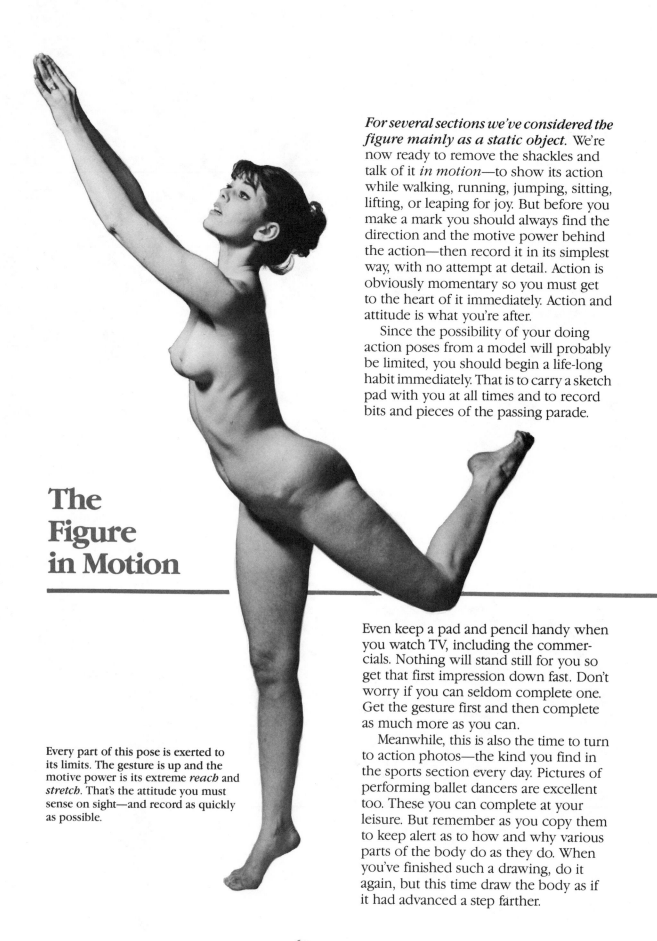

For several sections we've considered the figure mainly as a static object. We're now ready to remove the shackles and talk of it *in motion*—to show its action while walking, running, jumping, sitting, lifting, or leaping for joy. But before you make a mark you should always find the direction and the motive power behind the action—then record it in its simplest way, with no attempt at detail. Action is obviously momentary so you must get to the heart of it immediately. Action and attitude is what you're after.

Since the possibility of your doing action poses from a model will probably be limited, you should begin a life-long habit immediately. That is to carry a sketch pad with you at all times and to record bits and pieces of the passing parade.

The Figure in Motion

Every part of this pose is exerted to its limits. The gesture is up and the motive power is its extreme *reach* and *stretch*. That's the attitude you must sense on sight—and record as quickly as possible.

Even keep a pad and pencil handy when you watch TV, including the commercials. Nothing will stand still for you so get that first impression down fast. Don't worry if you can seldom complete one. Get the gesture first and then complete as much more as you can.

Meanwhile, this is also the time to turn to action photos—the kind you find in the sports section every day. Pictures of performing ballet dancers are excellent too. These you can complete at your leisure. But remember as you copy them to keep alert as to how and why various parts of the body do as they do. When you've finished such a drawing, do it again, but this time draw the body as if it had advanced a step farther.

68

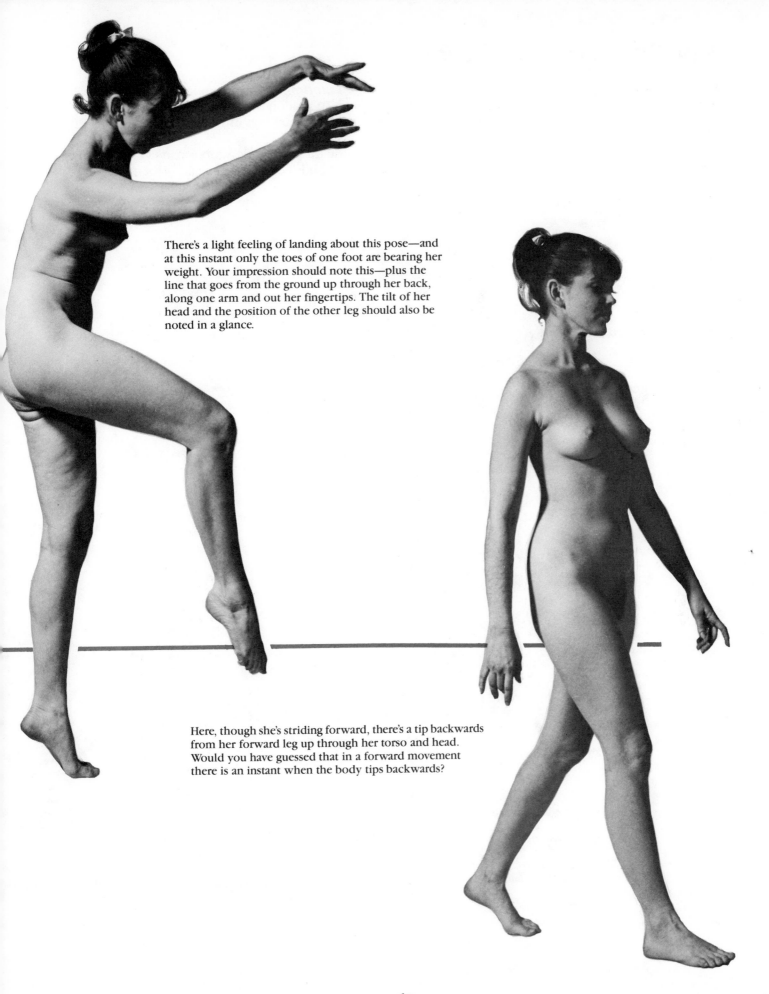

There's a light feeling of landing about this pose—and at this instant only the toes of one foot are bearing her weight. Your impression should note this—plus the line that goes from the ground up through her back, along one arm and out her fingertips. The tilt of her head and the position of the other leg should also be noted in a glance.

Here, though she's striding forward, there's a tip backwards from her forward leg up through her torso and head. Would you have guessed that in a forward movement there is an instant when the body tips backwards?

The Figure in Balance

Balance enables the human being, either standing still or in motion, to keep from falling. This balance results from equalized distribution of weight. When the figure is in motion the stage of balance constantly changes. The artist must be alert to these fleeting instants of balance. Drawings in which the figures are out of balance are always disturbing.

As an aid, start your drawing with a light vertical line as a guide for placing the various parts in the proper positions. This line is just as useful when drawing the figure in attitudes of running, walking, bending, crouching, etc.

In bending to one side, as in the action of lifting a heavy suitcase, or reaching, you will find that you

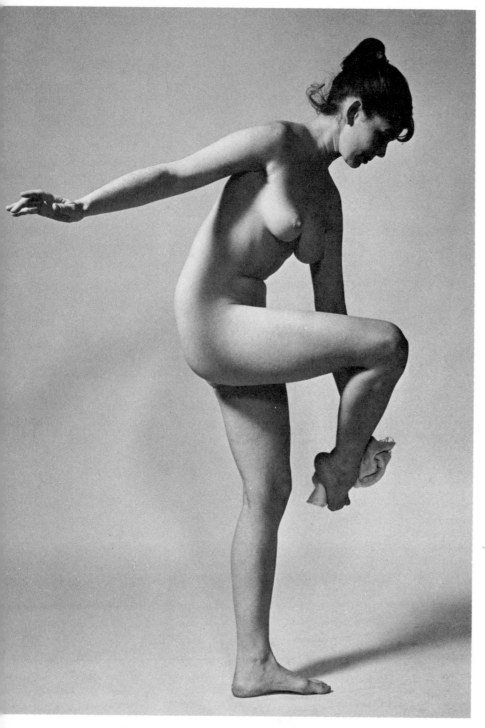

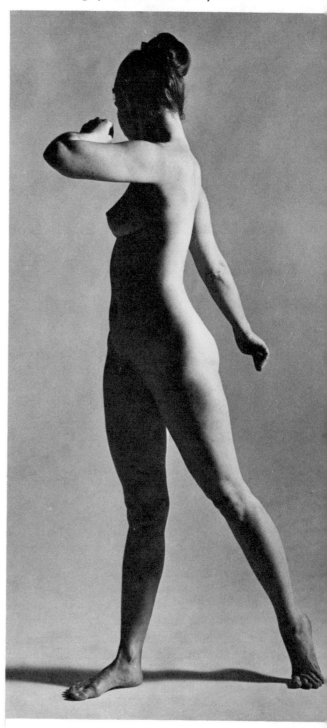

Because of the dual forward weights of the head and lifted leg, this model must extend her arm in the opposite direction to maintain balance.

Her balance line runs down her spine to an imaginary line between her right heel and left foot, since they share in bearing her weight. Also, the extreme twist of her torso has set up other forces which are compensated for by the counterweights of her arms.

naturally extend the arm on the other side to preserve your balance—and you usually raise the heel of the foot on the other side as well. This shows that you must place a sufficient weight on the opposite side to preserve your balance in every attitude and action. When the body bends, it tends to lengthen on one side as much as it shortens on the other.

The spinal column is the key to balance all through the body. Its flexibility allows it to automatically adjust to changes of positions and shifts of weight, thereby affecting the slant of the shoulders and hips as well as the turning and bending of the torso.

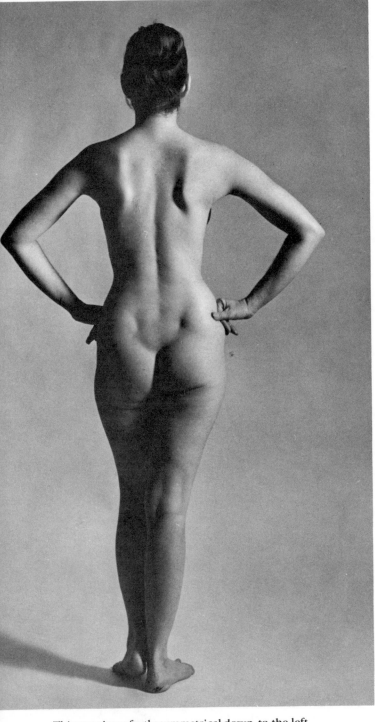

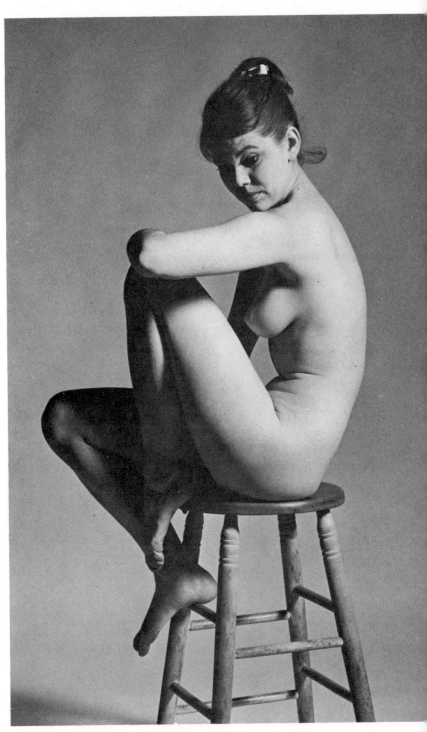

This pose is perfectly symmetrical down to the left leg which is a bit forward.

Her weight is off her feet here and rests upon her buttocks. She can adjust any imbalance by pressure on either one of her heels against the stool.

71

The Figure *Walking*

In walking, the body alternately shifts its weight first to one leg and then the other, with the center of balance over the foot on the ground. The leg is extended slightly in advance of the body—the heel touches the ground first, quickly followed by the toes. With the forward foot resting on the ground, the heel of the other foot is raised, with the knee bending slightly as the leg swings forward past the other. As this leg swings forward, the foot of the other leg bears the whole weight of the body. As the leg swings forward to rest on the ground, it takes its turn at supporting the weight of the body. During this process the body is always passing vertically over the supporting foot.

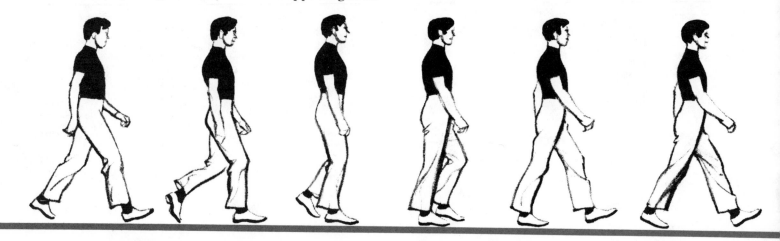

Each time that the foot is raised it thrusts the weight of the body *to the side over the other foot* as well as forward. The unconscious effort to balance the movement of the limbs in walking causes the arms to swing alternately in opposite directions to the legs so that when the right leg *swings forward* the right arm *swings back*—with the reverse action applying to the other two limbs.

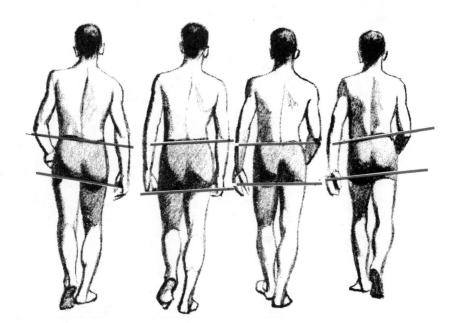

A longer stride, accompanied by a more pronounced alternate swinging of the arms, distinguishes a fast walk from an ordinary normal walk. When you draw either of these actions, remember to show that the knees are bent, to avoid an appearance of stiffness.

This man is walking at a normal pace and performing a complete stride. Draw the same thing yourself so you'll understand the arm and leg positions as a walker proceeds. Note the direction and movement of the hips and buttocks as the weight shifts from one foot to the other in a normal walking stride.

Observe, too, how the forward foot crosses in front of the rear one—and closely misses as they pass each other.

The Figure *Running*

***When running, the body should always be thrown** ahead* of the center of gravity.

The faster the figure runs, the further forward the body is thrust in front of the imaginary line of balance. Unless these fundamental actions are observed and correctly drawn, they will never look convincing.

With the endless number of sports events now on television, you have a steady stream of running models to observe and draw from. Keep a sketch pad handy with your TV schedule.

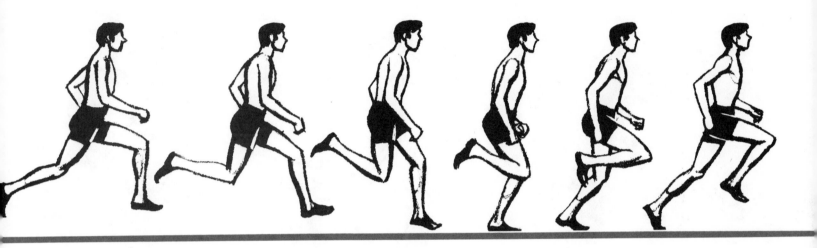

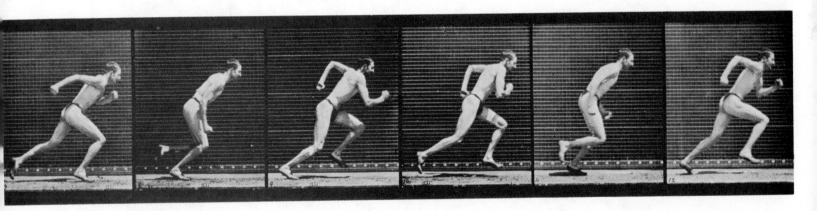

Every phase of an action has its own over-all attitude or flow of movement. In the case of these stopped-action photos, the runner's attitude is one of hustling forward with strength, drive and determination.

Study the flow of movement here—the angle of the body, the position of the arms and legs. It's these large observations you must make, not petty detail which will be meaningless if the broad action is not correct.

Drawing the Standing Female Figure

This is an appropriate point for you to start with the photo of the standing nude and to draw it five different times on successive sheets of tracing paper—each time building on the information gleaned from the preceding one. (This tracing paper method is explained on page 80.)

But before you touch your paper, look the figure over carefully. Study the main lines of action, the direction of the arms, legs and torso and the position of the head.

Now do a spirited *gesture drawing* to know the flow of the pose.

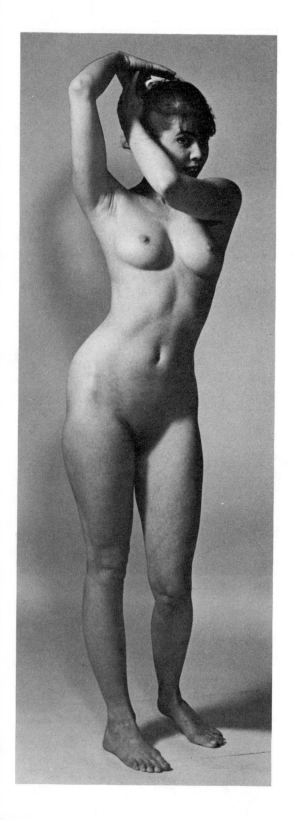

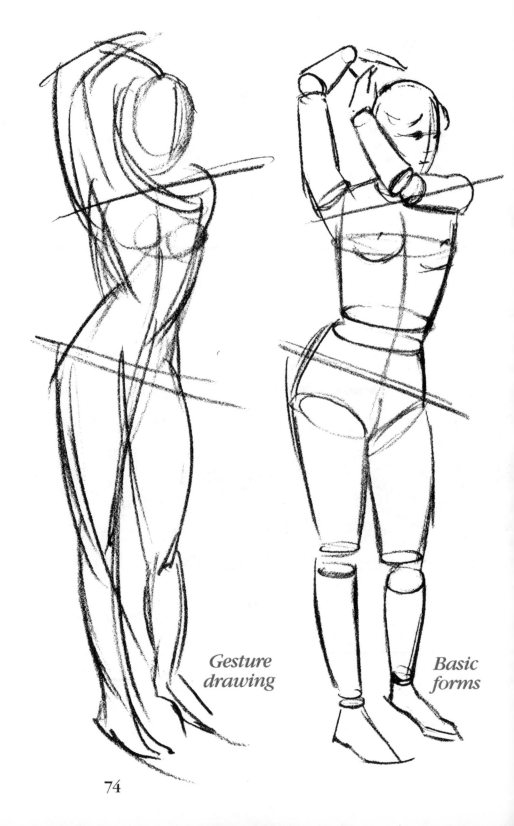

Gesture drawing

Basic forms

74

Next, lay in the *basic forms*, limb by limb plus neck, head and torso. Check all proportions.

Now flesh out the figure, smoothing, joining and giving it an overall cohesiveness while retaining its femininity.

At this stage, lay in the basic light and shadow pattern from the photo.

Now comes the final version in which you give it your best. Improve and perfect everything you've discovered in the first four drawings. In this instance, eliminate any flaws you've found in the lighting—superfluous wrinkles, etc. Note that the shadow edges on the thighs and breast are wide and soft, while around the bony areas they are crisper and harder. Keep a clear value difference between light and shadow.

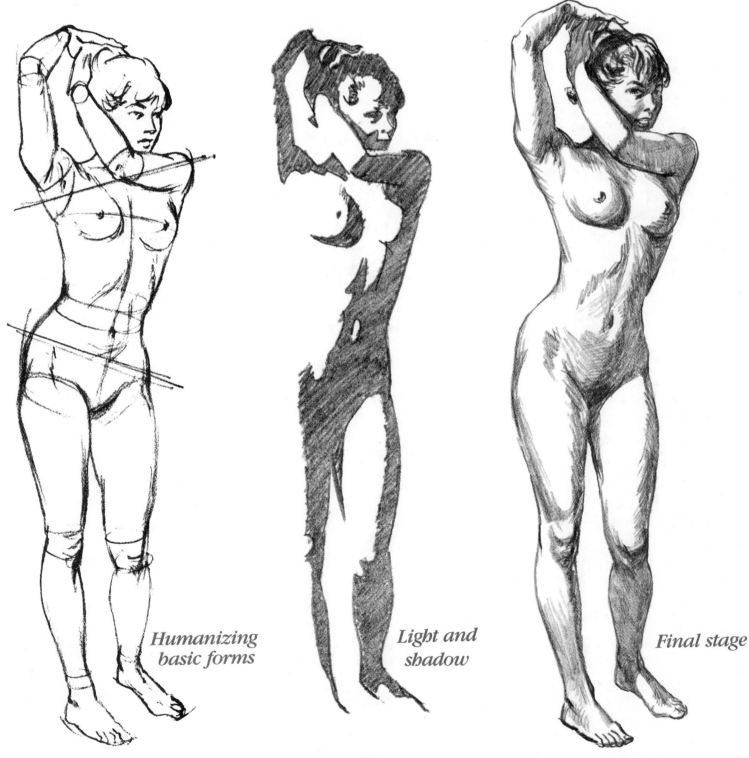

*Humanizing
basic forms*

*Light and
shadow*

Final stage

75

Drawing the Standing Male Figure

The procedure here for the male figure is the same as for the female. Bear in mind, however, that you must now change mental gears and "think male." Where before, you sought to observe and maintain everything feminine about the figure, you will now do the reverse.

You are now dealing with a huskier frame and a much greater muscular structure; the very pose itself is a male one.

Have the appropriate attitude when you draw either sex.

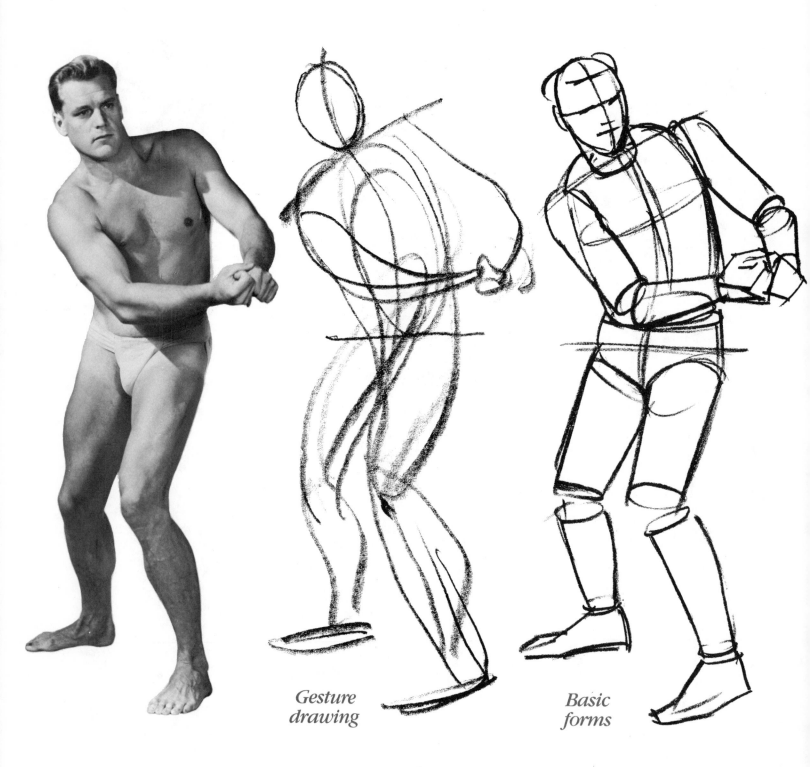

Gesture drawing

Basic forms

76

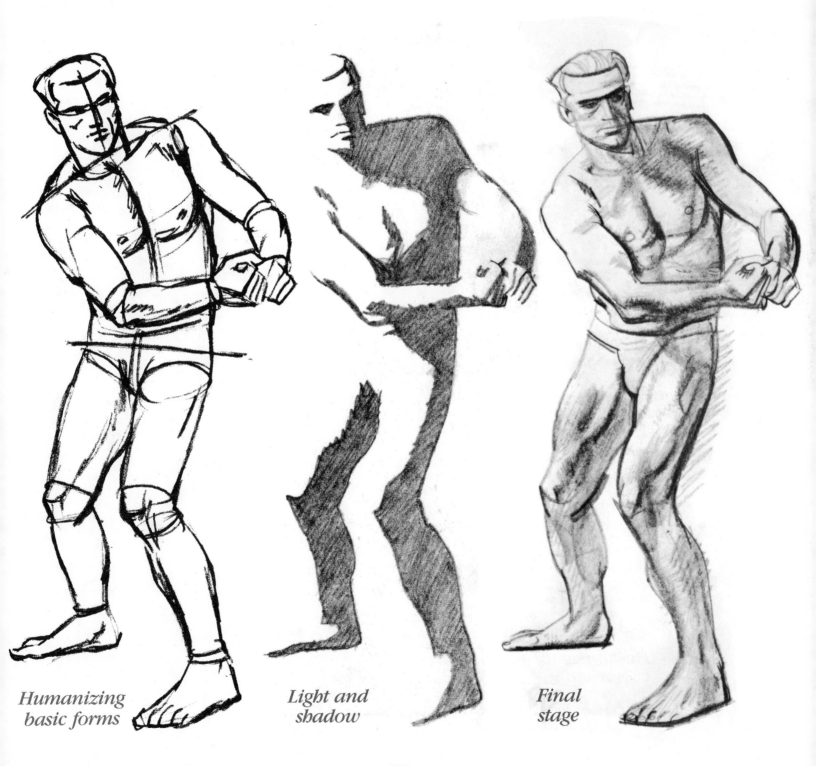

*Humanizing
basic forms*

*Light and
shadow*

*Final
stage*

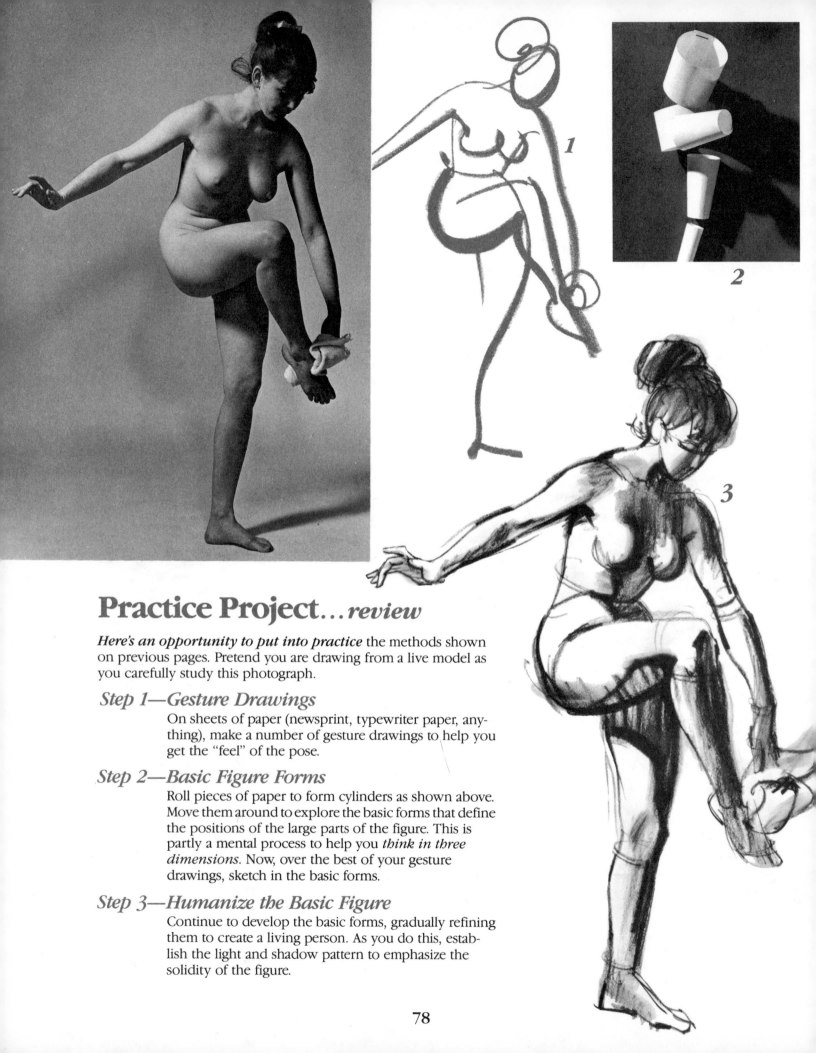

Practice Project...*review*

Here's an opportunity to put into practice the methods shown on previous pages. Pretend you are drawing from a live model as you carefully study this photograph.

Step 1—Gesture Drawings

On sheets of paper (newsprint, typewriter paper, anything), make a number of gesture drawings to help you get the "feel" of the pose.

Step 2—Basic Figure Forms

Roll pieces of paper to form cylinders as shown above. Move them around to explore the basic forms that define the positions of the large parts of the figure. This is partly a mental process to help you *think in three dimensions*. Now, over the best of your gesture drawings, sketch in the basic forms.

Step 3—Humanize the Basic Figure

Continue to develop the basic forms, gradually refining them to create a living person. As you do this, establish the light and shadow pattern to emphasize the solidity of the figure.

78

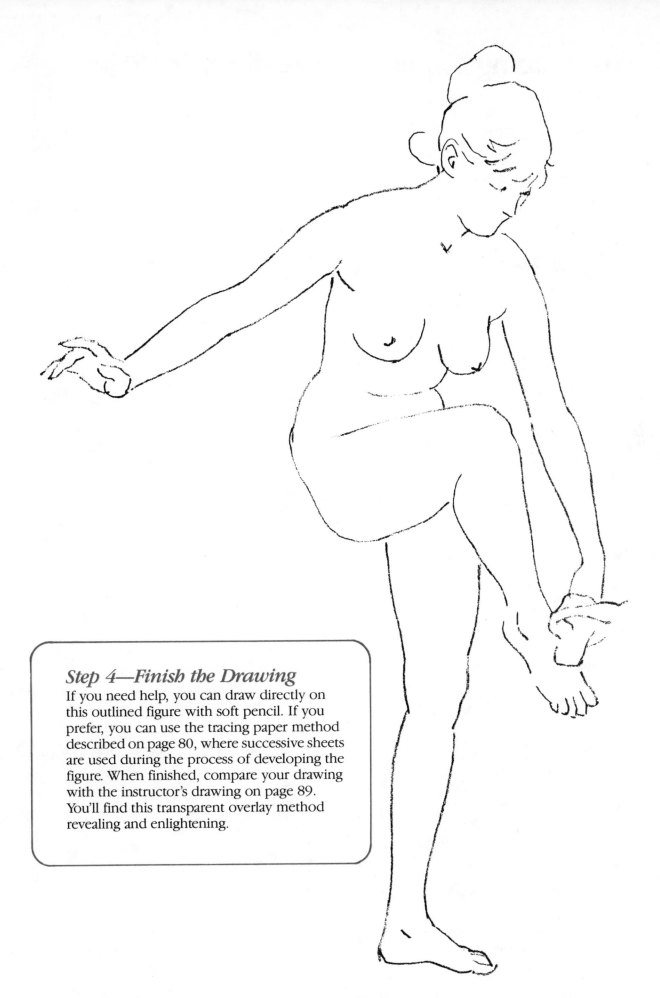

Step 4—Finish the Drawing

If you need help, you can draw directly on this outlined figure with soft pencil. If you prefer, you can use the tracing paper method described on page 80, where successive sheets are used during the process of developing the figure. When finished, compare your drawing with the instructor's drawing on page 89. You'll find this transparent overlay method revealing and enlightening.

Think with Tracing Paper

The beauty of using tracing paper is that it allows you to first make a preliminary trial drawing; then, because it's transparent, you can slip it under a clean sheet and proceed to correct and adjust as you redo the drawing.

You can repeat this as many times as it takes. Be sure, however, that you *don't just mindlessly trace.* Make each successive drawing an improvement, and strive for spontaneity in every new version.

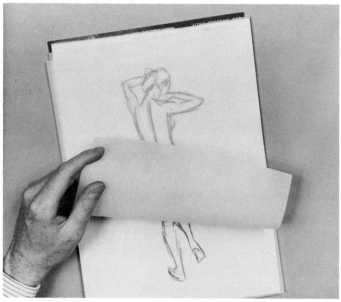

New sheet: Fasten a sheet of tracing paper over your **1** sketch and do a new drawing, using your previous one as a guide and making the necessary improvements.

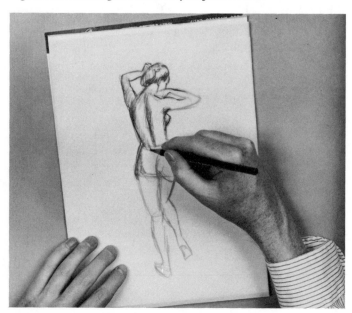

Refining your drawing: If your drawing needs **2** further adjustments, place a clean sheet of tracing paper over it and continue developing it to the degree of finish you wish.

Transfer with Tracing Paper

It's easy to transfer the outlines of a drawing onto another surface. First, lay a sheet of tracing paper over the picture you wish to duplicate and, with a medium soft pencil, trace the main outlines. Then follow the steps below. If your original drawing was done on tracing paper, as described to the left, just turn it over, blacken the back of the outlines, and trace it down. This method gives you a clean surface on which to work, free from erasures and smears.

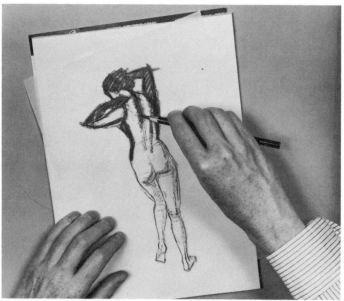

Preparing the back: Turn your tracing over and **1** blacken the paper right over the back of your traced lines with a soft pencil.

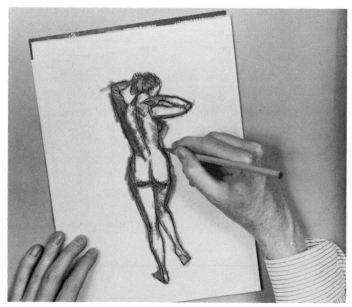

Transferring: Tape the top corners of your tracing on- **2** to the surface on which you plan to draw or paint. With a sharp pencil trace over the outlines and they will be transferred to your drawing surface.

Tracing Papers... *the following pages include these items:*

11 Instructor Overlays. These demonstrations show how instructors at Famous Artists School completed the Practice Projects. Remove them to compare with your own project drawings.

4 blank sheets of tracing paper. These will give you a chance to try out this useful and popular type of paper. Similar paper is readily available at stores selling art supplies.

FREE ART LESSON. This is the most important project of all. You'll find it at the end of the book. Complete it and mail it to get a free evaulation from the instruction staff of Famous Artists School.

<div style="border:1px solid">

More Practice Projects

- ### Gesture drawings
 First review pages 14 through 16. Then start several gesture drawings using the model on page 68. Then turn to page 90 and you'll see sketches made by Famous Artist School Instructors. Compare them with yours.

- ### Basic form figures
 Study pages 22 through 27 and then make basic form figure drawings of the two poses on page 69. Be sure to keep in mind the cylindrical forms as you establish the positions of the various body parts. You'll find drawings by an Instructor on page 91. Tear out that sheet and place it over or beside your drawings for comparison.

- ### Lighting the figure
 After reviewing pages 64 through 67 make drawings of the figures on page 64. First construct the figures using the basic forms. Then place a sheet of tracing paper over your drawing and develop figures with simple light-and-shadow patterns. Now check your results with the Instructor's drawings on page 92.

</div>

TEAR OUT PAGE ALONG THE PERFORATION

Note: Slip a sheet of white paper under this page for easy reading.

Tracing Papers...the following pages include these items:

4 Instructor Overlays. These demonstrations show how instructors at Famous Artists School completed the Practice Projects. Remove them to compare with your own project drawings.

4 blank sheets of tracing paper. These will give you a chance to try out this useful and popular type of paper. Similar paper is readily available at stores selling art supplies.

FREE ART LESSON. This is the most important project of all. You'll find it at the end of the book. Complete it and mail it to get a free evaluation from the instruction staff of Famous Artists School.

More Practice Projects

- **Gesture drawings**
 First review pages 14 through 16. Then start several gesture drawings using the model on page 68. Then turn to page 90 and you'll see sketches made by Famous Artist School instructors. Compare them with yours.

- **Basic form figures**
 Study pages 22 through 27 and then make basic form figure drawings of the two poses on page 69. Be sure to keep in mind the cylindrical forms as you establish the positions of the various body parts. You'll find drawings by an instructor on page 91. Tear out that sheet and place it over or beside your drawings for comparison.

- **Lighting the figure**
 After reviewing pages 64 through 67 make drawings of the figures on page 64. First construct the figures using the basic forms. Then place a sheet of tracing paper over your drawing and develop figures with simple light and shadow patterns. Now check your results with the instructor's drawings on page 92.

Note: Slip a sheet of white paper under this page for easy reading.

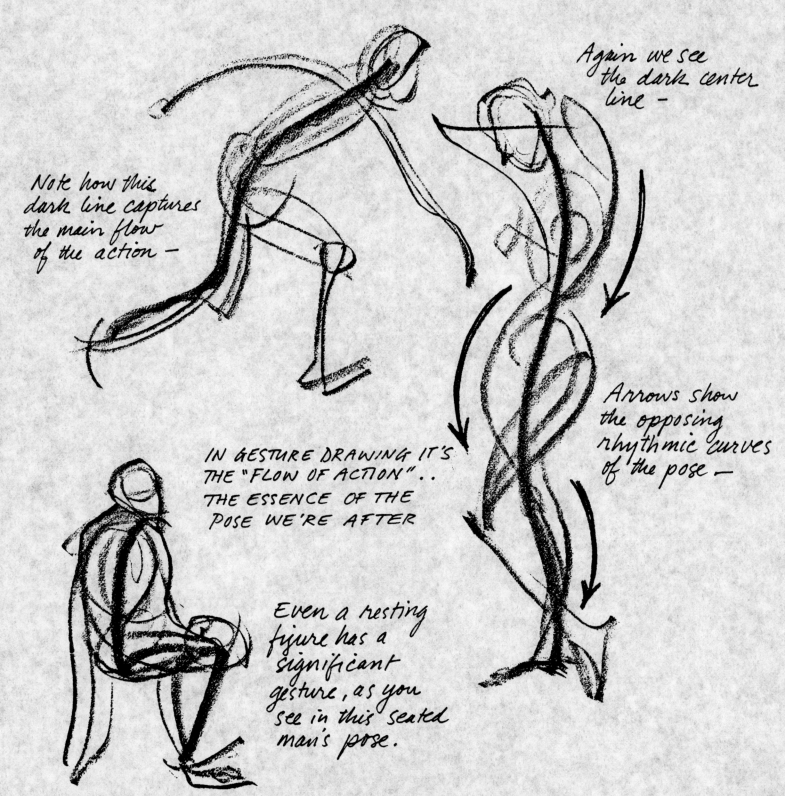

Note how this dark line captures the main flow of the action —

Again we see the dark center line —

IN GESTURE DRAWING IT'S THE "FLOW OF ACTION".. THE ESSENCE OF THE POSE WE'RE AFTER

Arrows show the opposing rhythmic curves of the pose —

Even a resting figure has a significant gesture, as you see in this seated man's pose.

TEAR OUT PAGE ALONG THE PERFORATION

Slip a sheet of white paper under this overlay for easy viewing. You can remove it for comparison with your Practice Project. You'll find these suggestions from an Instructor of the Famous Artists School most helpful.

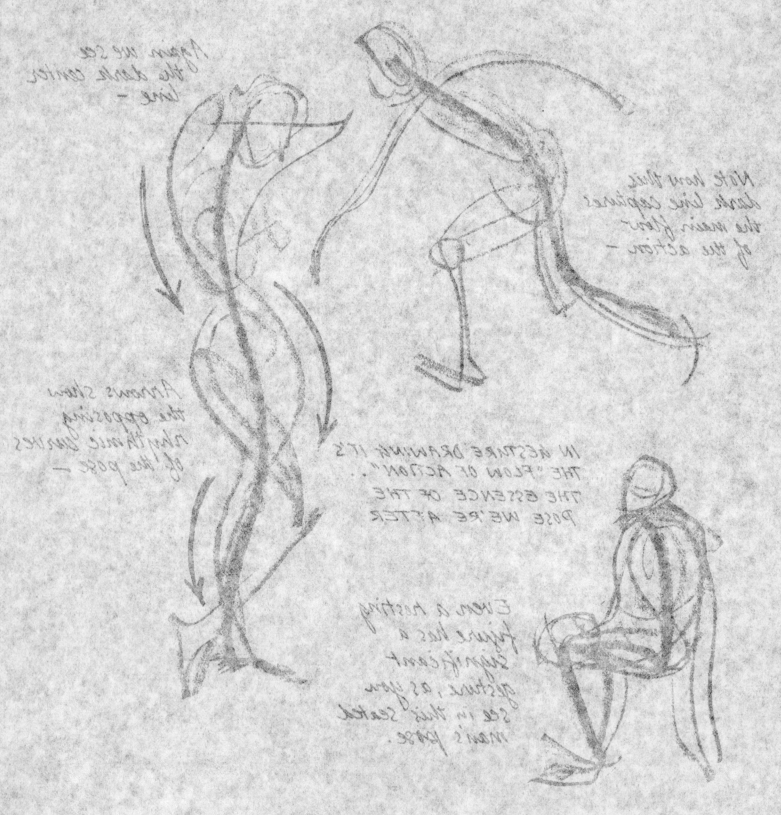

Slip a sheet of white paper under this overlay for easy viewing. You can remove it for comparison with your Practice Project. You'll find these suggestions from an Instructor of the Famous Artists School most helpful.

82

Instructor Overlay...*the basic form figure*
For Practice Project on pages 32 and 33.

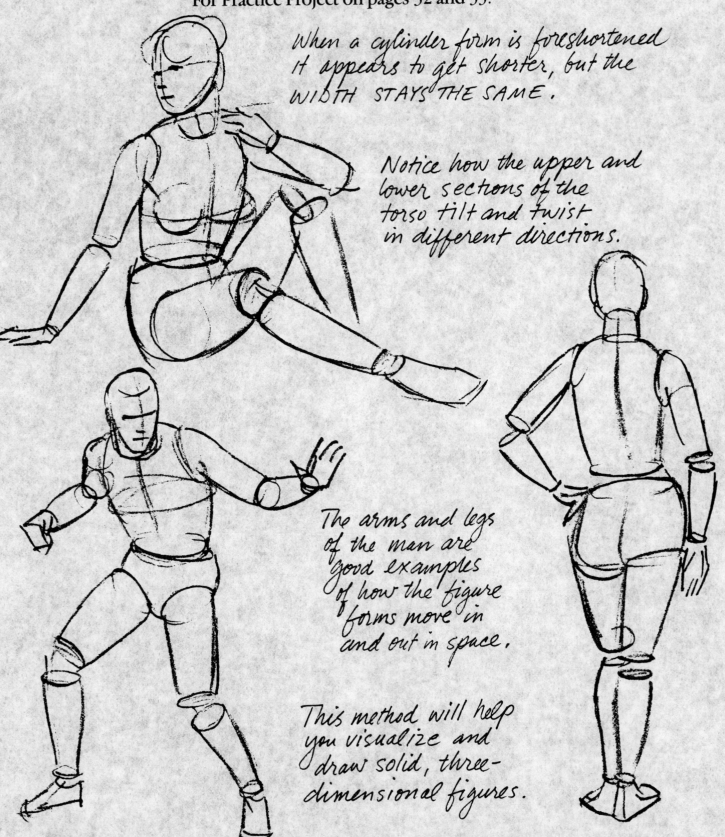

When a cylinder form is foreshortened it appears to get shorter, but the WIDTH STAYS THE SAME.

Notice how the upper and lower sections of the torso tilt and twist in different directions.

The arms and legs of the man are good examples of how the figure forms move in and out in space.

This method will help you visualize and draw solid, three-dimensional figures.

TEAR OUT PAGE ALONG THE PERFORATION

Slip a sheet of white paper under this overlay for easy viewing. You can also remove it and place it over your Practice Project for comparison and helpful suggestions from an Instructor of the Famous Artists School.

When a cylindrical form is foreshortened, it appears to get shorter, but the WIDTH STAYS THE SAME.

Notice how the upper and lower sections of the torso tilt and twist in different directions.

The arms and legs of the wire and wood examples show how the figure forms move in and out in space.

This method will help you visualize and draw solid, three-dimensional figures.

Slip a sheet of white paper under this overlay for easy viewing. You can also remove it and place it over your Practice Project for comparison and helpful suggestions from an instructor of the Famous Artists School.

Instructor Overlay... *contour drawing*
For Practice Project on pages 38 and 39.

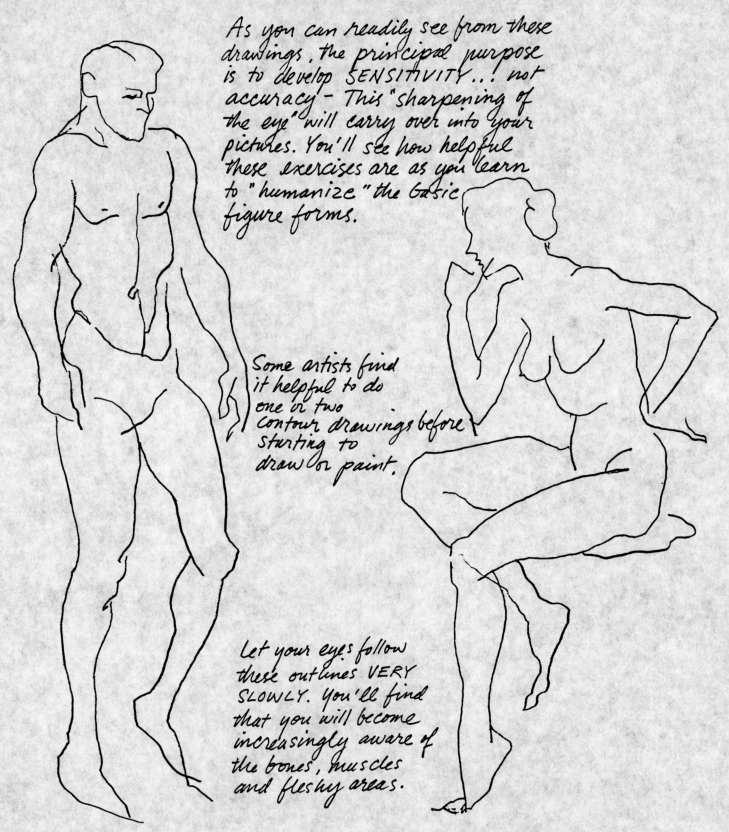

As you can readily see from these drawings, the principal purpose is to develop SENSITIVITY...! not accuracy - This "sharpening of the eye" will carry over into your pictures. You'll see how helpful these exercises are as you learn to "humanize" the basic figure forms.

Some artists find it helpful to do one or two contour drawings before starting to draw or paint.

Let your eyes follow these outlines VERY SLOWLY. You'll find that you will become increasingly aware of the bones, muscles and fleshy areas.

TEAR OUT PAGE ALONG THE PERFORATION

Slip a sheet of white paper under this overlay for easy viewing. You can remove it for comparison with your Practice Project. You'll find these suggestions from an Instructor of the Famous Artists School most helpful.

Slip a sheet of white paper under this overlay for easy viewing. You can remove it for comparison with your Practice Project. You'll find these suggestions from an Instructor of the Famous Artists School most helpful.

84

HOW TO AVOID THE PROPORTION

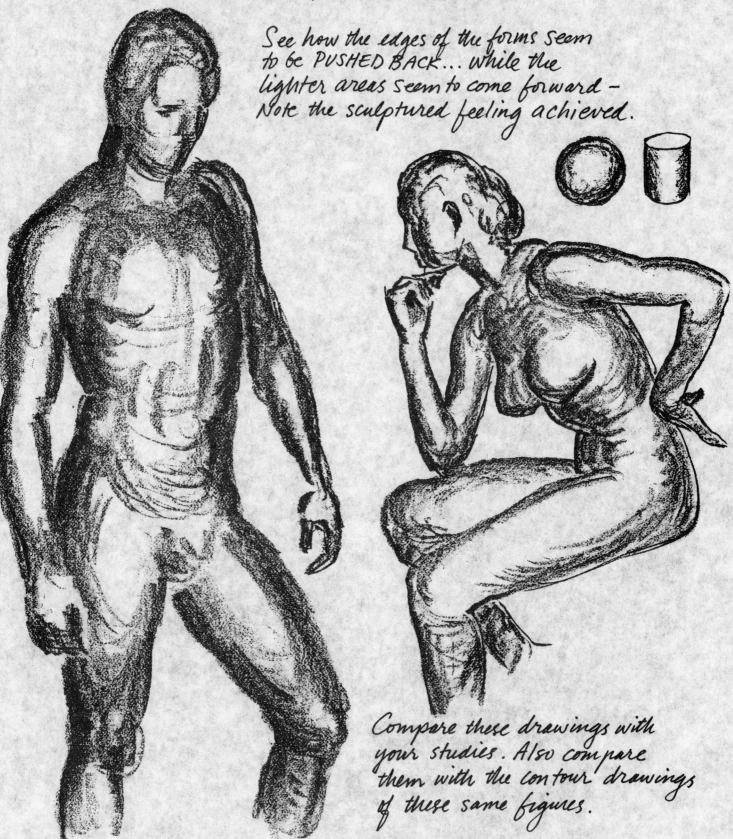

See how the edges of the forms seem to be PUSHED BACK... while the lighter areas seem to come forward — Note the sculptured feeling achieved.

Compare these drawings with your studies. Also compare them with the contour drawings of these same figures.

Slip a sheet of white paper under this overlay for easy viewing. You can remove it for comparison with your Practice Project. You'll find these suggestions from an Instructor of the Famous Artists School most helpful.

TEAR OUT PAGE ALONG THE PERFORATION

Instructor Overlay... *the skeleton*

For Practice Project on page 58.

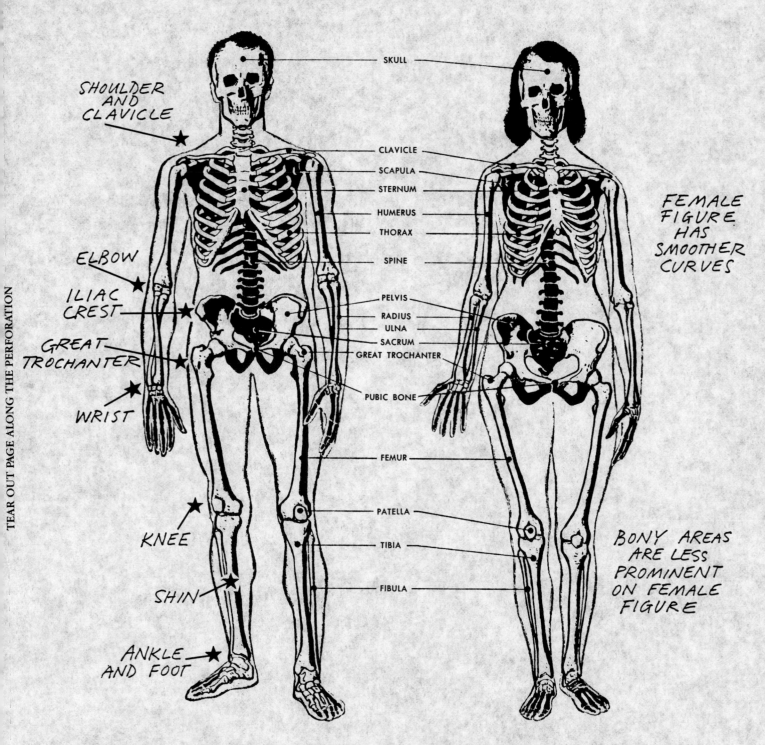

SHOULDER AND CLAVICLE

ELBOW

ILIAC CREST

GREAT TROCHANTER

WRIST

KNEE

SHIN

ANKLE AND FOOT

SKULL

CLAVICLE

SCAPULA

STERNUM

HUMERUS

THORAX

SPINE

PELVIS

RADIUS

ULNA

SACRUM

GREAT TROCHANTER

PUBIC BONE

FEMUR

PATELLA

TIBIA

FIBULA

FEMALE FIGURE HAS SMOOTHER CURVES

BONY AREAS ARE LESS PROMINENT ON FEMALE FIGURE

★ STARS MARK AREAS WHERE BONES ARE NEAR SURFACE AND SHOW PROMINENTLY.

TEAR OUT PAGE ALONG THE PERFORATION

Slip a sheet of white paper under this overlay for easy viewing. You can also remove it and place it over your Practice Project for comparison and helpful suggestions from an Instructor of the Famous Artists School.

Slip a sheet of white paper under this overlay for easy viewing. You can also remove it and place it over your Practice Project for comparison and helpful suggestions from an instructor of the Famous Artists School.

56

Instructor Overlay... *the muscles*

For Practice Project on page 59.

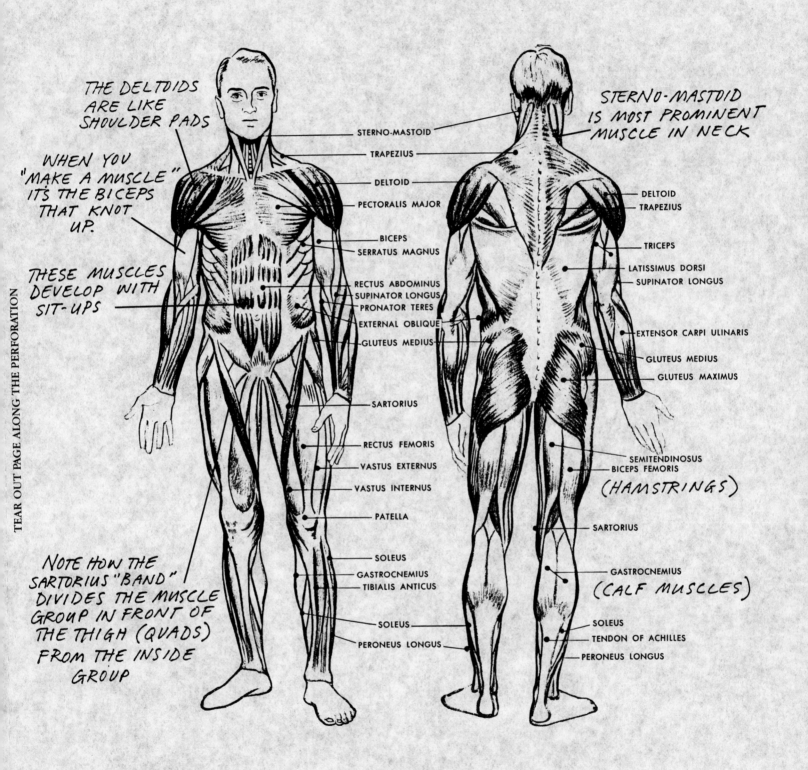

THE DELTOIDS
ARE LIKE
SHOULDER PADS

WHEN YOU
"MAKE A MUSCLE"
IT'S THE BICEPS
THAT KNOT
UP.

THESE MUSCLES
DEVELOP WITH
SIT-UPS

NOTE HOW THE
SARTORIUS "BAND"
DIVIDES THE MUSCLE
GROUP IN FRONT OF
THE THIGH (QUADS)
FROM THE INSIDE
GROUP

STERNO-MASTOID
IS MOST PROMINENT
MUSCLE IN NECK

(HAMSTRINGS)

(CALF MUSCLES)

STERNO-MASTOID
TRAPEZIUS
DELTOID
PECTORALIS MAJOR
BICEPS
SERRATUS MAGNUS
RECTUS ABDOMINUS
SUPINATOR LONGUS
PRONATOR TERES
EXTERNAL OBLIQUE
GLUTEUS MEDIUS
SARTORIUS
RECTUS FEMORIS
VASTUS EXTERNUS
VASTUS INTERNUS
PATELLA
SOLEUS
GASTROCNEMIUS
TIBIALIS ANTICUS
SOLEUS
PERONEUS LONGUS

DELTOID
TRAPEZIUS
TRICEPS
LATISSIMUS DORSI
SUPINATOR LONGUS
EXTENSOR CARPI ULINARIS
GLUTEUS MEDIUS
GLUTEUS MAXIMUS
SEMITENDINOSUS
BICEPS FEMORIS
SARTORIUS
GASTROCNEMIUS
SOLEUS
TENDON OF ACHILLES
PERONEUS LONGUS

TEAR OUT PAGE ALONG THE PERFORATION

Slip a sheet of white paper under this overlay for easy viewing. You can also remove it and place it over your Practice Project for comparison and helpful suggestions from an Instructor of the Famous Artists School.

87

Slip a sheet of white paper under this overlay for easy viewing. You can also remove it and place it over your Practice Project for comparison and helpful suggestions from an Instructor of the Famous Artists School.

Instructor Overlay
...humanizing basic forms
For Practice Project on pages 62 and 63.

USING YOUR KNOWLEDGE AND OBSERVATION OF THE STRUCTURE OF THE HUMAN FIGURE YOU CAN MODIFY THE BASIC FORMS TO ACHIEVE A CONVINCING, REALISTIC FIGURE.

Observe how the muscles of the arms and shoulders can be indicated

Note how the flow of muscles and fleshy areas has been achieved.

The simple cylinder-like basic forms are modified, without losing their solid structure... the forms must still go in out in space.

TEAR OUT PAGE ALONG THE PERFORATION

Slip a sheet of white paper under this overlay for easy viewing. You can also remove it and place it over your Practice Project for comparison and helpful suggestions from an Instructor of the Famous Artists School.

Instructor Overlay

...humanizing basic forms

For Practice Project on pages 62 and 63.

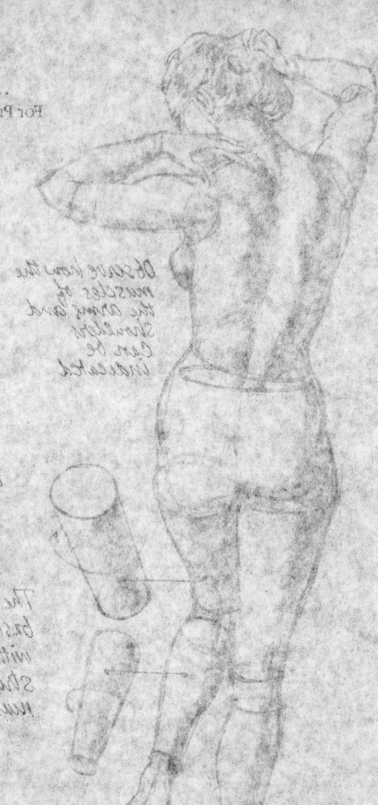

USING YOUR KNOWLEDGE AND OBSERVATION OF THE STRUCTURE OF THE HUMAN FIGURE YOU CAN MODIFY THE BASIC FORMS TO ACHIEVE A CONVINCING, REALISTIC FIGURE.

Observe how the muscles of the arms and shoulders can be indicated.

Note how the flow of muscles and fleshy areas has been achieved.

The simple cylinder-like basic forms are modified, without losing their solid structure... the forms must still go in and out in space.

TEAR OUT ALONG THE PERFORATION

Slip a sheet of white paper under this overlay for easy viewing. You can also remove it and place it over your Practice Project for comparison and helpful suggestions from an instructor of the Famous Artists School.

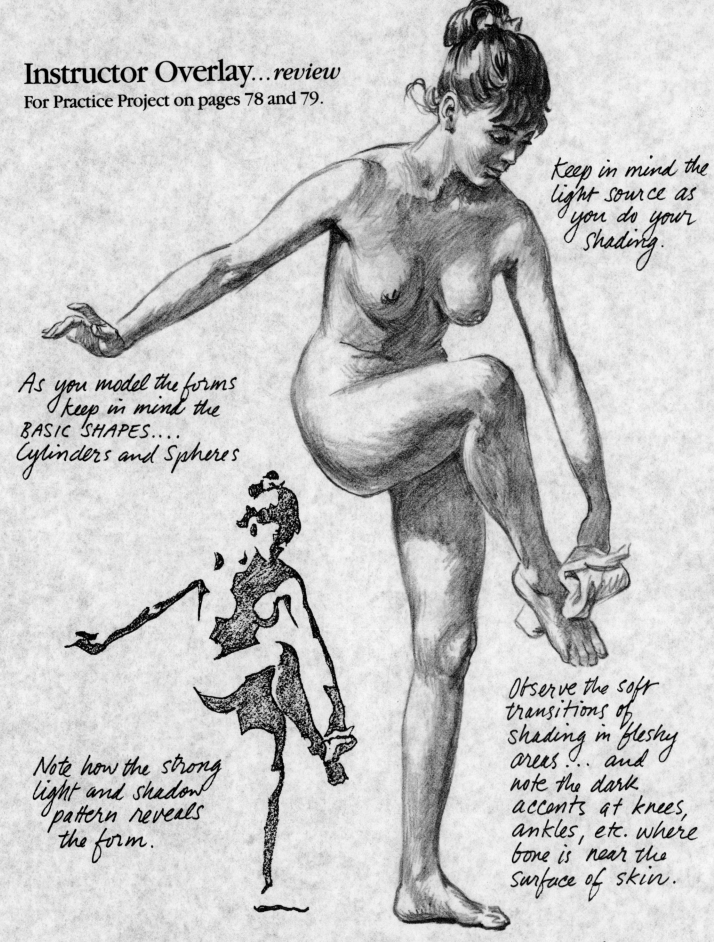

Instructor Overlay...*review*

For Practice Project on pages 78 and 79.

keep in mind the
light source as
you do your
shading.

As you model the forms
keep in mind the
BASIC SHAPES....
Cylinders and Spheres

Note how the strong
light and shadow
pattern reveals
the form.

Observe the soft
transitions of
shading in fleshy
areas... and
note the dark
accents at knees,
ankles, etc. where
bone is near the
surface of skin.

TEAR OUT PAGE ALONG THE PERFORATION

Slip a sheet of white paper under this overlay for easy viewing. You can also remove it and
place it over your Practice Project for comparison and helpful suggestions from an Instructor
of the Famous Artists School.

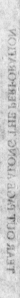

Slip a sheet of white paper under this overlay for easy viewing. You can also remove it and place it over your Practice Project for comparison and helpful suggestions from an Instructor of the Famous Artists School.

89

DO MANY
RAPID SKETCHES
TO CAPTURE THE
FLOW OF ACTION

With her weight
poised on her
toes, she throws
her head back
for balance

Arrow shows
how the action
pulls through
the body to the
raised knee.

QUICK PEN
GESTURE SKETCH -
TRY THIS WHEN
LOOKING AT SPORTS
ON T.V.

Slip a sheet of white paper under this overlay for easy viewing. You can also remove it and
place it over your Practice Project for comparison and helpful suggestions from an Instructor
of the Famous Artists School.

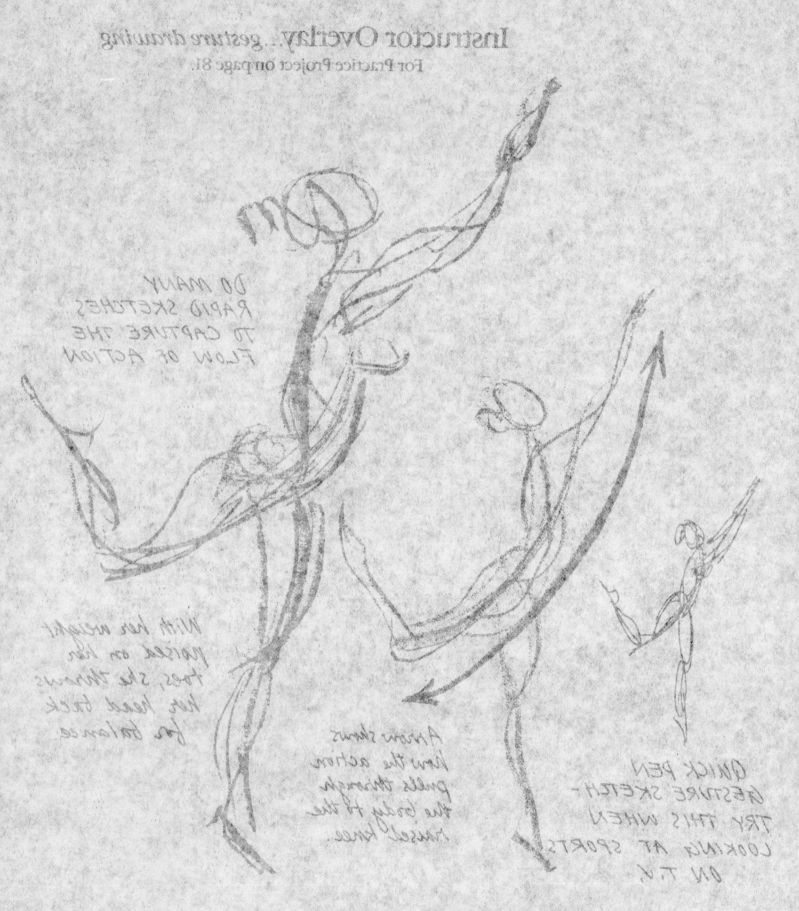

Slip a sheet of white paper under this overlay for easy viewing. You can also remove it and place it over your Practice Project for comparison and helpful suggestions from an instructor of the Famous Artists School.

90

Instructor Overlay...*basic form figure*
For Practice Project on page 81.

Keep in mind how the cylindrical forms point in different directions

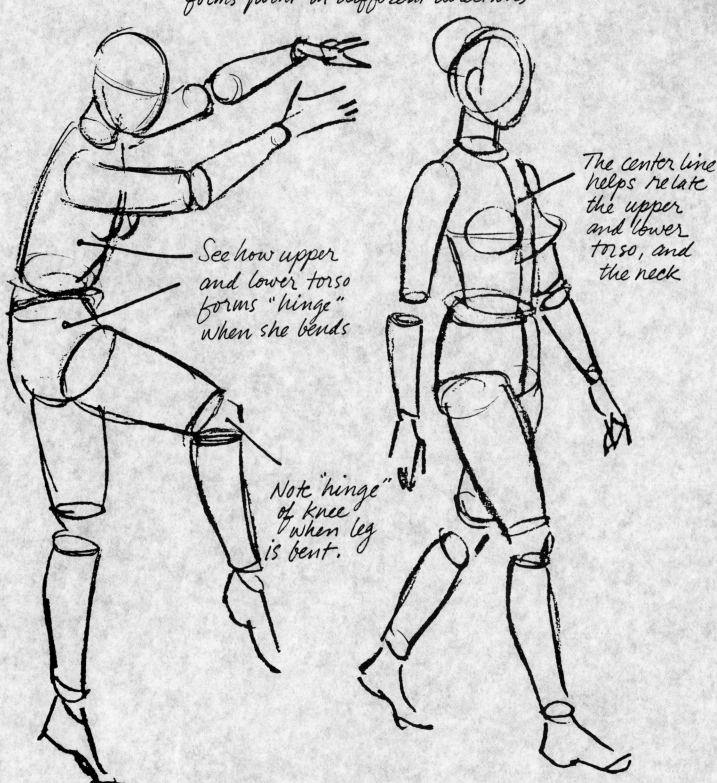

See how upper and lower torso forms "hinge" when she bends

Note "hinge" of knee when leg is bent.

The center line helps relate the upper and lower torso, and the neck

TEAR OUT PAGE ALONG THE PERFORATION

Slip a sheet of white paper under this overlay for easy viewing. You can also remove it and place it over your Practice Project for comparison and helpful suggestions from an Instructor of the Famous Artists School.

Keep in mind how the cylindrical forms relate in different directions.

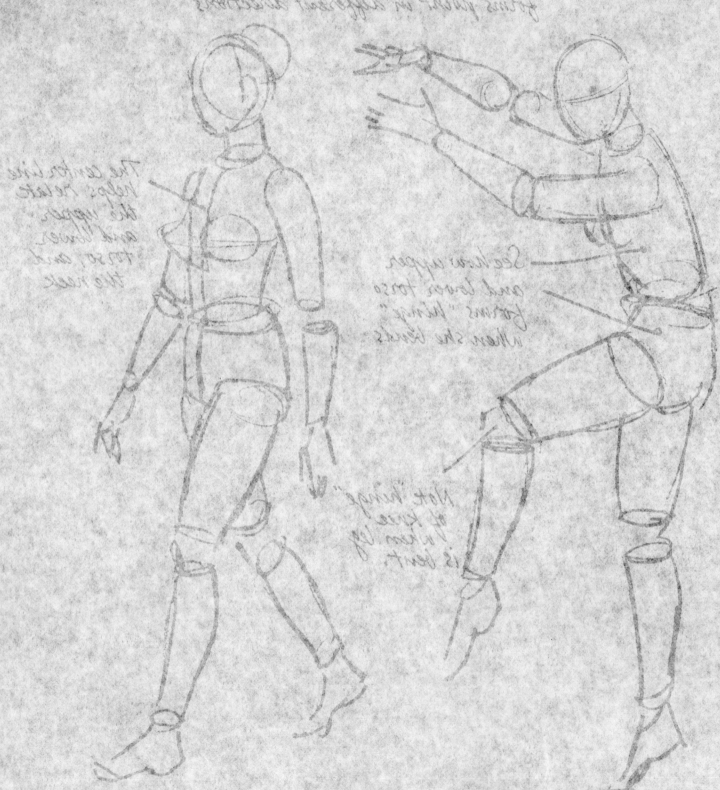

Slip a sheet of white paper under this overlay for easy viewing. You can also remove it and place it over your Practice Project for comparison and helpful suggestions from an instructor of the Famous Artists School.

91

Instructor Overlay… *lighting the figure*
For Practice Project on page 81.

TEAR OUT PAGE ALONG THE PERFORATION

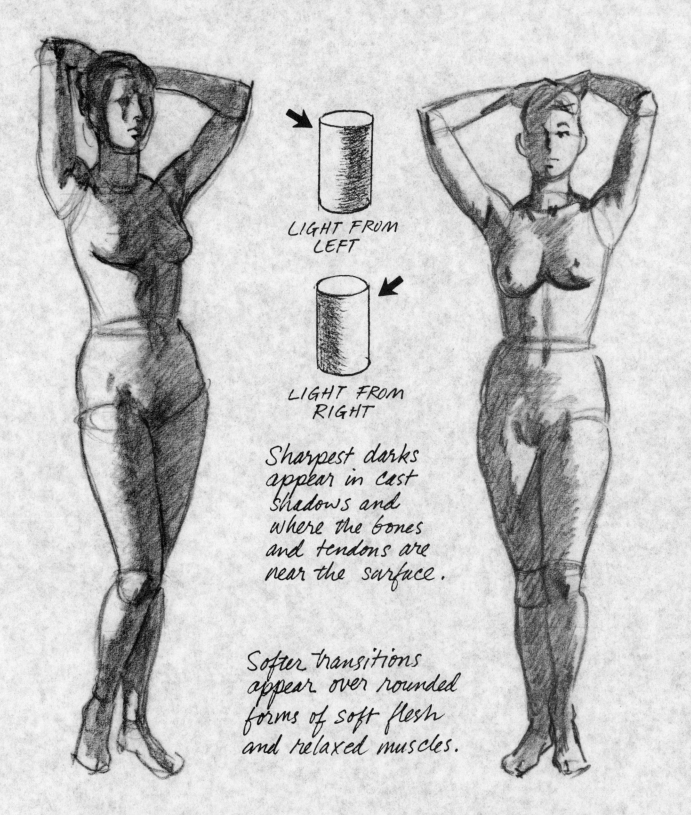

LIGHT FROM
LEFT

LIGHT FROM
RIGHT

Sharpest darks
appear in cast
shadows and
where the bones
and tendons are
near the surface.

Softer transitions
appear over rounded
forms of soft flesh
and relaxed muscles.

Slip a sheet of white paper under this overlay for easy viewing. You can also remove it and place it over your Practice Project for comparison and helpful suggestions from an Instructor of the Famous Artists School.

Slip a sheet of white paper under this overlay for easy viewing. You can also remove it and place it over your Practice Project for comparison and helpful suggestions from an Instructor of the Famous Artists School.

92

Tracing Paper. These sheets will give you a chance to try out this useful and popular type of paper. Similar paper is readily available at stores selling art supplies.

TEAR OUT PAGE ALONG THE PERFORATION

Tracing Paper. These sheets will give you a chance to try out this useful and popular type of paper. Similar paper is readily available at stores selling art supplies.

Tracing Paper. These sheets will give you a chance to try out this useful and popular type of paper. Similar paper is readily available at stores selling art supplies.

Tracing Paper. These sheets will give you a chance to try out this useful and popular type of paper. Similar paper is readily available at stores selling art supplies.

Tracing Paper. These sheets will give you a chance to try out this useful and popular type of paper. Similar paper is readily available at stores selling art supplies.

TEAR OUT PAGE ALONG THE PERFORATION

Tracing Paper. These sheets will give you a chance to try out this useful and popular type of paper. Similar paper is readily available at stores selling art supplies.

Tracing Paper. These sheets will give you a chance to try out this useful and popular type of paper. Similar paper is readily available at stores selling art supplies.

TEAR OUT PAGE ALONG THE PERFORATION

Tracing Paper: These sheets will give you a chance to try out this useful and popular type of paper. Similar paper is readily available at stores selling art supplies.

Tracing Paper: These sheets will give you a chance to try out this useful and popular type of paper. Similar paper is readily available at stores selling art supplies.

Famous Artists School
invites you to enjoy this valuable FREE Art Lesson

Just complete this FREE Art Lesson using your own natural talents and what you have learned from this step-by-step method book. The Lesson covers several areas of artistic development. Then fill in the information on the reverse side, fold as indicated and mail to Famous Artists School. A member of our professional Instruction Staff will personally evaluate your Special Art Lesson and return it to you with helpful suggestions. You will also receive information describing the complete Famous Artists School courses which will open up a world of personal satisfaction and creative achievement for you. No obligation—this personal evaluation and information are yours absolutely free. Don't miss this important opportunity—mail this valuable Art Lesson today.

Picture composition...how shapes fit together

- All pictures are composed of shapes. Objects in a picture are called positive shapes. The remaining areas are negative shapes. Indicate the total number of separate shapes, both positive and negative, that you see in the design at right.

In this example there are two shapes

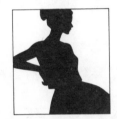

one two three four five six

Observation...part natural and part learned

- On a bright, sunny day, the color of green leaves on a tree looks
 - a) yellow-green in sunlight and blue-green in the shadows
 - b) blue-green in sunlight and yellow-green in the shadows
 - c) the same in sunlight and shadow

- Which triangle appears closest to you?

A B C

- Half close your eyes as you look at these four panels. While squinting, which one appears to be the darkest?

A B C D

Lighting...shadow pattern reveals form

- Diagram A shows the way the shadows would look if there was one light source as shown. Using a pencil or pen, shade in how the shadows would fall on Box B with the same light.

A B

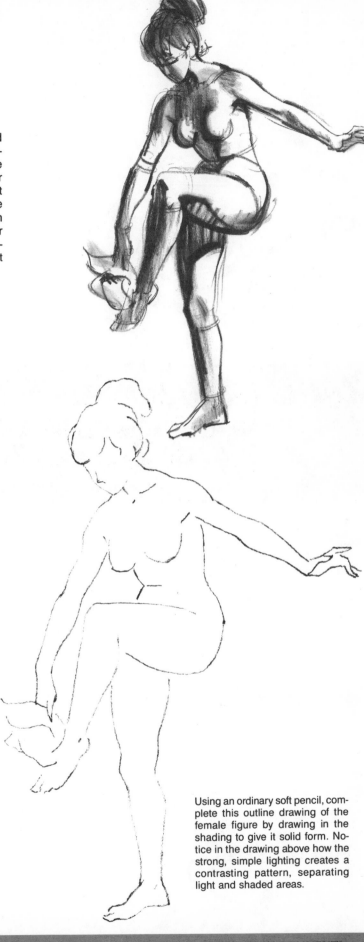

Using an ordinary soft pencil, complete this outline drawing of the female figure by drawing in the shading to give it solid form. Notice in the drawing above how the strong, simple lighting creates a contrasting pattern, separating light and shaded areas.

This Special Lesson was created by Famous Artists School, whose unique home-study programs have enjoyed a reputation of professional excellence for over thirty-five years. When you have completed the Lesson, fill in the information on the reverse side, fold as indicated, and mail to us. We will be glad to send you your personal evaluation and helpful suggestions without obligation.

INSTRUCTOR'S COMMENTS:

DETACH HERE

Like to Learn More About Drawing the Human Figure?

You can…with Famous Artists School's time-tested method.
Get started today with this valuable art lesson.

THIS OFFER IS AVAILABLE ONLY IN THE UNITED STATES AND CANADA.

This side out for mailing. Fold in half along broken line.

Mr.
Mrs.
Miss_____
Ms
Address_____ Apt. No. _____

City_____ State _____ Zip_____

Telephone Number__()_____
 (area code)

PLACE
PROPER
POSTAGE
HERE

FAMOUS ARTISTS SCHOOL
Dept. FF1
17 Riverside Avenue
Westport, CT 06880

First Class Mail

ATTENTION:
Instruction Department
FREE ART LESSON